Type & Typographers

Type & Typographers

Manfred Klein

Yvonne Schwemer-Scheddin

Erik Spiekermann

Architecture Design and Technology Press, London

First published in Great Britain in 1991 by
Architecture Design and Technology Press
128 Long Acre.
London WC2E 9AN.
An imprint of the Longman Group (UK) Ltd.

© 1991 V+K Publishing, P.O. Box 144,
1250 AC Laren, The Netherlands.

British Library Cataloguing in Publication Data.
A CIP record for this book is available from the
British Library.

ISBN 1-85454-848-4

Printed and bound in The Hague, Netherlands.

Contents

On letters, figures and punctuation marks

Wood and lead letters, 'output' on paper or film.
Technical skills, creativity and aesthetics.

Typography as a medium.
Housewives and women's magazines, accountants and annual reports,
art historians and exhibition catalogues.

There are letters, I believe, which are specially meant for poets, or even
for multinationals. And there are letters you would only use to write dirty
words.

A personal and direct relationship with typography is of vital importance
for a designer.
For 'Type & Typographers' we have made a choice from thousands of
typefaces.
Twenty-six faces have been selected by Ernst Schilp and myself in
collaboration with Erik Spiekermann, Yvonne Schwemer-Scheddin and
Manfred Klein.
Ernst and I also designed the book.

In our information culture, classic, 'modern classic' and recently
developed typefaces are used in a mix and side by side. 'Type &
Typographers' includes classic faces that can be set on a pedestal or
framed in gold.

'Do-it-yourself, fast-moving consumer' typographers will be primarily
interested in the current developments in 'ready-to-use PostScript fonts'
covered in this book.

In the end everyone has to do with letters and figures. But also with the
designer of them - or the cutter or engraver - who has expressed his
vision of legibility, functionality and beauty in black and white forms,
forms which can even reflect cultural trends.

Cees de Jong

Laren, spring 1991

Foreword

I was really quite surprised when I was asked, as chairman of the Royal Association of Printing Companies (KGVO), the Netherlands, to write a foreword for *Type & Typographers*. In the first place I thought that the book was an English-language publication and in the second I do not regard myself as an expert on types and typographers. After a while, however, when I had looked carefully at the contents, I saw that *Type & Typographers* would be a book about a subject which I now - after considering various points - believe to be of essential importance for the printing industry. Letters are the central component in printed communication. They are pre-eminently the means by which the printing industry brings about this communication. Without letters there can be no print. The fact that I have only now become aware of this and that I have always taken the existence of letters in all kinds of forms more or less for granted may give pause for thought, but I believe it also underlines the importance of this book. At least it seems to me a good thing that from time to time, for example through a publication such as this, we should be made aware of what letters mean for us - not only for the printing industry but also, in a wider sense, for our culture and for communication between people and nations. This book, in particular, is a stimulus in that direction, principally through the way in which the twenty-six typefaces selected are presented. This is clear and well-organised and reveals considerable attention to detail and respect for the subject. As a result this book provides a surprising and impressive introduction to types and their designers. The fact that it appears now, in 1991, also seems to me a good thing. The dramatic technical developments over recent years, especially in the 'pre-press' field, have meant that many have not had time to study all the aspects. This book invites us to pause and consider whether with all these new developments we are still on the right track. It is therefore appropriate that it should appear on the occasion of the ninetieth anniversary of the Royal Association. By describing the history, the background and the current state of affairs, *Type & Typographers* also gives guidelines for the future for the printing industry, for designers and for everyone concerned with letters in one way or another.

M. Handgraaf

(Chairman, Royal Association of Printing Companies (KGVO), The Netherlands)

Akzidenz-Grotesk

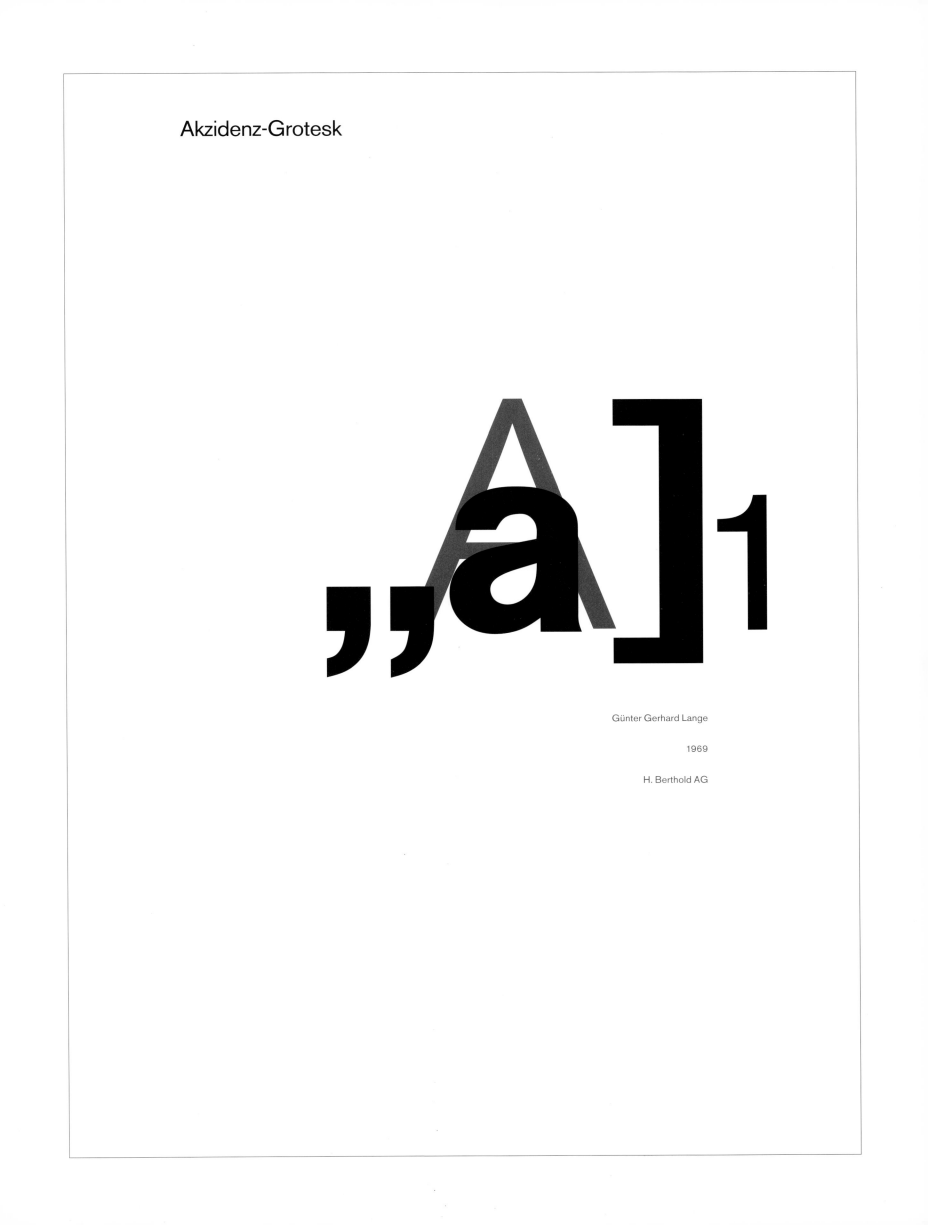

Günter Gerhard Lange

1969

H. Berthold AG

ABCDEFGHIJK
LMNOPQRST
UVWXYZ
1234567890
&
abcdefghijklmn
opqrstuvwxyz
–.,:;!?„""''—

normal
normal
regular

ABCDEFGHIJKLMNOPQRSTUVWXYZ

abcdefghijklmnopqrstuvwxyz

1234567890/%

(.,-:;!?)[''„""»«]—+=/$§*&

ÆŒØÇæœøçáàäâéèëêíìïîóòöôúùüû

italique
kursiv
italic

ABCDEFGHIJKLMNOPQRSTUVWXYZ

abcdefghijklmnopqrstuvwxyz

1234567890/%

(.,-:;!?)[''„""»«]—+=/$§*&

ÆŒØÇæœøçáàäâéèëêíìïîóòöôúùüû

demi-gras
halbfett
medium

ABCDEFGHIJKLMNOPQRSTUVWXYZ

abcdefghijklmnopqrstuvwxyz

1234567890/%

(.,-:;!?)[''„""»«]—+=/$§*&

ÆŒØÇæœøçáàäâéèëêíìïîóòöôúùüû

italique
demi-gras
kursiv halbfett
medium italic

ABCDEFGHIJKLMNOPQRSTUVWXYZ

abcdefghijklmnopqrstuvwxyz

1234567890/%

(.,-:;!?)[''„""»«]—+=/$§*&

ÆŒØÇæœøçáàäâéèëêíìïîóòöôúùüû

gras
fett
bold

ABCDEFGHIJKLMNOPQRSTUVWXYZ

abcdefghijklmnopqrstuvwxyz

1234567890/%

(.,-:;!?)[''„""»«]—+=/$§*&

ÆŒØÇæœøçáàäâéèëêíìïîóòöôúùüû

AG, the evergreen of the sans serifs

AkziDenzGroTesK

"Typefaces must be functional. The one you are reading has been my favourite for 60 years. Its name is 'Akzidenz-Grotesk.' (Advertisement by Anton Stankowski, Stuttgart, 1989).

*"It is at once very simple and highly typical. Its outstanding legibility and anonymity make it the general purpose typeface **par excellence.***" (Hans Neuburg, Zurich, 1962).

"It is the work of anonymous typecutters: craftsmen, specialists, whose professional background and experience meant they were familiar with the finest subtleties and principles, and not just those of Grotesque. They gave Akzidenz-Grotesk the ultimate accolade a typeface can have: a functional, formal rightness, transcending the whims of fashion." (Karl Gerstner, Basle, 1963).

In fact, 'AG', as connoisseurs like to call it, is a centenarian amongst typefaces. It was already over twenty years old at the start of the heyday of Constructivism; de Stijl, Bauhaus, Dada and others used it to great effect. It was in at the birth of Swiss typography - as its major typeface. It was also the hallmark of the short-lived but influential successor to the Bauhaus, the High School of Design in Ulm. And it was midwife and wet nurse to many new anonymous-looking Grotesque faces,

some of which, like Helvetica, outsold AG without ever threatening its reputation for high visual quality. Quite the opposite: the ('living') irregularities of Akzidenz-Grotesk are now widely preferred to the absolute regularity of ('dead') Helvetica. People have realised that type does not have to be uniform to make it legible and attractive; on the contrary, it is the difference between characters which makes them legible.

Nowadays, Akzidenz Grotesk is rightly presented as a Berthold product from the turn of the century. But that's not the whole truth. Günter Gerhard Lange points to sources in Stuttgart, at least for the standard face. The evidence is in the *Deutscher Buch und Steindrücker* of January 1899: by two companies who presented 'Accidenz-Grotesk' in an advertisement. One was Berthold, the other Bauer & Co., of Stuttgart, who apparently merged with Berthold at around this time.

So far, we have only been talking about the original Akzidenz-Grotesk, the present-day 'old face'. Of course, AG has also had its share of face-lifts, such as the AG Book series for the then new technology of photosetting at Berthold at the start of the 70s. This came into being as a completely redesigned series of faces, combining various AGs of different origins, the

inevitable result of the (up to then) unavoidable manual and machine typesetting, into a single form. Günther Gerhard Lange, its originator, described the work in 1973:

"In this work, the basic proportions of the well-known and well-loved Akzidenz-Grotesk semi-bold were used to determine the average length and individual shapes. The family similarities between the individual styles had of course to be taken into account, as did the mood of the times and fashion."

The fashion of course was the then brand-new Helvetica; and, for marketing reasons, AG Book was soon forced to come up with a promising contender for this market leader. Of course, there were problems of copyright. Which came first, the chicken or the egg? Lange says, *"Where Grotesque faces have a common origin, the results are bound to be very similar. The difference in individual styles between the Akzidenz-Grotesk Buch series and Helvetica is less obvious in the smaller sizes, but very obvious in the larger ones."*

On the philosophy underlying the new AG faces, Lange has this to say:

"A typeface is not just there to present the reader with a solid mass of grey, which very quickly tires the eye, since there is no contrast. This confuses regularity with monotony and character with blandness."

Of course, there was also a commercial side to this argument: Berthold now had to find a niche for its own version - alongside the now all-conquering Helvetica and other competing new faces such as Univers by Adrian Frutiger or Folio by Bauer. Akzidenz-Grotesk had the advantage over the newcomers of being the original and a good foundation for a certain visual tension between the old AG characters. But Univers and Helvetica emerged as the new stars of the sans serif world. But we also know that this also has to do with the different market strengths and advertising expenditure by the suppliers, and not just with inherent quality in the typeface itself.

AG still had its devotees, though, in both its old and new forms: see the statement by Anton Stankowski at the start of this section.

Nowadays, people who never used to have anything to do with typefaces are starting to discover them: typography has become

13

AG Tee: Berthold ad from the 60s, sample no. 465.

Aus den fruchtbarsten Gebieten Indiens, Ceylons und Japans kommen die bedeutendsten Teesorten der Welt. Der Teestrauch wird zwischen 5 und 15 m hoch und besitzt lange schmale Blätter. Die gereiften Blätter werden durch uralte Aufbe-reitungsmethoden in die verschiedenen hocharoma-tischen Teesorten umge-wandelt. Der bei uns bekannte »schwarze Tee« wechselt seine grüne Farbe in ein dunkles, kupferfarbe-nes Braun und nimmt seinen angenehmen Duft an

Neue Grafik
New Graphic Design
Graphisme actuel

Internationale Zeitschrift für Grafik und verwandte Gebiete Text dreisprachig (deutsch, englisch, französisch)	International Review of Graphic Design and related subjects Issued in German, English and French	Revue internationale du graphisme et des domaines annexes Parution en langue allemande, anglaise et française

14

	Ausgabe Dezember 1962	Issue for December 1962	Décembre 1962
	Inhalt	Contents	Table des matières
Hans Neuburg, Zürich	Konsequente grafische Haltung einer Industriefirma	An Industrial Firm with a Consistent Attitude to Graphic Design	Attitude graphique conséquente d'une entreprise industrielle
Richard P. Lohse, Zürich	Stützensystem für Schaufensterausstellungen	Supports for a Window Display	Système d'appui pour expositions de vitrines
Margit Staber, Zürich	Swissair-Informationsstand	Swissair Information Stand	Stand d'information Swissair
Hans Neuburg, Zürich	Ausstellung ‹Die gute Form›	Exhibition "Die gute Form"	L'exposition «Forme utile»
LMNV	Sachliche Industrie-Anzeigen	Objective Industrial Advertising	Annonces industrielles
Christof Gassner, Frankfurt/M	Systematisierte Grafik	A Method of Design Applied to Advertisements and Business Stationery	Art graphique systématisé
LMNV	Eine neuzeitliche Wein-Preisliste	A Modern Wine List	Une liste des prix de vin de forme nouvelle
Pierre Mendell, München	Eine pharmazeutische Prospektreihe	A Series of Pharmaceutical Prospectuses	Une série de prospectus pharmaceutiques
Richard P. Lohse, Zürich	De 8 en opbouw	De 8 en opbouw	De 8 en opbouw
LMNV	‹Gestaltungsprobleme des Grafikers›	"The Graphic Artist and his Design Problems"	«Les problèmes d'un artiste graphique»
LMNV	Deutsche Grafik in der ‹Werbeform›	German Graphic Design in "Werbeform"	Graphisme allemand dans la revue «Werbeform»
Günter Gerhard Lange, Stuttgart	Zur Gestaltung von Groteskschriften	On the Designing of Sans Serif Types	La création des caractères Antique
Herbert Lindinger, Ulm	Drucksachen für ein Hotelunternehmen	Hotel Stationery Design	Imprimés pour une entreprise hôtelière
	Einzelnummer Fr. 15.–	Single number Fr. 15.–	Le numéro Fr. 15.–
Herausgeber und Redaktion Editors and Managing Editors Editeurs et rédaction	Richard P. Lohse SWB/VSG, Zürich J. Müller-Brockmann SWB/VSG, Zürich Hans Neuburg SWB/VSG, Zürich Carlo L. Vivarelli SWB/VSG, Zürich		
Druck/Verlag Printing/Publishing Imprimerie/Édition	Walter-Verlag AG, Olten Schweiz/Switzerland/Suisse		

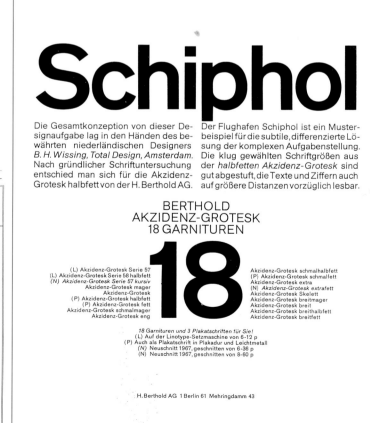

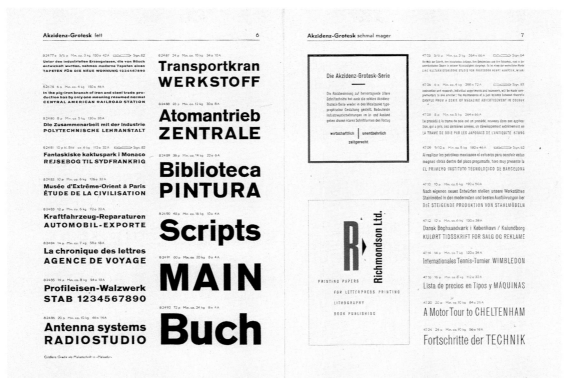

a matter of common concern, and not because of anything typographers have done. The reason personal computers such as the IBM PC, but mainly the Apple Macintosh.

For the first time, millions of PC users can use their dot matrix or laser printers to get imperfect but recognisable versions of a number of fonts. Typography has been democratised, and is now only to a limited extent the province of typesetters and graphic designers.

Lay users still only have a small range of fonts to choose from, although this includes Times and Helvetica. But they are acquiring the taste. These people, who without any training usually produce ghastly typography which is only rarely any good to look at, are gradually realising that, as well as Times and Helvetica, there are thousands of other fonts. And there are some which fit their business better, being more individual and having an unmistakeable visual impact.

If, after a while, these new 'typesetters' start to notice that their typographical skills are inadequate for their own needs or a sophisticated image, they frequently turn to professional designers, who now use the same computers.

So good old Akzidenz-Grotesk, like many other good old fonts which have fallen from grace, now has a chance of playing a major role in the ever-changing world of printing

fashions. One logical consequence is that there is now a Berthold version of AG, deliberately simplified as 'Layout Types' and which Berthold supplies cheaply on the 'Petroleumlampenprinzip'. And a full PostScript version from Linotype, which of course can be used on anyone else's PostScript output peripherals.

*In Berthold's exclusive 'Akzidenz-
Grotesk' sample, Karl Duschek and
Anton Stankowski demonstrate their
mastery of a classical Grotesque.
A two-page spread of visual puns.*

*Stankowski's work from the '20s and
'30s: a single integrated design
which has lost none of its freshness
and originality after 70 years.*

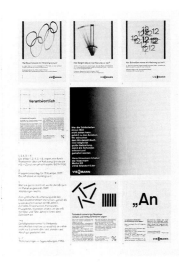

Baskerville

John Baskerville

1706-1775

Günter Gerhard Lange

1980

H. Berthold AG

ABCDEFGHIJK
LMNOPQRST
UVWXYZ
1234567890
&
abcdefghijklmn
opqrstuvwxyz
_.,.:;!?„""''—
1234567890

normal
normal
regular

ABCDEFGHIJKLMNOPQRSTUVWXYZ

abcdefghijklmnopqrstuvwxyz

1234567890 / %

(.,-:;!?) [' ' „ " " » «] — + = / $ § * &

ÆŒØÇæœøçáàäâéèëêíìïîóòöôúùüû

italique
kursiv
italic

ABCDEFGHIJKLMNOPQRSTUVWXYZ

abcdefghijklmnopqrstuvwxyz

1234567890 / %

(.,-:;!?) [' ' „ " " » «] — + = / $ § * &

ÆŒØÇæœøçáàäâéèëêíìïîóòöôúùüû

demi-gras
halbfett
medium

ABCDEFGHIJKLMNOPQRSTUVWXYZ

abcdefghijklmnopqrstuvwxyz

1234567890 / %

(.,-:;!?) [' ' „ " " » «] — + = / $ § * &

ÆŒØÇæœøçáàäâéèëêíìïîóòöôúùüû

italique
demi-gras
kursiv halbfett
medium italic

ABCDEFGHIJKLMNOPQRSTUVWXYZ

abcdefghijklmnopqrstuvwxyz

1234567890 / %

(.,-:;!?) [' ' „ " " » «] — + = / $ § * &

ÆŒØÇæœøçáàäâéèëêíìïîóòöôúùüû

19

The Types of the Baskerville

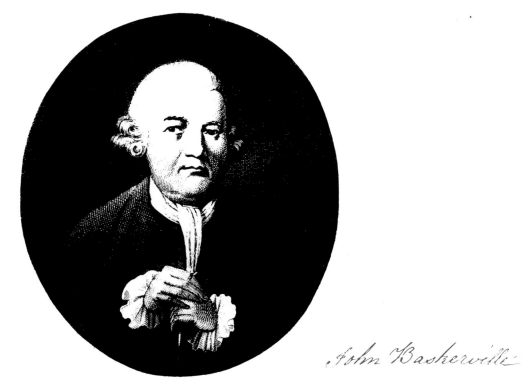

John Baskerville

When we talk about historic typefaces today, we usually mean the versions available now, but, of course, these are not those the original designers themselves used, but modern reproductions. Since photosetting only came into its own in the mid-sixties, and digital typesetting followed ten years later, most of the typefaces we know have come into being since then, although based on the old models. Baskerville is one of these historic typefaces - so familiar that virtually no-one wonders where it came from. And, when it comes to which Baskerville we're actually reading at any time, no-one has the slightest idea.

In this chapter, therefore, we will have a look at what happens to typefaces before they can be computerised. But, first, a bit of history:

John Baskerville started cutting and casting his own type some time around 1754. His work was mainly influenced by the lettering used by stonemasons, which then developed into the typefaces we regard as typically English today: the Clarendons, Grotesques and Egyptians, which also appeared elsewhere with the Industrial Revolution. This influence is apparent even in the English typeface par excellence, Caslon, which appeared in 1725. With its generous proportions, Baskerville at first appears not very different from its predecessors, but a

closer look - comparing it mainly with Caslon - shows why Baskerville is known as the 'transitional Roman'. The difference between fine and bold strokes is more marked, the lower-case serifs are almost horizontal and the emphasis on the stroke widths is almost vertical.

Hindsight is 20/20

John Baskerville had to imagine what his typeface would look like once it had been printed on paper. Even today, printing technology has a major effect on a typeface's appearance. With high-resolution media, it does not matter whether the outlines of the letters are filled in with horizontal or vertical lines, whether via cathode-ray tube or laser beam, on paper or film. Whatever the method used, it is now possible to give the copy exactly the same appearance as the original. More than ever, the quality of a typeface depends on the designer and less on the shortcomings of technology, which is now unforgiving and exposes any weaknesses of drawing or preparation mercilessly. Copy quality is now just a question of how much data is available.

No more excuses

Giambattista Bodoni produced over 55,000 matrices himself: likewise, a modern typeface designer can bring his influence to

PUBLII VIRGILII

MARONIS

BUCOLICA,

GEORGICA,

ET

AENEIS.

BIRMINGHAMIAE:

Typis JOHANNIS BASKERVILLE.

MDCCLVII.

Two pages from "John Baskerville - A Memoir" by Ralph Stens and Robert K. Dent, University Press, London 1907.

JUVENALIS SATYRA VI. 73

Jamque eadem fummis pariter, minimifque libido:
Nec melior pedibus filicem quæ conterit atrum;
Quam quæ longorum vehitur cervice Syrorum.
Ut fpectet ludos, conducit Ogulnia veftem,
Conducit comites, fellam, cervical, amicas,
Nutricem, et flavam, cui det mandata, puellam.
Hæc tamen argenti fupereft quodcumque paterni
Lævibus athletis, ac vafa noviffima donat.
Multis res angufta domi eft: fed nulla pudorem
Paupertatis habet; nec fe metitur ad illum,
Quem dedit hæc pofuitque modum. Tamen utile quid fit,
Profpiciunt aliquando viri; frigufque, famemque,
Formica tandem quidam expavere magiftra.
Prodiga non fentit pereuntem fœmina cenfum:
At velut exhaufta redivivus pullulet arca
Nummus, et e pleno femper tollatur acervo,
Non unquam reputat, quanti fibi gaudia conftent.
Sunt quas eunuchi imbelles, ac mollia femper
Ofcula delectent, et defperatio barbæ,
Et quod abortivo non eft opus. Illa voluptas
Summa tamen, quod jam calida et matura juventa
Inguina traduntur medicis, jam pectine nigro.
K Ergo

bear on all phases of its production, even if he needs assistants. Interactive computer programs allow designers to intervene at any time, so they can no longer use inadequate technology or human error as an excuse.

From craft to computer

A programmer's worst nightmare is finding something which cannot be clearly expressed in terms of numbers, coordinates, black and white. No wonder that all attempts by engineers to mould letters to suit their rigid thinking end up looking more like embroidery patternsthan the complex characters which took thousands of years to develop into the alphabet we know.
We often forget that these familiar forms are themselves largely the result of technical, commercial and artistic compromise. It took nearly 3000 years for individual ideographs to evolve into the Roman alphabet, which consisted solely of capitals, and another millenium to arrive at the characters which we - another thousand years on - regard as normal today. The reasons for this development were purely practical ones: the poor monks were unable to keep up with copying manuscripts (this was before printing was invented), and started fudging their Roman capitals until two different alphabets appeared: upper and lower case.

Gutenberg was mainly aiming at imitating the manuscripts which people were used to and which they bought. He did not succeed very well, but developed his own distinctive style by which all other printed products would be measured for a long time to come. I am deliberately avoiding using the term 'setting' here, because the distinction between setting and printing did not arise until much later. Letters were only ever sold to printers, who judged them not by the design drawings, but by how they looked on paper when printed under normal conditions.

What was John Baskerville trying to say?

This is the dilemma we face when we try to decide which of the many modern versions comes closest to the original. Should we look at John Baskerville's original drawings and compare them with pages from a Linotronic, Lasercomp or Laserstation? Or should we use the printed page, always bearing in mind that the paper Baskerville used was quite different from the smooth coated stock we are used to, and that he couldn't just ring up his suppliers and order the colour he wanted? And, if we look at sample typefaces, what is the right size? Of course, the larger the size, the smoother the outlines and the more impressive John Baskerville's design abilities. But why did he

Intertype Corporation 1947 (left); Lanston Monotype 1927 (right).

Double page from "A Specimen of Printing Letters, Designed by John Baskerville", Monotype 1926.

Intertype Baskerville Alphabets 6 to 24 point
See Page 13 for Alphabet Lengths and Characters per Pica

CHARACTERS OF THE FOUNT

THIRTY-SIX POINT

BASKERVILLE
ABCDEFGHIJKLMNOPQRS
TUVWXYZ
ABCDEFGHIJKLMNOPQRST
abcdefghijklmnopqrstuvwxyz
1234567890
abcdefghijklmnopqrstuvwxyz
1234567890

THIRTY POINT

Of all the occupations
A beggar's is the best
For whenever he's a-weary
He can lay him down to rest
So a-begging we will go

29

twenty-four point solid

ſtopped to refit, ſeated almoſt
directly opposite him in the
gallery, with a look of perfect
satisfaction and composure,
as if nothing of the sort had
happened to him, the idea of
his late disaster and present

leaded two points

self-complacency ſtruck him
so powerfully, that, unable to
resist the impulse, he flung
himself back in the pulpit,
and laughed until he could
laugh no longer. I remember
once reading a tale in an odd

26

TWENTY-FOUR POINT SOLID

number of the "European Maga-
zine," of an old gentleman who
used to walk out every afternoon
with a gold-headed cane, in the
fields opposite Baltimore House,
which were then open, only with
foot-paths croſſing them. He was

LEADED TWO POINTS

frequently accosted by a beggar
with a wooden leg, to whom he
gave money, which only made him
more importunate. One day, when
he was more troublesome than
usual, a well-dressed individual
happening to pass, and observing

27

AHRWSaefghswz1359 &
AHRWSaefghswz1359 &
AHRWSaefghswz1359 &
AHRWSaefghswz1359 &

change the shapes for each size? Was it that reproducing all the details became more difficult as the letters got smaller? Plus the fact that he had to do his engraving in metal: he couldn't just take a design drawing and put it on the process camera and reduce it down to size. Of course, it wasn't a lack of skill which led to some details being missing from the smaller sizes, but the simple fact that, while our eyes don't miss the smallest detail, too much detail merely generates visual noise which makes it hard to read text comfortably. The larger the typeface, the less we can read before our attention strays from the purely verbal information to the type itself, which would pass unnoticed in smaller sizes.

Making a virtue of necessity

Photosetting's weakness was also one of its greatest strengths: since there was only one model for all typeface sizes, you could have any size you wanted, even ones which had never existed before - e.g. 17 point - in steps of 1/100ths of a millimetre capital height. You didn't need to buy more than one size, and - in contrast to hot metal - you could never run out of letters.

This was very useful, but it meant that things could never be quite the same any more: since one model had to do for everything from the smallest footnote to a double-page headline, redesigners of traditional typefaces were forced to make compromises. Instead of a medium-sized model - say, the 12 point size from an original sample -, they needed something which wasn't too thin in 6-point and not too heavy in 72-point. The results were often neither particularly readable nor elegant; at best, however, they still retained something of the elegance of the original. Metal was no longer competitive, except for book setting and printing, so that designers and

typographers had to come to terms with what the new technology could do.

Market rules aesthetics OK

Some typeface manufacturers recognised the dilemma and revamped their versions of classical typefaces. They made models for three different ranges - small, medium and large -, much the same as the originals, only somewhat broader and with less contrast between fine and bold strokes in the smaller sizes. Eventually, though, they stopped bothering, since customers simply ignored them and went on buying just one size. Neither printers nor graphic designers were apparently prepared to pay more for quality. Not that this stopped anyone from weeping for the good old days - even if, as history shows, these were only crocodile tears.

From production to marketing

Once the first generation of photo typefaces had been around for a few years, demand for revamps of classical typefaces and completely new designs, at first vociferous, had slackened somewhat. Typeface manufacturers - who were also still the manufacturers of typesetting equipment - adopted a more laid-back approach. One of the major reasons for this was the establishment of ITC, the International Typeface Corporation. ITC did not compete in selling equipment, but worked by contracting out new typeface designs and selling them under licence. Although the more traditionally-minded typographers were loath to touch some of the new ITC typefaces, they still managed to set the style in advertising. Today, some early ITC typefaces have joined the ranks of the classics, sixteen years after they appeared.

Other manufacturers' typefaces also

flourished under ITC. Matthew Carter had designed a new Baskerville for Mergenthaler Linotype, which was marketed, logically, as New Baskerville. ITC brought this family under its wing and, as ITC New Baskerville it is now available on any make of equipment, and as dry-transfer lettering and on laser printers. ITC gives each licencee identical design drawings, which the licencee then converts to his own formats. In theory, this means each typeface should look exactly the same, no matter what reproduction equipmentis used. However, as everyone knows, theory and practice are two different things: original design drawings are one thing, typesetting and printing another. Some manufacturers have their own standards of quality: Berthold, for instance, revises all ITC models as a matter of course, sometimes to bring the letters within its own unit system, but sometimes also because the artistic director, Günter Gerhard Lange, sees irregularities which everyone else missed. ITC themselves admit that Berthold's design drawings are far superior to their own. In the last resort, what you see is what you get, not what the original looked like. John Baskerville would have been content.

The finer the resolution, the more precisely the recorder can fill in the designer's letter outlines.

Beowolf

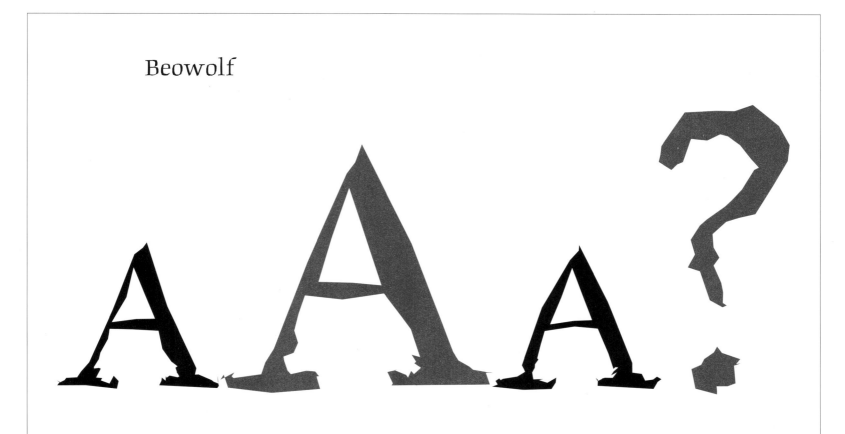

1990

Erik van Blokland

Just van Rossum

Fontshop

ABCDEFGHIJK
LMNOPQRST
UVWXYZ
1234567890
&
abcdefghijklmn
opqrstuvwxyz
- .,.:!? ”’‘”_
.,.;,. • „

normal 21
normal 21
normal 21
regular 21

ABCDEFGHIJKLMNOPQRSTUVWXYZ

abcdefghijklmnopqrstuvwxyz

1234567890/%

(.,-:;!?)['',„""»«]-+=/$£*&

ÆŒØÇæœøçáàäâíìïîóòöôúùüû

normal 22
normal 22
normal 22
regular 22

ABCDEFGHIJKLMNOPQRSTUVWXYZ

abcdefghijklmnopqrstuvwxyz

1234567890/%

(.,-:;!?)['',„""»«]-+=/$£*&

ÆŒØÇæœøçáàäâíìïîóòöôúùüû

normal 23
normal 23
normal 23
regular 23

ABCDEFGHIJKLMNOPQRSTUVWXYZ

abcdefghijklmnopqrstuvwxyz

1234567890/%

(.,-:;!?)['',„""»«]-+=/$£*&

ÆŒØÇæœøçáàäâíìïîóòöôúùüû

27

No advertisement for Fontshop? Beowolf and its contemporaries

'Contemporaries' here means the typefaces of the 90s. A new decade, a new era. The environment is devastated, the planet overpopulated. Information overload prevails. No-one, not even the experts, knows whether everything that is printed gets read. Even the typefaces themselves seem to be changing.

This new spirit of the times has been around since the 60s: it started with the Beatles and the Rolling Stones, went on to clothing and design for young people and then to their favourite magazines - and, in particular, the design of those magazines and other printed matter aimed at young people.

These magazines mix classical types without any respect for typographical tradition. Eclecticism is the order of the day, everything is in quotes. Here and there, there are even a few *Gothic* characters - as illustrations, like pictures of some historic woodcut. No-one learns to read Gothic letters any more, and, if you don't know them, they are difficult or even impossible to read. (Conversely, the more you read them, the easier it becomes.)

Computers are now well established in the world of typefaces. Ten years ago, the first electronic text media reached TV viewers. It used the gaps between TV images to hold text information. The typefaces for this new medium - Prestel in the UK, 'BTX' in Germany - were designed on the basis of minimum resolution. The question was how to develop legible characters with the minimum number of pixels. Now, in the last decade of the second millenium, we have got used to these letters, and we will read text in crude lettering on TV if it seems important. And any weather report can be important. In the meantime, PCs and work stations have turned professional typesetting on its head. PostScript now has more fonts in its library than any single dedicated typesetting system.

Even Macintosh started in 1984 with primitive pixel fonts such as Chicago or Monaco which used tiny squares to simulate curves or slants. The first PostScript fonts soon followed -

Helvetica, Times and the typewriter font Courier - but that was all there was at the time.

But, by 1990, Macintosh had become the most successful of the new front end systems in the type industry.

Meanwhile, letters on TV and PC have had a major effect on typeface development.

Like colour, type has always been a reflection of fashion or, if you prefer to put it more philosophically, the spirit of the times. So it comes as no surprise that, like the 20s with Dada, De Stijl or Bauhaus, these unquiet times have seen people trying out new ideas, new typography and new typefaces.

Which brings us to Beowolf. For the older typesetters and designers in the graphics industry, it's like a slap in the face. It goes against everything people have ever learnt about the aesthetics and legibility of type, a minor culture shock.

In *Offset Praxis* 9/90, for instance, we read, under the heading "No advertisement for FontShop?" (FontShop is an international chain of dealers for PostScript and other types):

"'They have brought out a typeface which does their reputation no favours...' everyone is telling me these days. They mean the Random Fonts, and have obviously missed the joke: each letter is different each time it appears on the Mac. It never looks the same twice. The software recreates the letters each time, with varying degrees of distortion available. FontShop markets it under the slogan "Fonts you can't trust". That such a font can have no aesthetic appeal comes as no surprise. Its appeal is more in its ugliness. Well, if you don't like it, you don't need to buy it...'".

The author of this article talked with one of its creators on the unusual topic of designing 'horrible' typefaces. Erik von Blokland is by no means a punk out to shock the typesetting establishment, like many with their Red Indian hairstyles and bizarre hair colours.

Fontshops Beowolf jumps over the lazy dog
and changes all experience of fonts
1234567890
Fontshops Beowolf jumps over the lazy dog
and changes all experience of fonts
1234567890

Jetzt gibt es eine Schrift, die aussieht, wie von Hand skizziert, obwohl sie aus dem Computer stammt. Beowolf von FontShop

Beowolf ad: Fontshop tells its customers that it's getting dull.
Beowolf breaks all the rules: it looks different eacht time you use it.

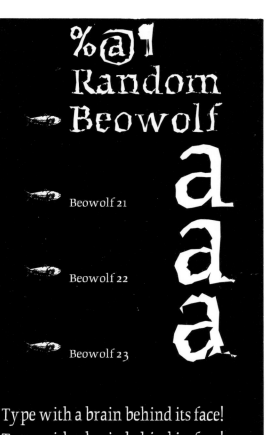

%@1
Random
Beowolf

a
Beowolf 21
a
Beowolf 22
a
Beowolf 23

Type with a brain behind its face!
Type with a brain behind its face!
Type with a brain behind its face!

Now available at FontShop. Add some Real Adventure
to your Typography! New Typefaces for the Macintosh.

Font Shop

Using Beowolf on the Maintosh shows
that it has nothing to do with decorative
curves. Its aim is not consistency,
bu to break all the rules

He and J. van Rossum simply needed to exploit the opportunities offered by the computer in the field of type. So they took one of their own old Antiqua designs and digitalised it in PostScript format. But whereas most people, especially those using font design programs such as Fontographer or Ikarus M define outlines which guarantee the agreed contours in any version, they selected their outline character positions for individual points which changed each time they used them. So a dot is not set on a preprogrammed point on the screen or page, but anywhere within a number of points. With Beowolf, it's not the user who defines where the starting-point of an upright or curve goes, but the software which defines the letter.

At least, that's what Erik van Blokland says.

AntwortFax der Original BeowolfRandomDesigners! Idee: Erik van Blokland und Just van Rossum (1989) Schrift: Gestaltung Erik van Blokland (1988) Programm: IkarusM und dann von Hand in der PostScript code gehackt. Andere Schriften lassen sich erstmal nicht ändern, aber wir arbeiten dran. Die Schrift wird gekauft von vielen Leuten die interessiert sind an Typografie, und bereit sind das Abenteuer der RandomFonts an zu gehen. Die Fonts sind da um gegen die allgemeine Glattheit der Adobe u.ä. Fonts ein Gegengewicht zu setzen. Nah, ein Zielgruppe gibt's eigentlich nicht- oder vielleicht Leute mit Macintosh Computers und Laserdrucker, die etwas von Typo wissen. Nutzen? RandomFonts sehen einfach gut aus, und machen Riesenspaß beim Farb-trennung weil jede Farbe anders wird. Das offizielle FontShop Zahl zur RandomFont verkauf ist 20. (das kann ja aber auch ziemlich zufällig sein) grüß Erik van Blokland+Just van Rossum, FontShop

Beowolf is based on a design by Erik van Blokland. It was computerised in the early stages using Ikarus M and the finishing touches applied on screen.

31

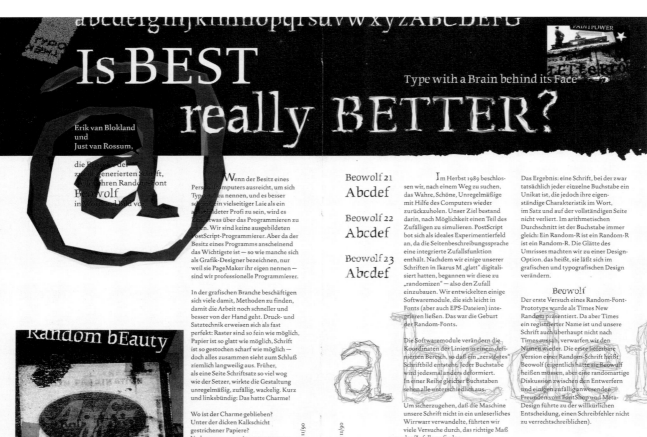

abcdefghijklmnopqrsuvwxyzABCDEFG

Is BEST really BETTER?

Type with a Brain behind its Face

Erik van Blokland und Just van Rossum,

die [...] der zu[...]enerierten Schrift, z[...] ihren Rando[...]font Beowolf in [...]von [...] und von

Wenn der Besitz eines Personalcomputers ausreicht, um sich Typograf zu nennen, und es besser schon ein vielseitiger Laie als ein ausgebildeter Profi zu sein, wird es nötig, etwas über das Programmieren zu lernen. Wir sind keine ausgebildeten PostScript-Programmierer. Aber da der Besitz eines Programms anscheinend das Wichtigste ist — so wie manche sich als Grafik-Designer bezeichnen, nur weil sie PageMaker ihr eigen nennen — sind wir professionelle Programmierer.

In der grafischen Branche beschäftigen sich viele damit, Methoden zu finden, damit die Arbeit noch schneller und besser von der Hand geht. Druck- und Satztechnik erweisen sich als fast perfekt: Raster sind so fein wie möglich, Papier ist so glatt wie möglich, Schrift ist so gestochen scharf wie möglich — doch alles zusammen sieht zum Schluß ziemlich langweilig aus. Früher, als eine Seite Schriftsatz so viel wog wie der Setzer, wirkte die Gestaltung unregelmäßig, zufällig, wackelig. Kurz und linksbündig: Das hatte Charme!

Wo ist der Charme geblieben? Unter der dicken Kalkschicht gestrichener Papiere? Verlorengegangen im *outer space* von Bits und Bytes?

Random bEauty

page 11/90

80

Beowolf 21
Abcdef

Beowolf 22
Abcdef

Beowolf 23
Abcdef

Im Herbst 1989 beschlossen wir, nach einem Weg zu suchen, das Wahre, Schöne, Unregelmäßige mit Hilfe des Computers wieder zurückzuholen. Unser Ziel bestand darin, nach Möglichkeit einen Teil des Zufälligen zu simulieren. PostScript bot sich als ideales Experimentierfeld an, da die Seitenbeschreibungssprache eine integrierte Zufallsfunktion enthält. Nachdem wir einige unserer Schriften in Ikarus M „glatt" digitalisiert hatten, begannen wir diese zu „randomizen" — also den Zufall einzubauen. Wir entwickelten einige Softwaremodule, die sich leicht in Fonts (aber auch EPS-Dateien) integrieren ließen. Das war die Geburt der Random-Fonts.

Die Softwaremodule verändern die Koordinaten der Linien in einem definierten Bereich, so daß ein „zerstörtes" Schriftbild entsteht. Jeder Buchstabe wird jedesmal anders deformiert. In einer Reihe gleicher Buchstaben sehen alle unterschiedlich aus.

Um sicherzugehen, daß die Maschine unsere Schrift nicht in ein unleserliches Wirrwarr verwandelte, führten wir viele Versuche durch, das richtige Maß des Zufalls zu finden.

page 11/90

Das Ergebnis: eine Schrift, bei der zwar tatsächlich jeder einzelne Buchstabe ein Unikat ist, die jedoch ihre eigenständige Charakteristik im Wort, im Satz und auf der vollständigen Seite nicht verliert. Im arithmetischen Durchschnitt ist der Buchstabe immer gleich: Ein Random-R ist ein Random-R ist ein Random-R. Die Glätte des Umrisses machten wir zu einer Design-Option, das heißt, sie läßt sich im grafischen und typografischen Design verändern.

Beowolf

Der erste Versuch eines Random-Font-Prototyps wurde als Times New Random präsentiert. Da aber Times ein registrierter Name ist und unsere Schrift auch überhaupt nicht nach Times aussah, verwarfen wir den Namen wieder. Die erste lieferbare Version einer Random-Schrift heißt Beowolf (eigentlich hätte sie Beowulf heißen müssen, aber eine randomartige Diskussion zwischen den Entwerfern und einigen zufällig anwesenden Freunden vom FontShop und MetaDesign führte zu der willkürlichen Entscheidung, einen Schreibfehler nicht zu verrechtschreiblichen).

81

32

The announcement in Page, November 1990: the designers introduce themselves, following a personal appearance at Type 90. Oxford: Down with decoration! Reminds you of Dada, doesn't it...

Bodoni

Giambatista Bodoni, 1818

H. Berthold AG, 1930

Günter Gerhard Lange, 1983

H. Berthold AG

ABCDEFGHIJK
LMNOPQRST
UVWXYZ
1234567890
&
abcdefghijklmn
opqrstuvwxyz
—.,:;!?„"'—

normal normal regular	ABCDEFGHIJKLMNOPQRSTUVWXYZ abcdefghijklmnopqrstuvwxyz 1234567890/% (.,-:;!?)['‚„""»«]—+=/$§*& ÆŒØÇæœøçáàäâéèêëíìïîóòöôúùüû
italique kursiv italic	*ABCDEFGHIJKLMNOPQRSTUVWXYZ* *abcdefghijklmnopqrstuvwxyz* *1234567890/%* *(.,-:;!?)['‚„""»«]—+=/$§*&* *ÆŒØÇæœøçáàäâéèêëíìïîóòöôúùüû*
demi-gras halbfett medium	**ABCDEFGHIJKLMNOPQRSTUVWXYZ** **abcdefghijklmnopqrstuvwxyz** **1234567890/%** **(.,-:;!?)['‚„""»«]—+=/$§*&** **ÆŒØÇæœøçáàäâéèêëíìïîóòöôúùüû**
italique demi-gras kursiv halbfett medium italic	***ABCDEFGHIJKLMNOPQRSTUVWXYZ*** ***abcdefghijklmnopqrstuvwxyz*** ***1234567890/%*** ***(.,-:;!?)['‚„""»«]—+=/$§*&*** ***ÆŒØÇæœøçáàäâéèêëíìïîóòöôúùüû***
gras fett bold	**ABCDEFGHIJKLMNOPQRSTUVWXYZ** **abcdefghijklmnopqrstuvwxyz** **1234567890/%** **(.,-:;!?)['‚„""»«]—+=/$§*&** **ÆŒØÇæœøçáàäâéèêëíìïîóòöôúùüû**
italique gras kursiv fett bold italic	***ABCDEFGHIJKLMNOPQRSTUVWXYZ*** ***abcdefghijklmnopqrstuvwxyz*** ***1234567890/%*** ***(.,-:;!?)['‚„""»«]—+=/$§*&*** ***ÆŒØÇæœøçáàäâéèêëíìïîóòöôúùüû***

The typeface of kings and the king of typefaces

*Page 37: Bodoni by Bodoni (top),
Monotype (lower left) and Linotype
(right).*

In 1990, Giambattista Bodoni was king, for that year was the 250th anniversary of his birth in the small Piedmontese town of Saluzzo.

His majesty the printer

Bodoni has been called the king of printers and the printer of kings. His reputation is based mainly on the Manuale Tipografico, which to some extent is a compilation of his life's work, and which was only published after his death. In 1818, three years after his death in Parma, his widow, Margherita Bodoni, finished printing the book and dedicated the first copy to Her Royal Highness Marie-Louise, Princess of Parma. As an expression of her pleasure and gratitude, the Princess sent a lady of the court to the widow Bodoni the very same day with a decorated clock bearing her monogram.

Apart from the dedication, the foreword by Margherita Bodoni and an introduction by Giambattista Bodoni himself, this handbook of the art of book printing consisted of 546

printed pages with a total of 665 different alphabets (including some 100 exotic typefaces and a series of 1300 vignettes). Of the 170 Latin scripts, some used up to 380 matrices. The book probably ran to 150 copies, although one source puts it as high as 290. (The letter in which this figure appeared has since disappeared, however.) According to his widow, in 50 years Bodoni made, corrected and cast over 55,000 matrices. This figure comes as no surprise if we consider that, once he had had printed a book, Bodoni immediately recut any letters he did not like.

The Euclid of printing

He was concerned not only with designing and making letters, but also with line layout, page harmony in terms of the choice and size of face, the leading, the interplay of line length, spacing and column width. It has been rightly said that Bodoni brought printing back to Euclidean basics, where the interplay of black and white and the generous use of white space plays a major role.

This striving for perfection is the benchmark for anyone trying to create a Bodoni for modern typesetting systems. While the master cut and perfected each type size individually, the new technology imposes a compromise between harmonic style with highly contrasting bold and fine lines in the large sizes and the more robust forms for better reproduction and legibility in the smaller ones.

So which Bodoni should it be?

The history of Bodoni imitations is a highly complex one. One thing we do know for

MANUALE
TIPOGRAFICO
DEL CAVALIERE
GIAMBATTISTA BODONI

———

VOLUME PRIMO.

PARMA

PRESSO LA VEDOVA
MDCCCXVIII.

PAPALE
tondo

Quousq;
tandem
abutêre,
Catilina,

SALUZZO

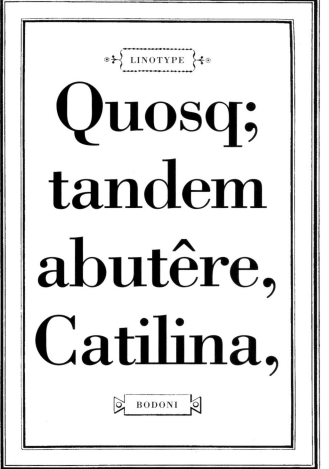

LINOTYPE

Quosq;
tandem
abutêre,
Catilina,

BODONI

MONOTYPE

Quosq;
tandem
abutêre,
Catilina,

BODONI

either to the author, or, more rarely, burned; acc
amount of which varied considerably. The fine
divided into three parts, and shared between som
following—the accuser, the court, the author, th
one of the three asylums, the Pietà, the Mendica
bili. It was occasionally divided into two, four o
twelve parts, and apportioned to twelve recipien
only one instance in which deprivation of the ri
his calling was threatened against a pirate print
case of the copyright granted on November 29th,
Alesio of Corfu, wherein, besides a fine of two h
and of ten ducats for each copy, the printer cou
debarred from the exercise of his profession for
given year varies greatly, ranging from none in
The number of works for which copyright was de
to eighty-two in 1544, eighty-eight in 1549, touc
dred in 1550, and one hundred and seventeen in
usually produced by some external cause. From
there is a steady increase, followed by a decline
bottom in 1511 with one application for copy

THE SILK MANUFACTURERS'
VIGILANT ASSOCIATION
Established 1910

ANNUAL DINNER
The Criterion Restaurant
7th February, 1925

Chairman :
R. HOMER LYNN, ESQ.

Seat Reserved for

M ...

TABLE CARD
PRINTED FIRST AND THIRD
PAGES ON ENGLISH HAND-MADE
DECKLE-EDGE PAPER
IN TWO COLOURS
WITH STOCK ORNAMENTS
AND SLIDE BORDER
SHEWING THE
SUITABILITY OF THE BODONI SERIES
OF TYPES FOR
DISPLAY PRINTING OF
CHARACTER AND
CHARM

DONA
TIONS

TO
THE PENSION FUND
will be thankfully received
and acknowledged by
Mr. H. J. Manning
9 Wood Street
N.E.15.

*Border and Type set on the Linotype Composing
Machine and printed direct from the slugs
at The Sign of The Dolphin in
Gough Square, E.C.4*

38

144 DE IMITATIONE

CAPVT XIV.

De confessione propriae infirmitatis, et huius vitae
miseriis, et quod in Deo super omnia bona
requiescendum est.

FIDELIS.

1. Confitebor adversvm me inivstitiam meam: confi-
tebor tibi, Domine, infirmitatem meam.

Saepe parva res est quae me deiicit et contristat.

Propono me fortiter acturum: sed cum modica ten-
tatio venit, magna mihi fit angustia.

Valde vilis quandoque res est, unde gravis tentatio
provenit; et dum puto me aliquantulum tutum, cum
non sentio, tunc invenio me nonnunquam pene deie-
ctum veluti a levi flatu.

2. Vide ergo, Domine, humilitatem meam, et fragi-
litatem tibi undique notam.

Miserere mei, et eripe me de luto, ut non infigar,
neque permaneam deiectus usquequaque.

One of the pages of *De Imitatione Christi* printed
by Giambattista Bodoni at Parma, shown here by
the courtesy of Comm. Pacq. Scotti, Head of the
Vatican Printing Office, Rome.

Où passer la soirée?

Suivez le conseil de....

H. André-Legrand (Comoedia)

»Nous irons aux 'Miracles' voir ce film superficiel
et ravissant qui ressemble à des vacances.«

Jean Chataignier (Le Journal)

»Votre soirée ne sera pas perdue si vous décidez
d'aller vous amuser au Congrès, aussi bien et aussi
follement que le congrès s'amuse.«

Michel Ferry (Le Micro)

»Un rêve exquis. Laissez-vous tenter par son charme.«

R. de Lafforest (L'Ami du Peuple)

»Quand un tel film est projeté sur un écran parisien,
on n'a plus le droit de dire que l'on ne sait que
faire de sa soirée.«

Jean Fayard (Candide)

»Je suis certain que vous prendrez un très vif plaisir
à ce spectacle.«

Paul Reboux (Paris-Midi)

»Je ne crois pas abuser de votre confiance en vous
engageant à aller voir 'Le Congrès s'amuse'.«

....et allez voir

Le Congrès s'amuse

Edité par l'Alliance Cinématographique Européenne (Production U.F.A.)

aux Miracles!

Anker-Teppiche

errangen ihren Weltruf ohne
Reklame, nur allein durch ihre
große Haltbarkeit, Farbenecht-
heit, Musterschönheit wie auch
Preiswürdigkeit. Deshalb emp-
fehlen wir die Anker-Teppiche

ANKER-TEPPICHE HALTEN –
WAS DER ANKER VERSPRICHT

certain is that Morris Fuller Benton
designed a version for American Type-
founders (ATF) some time after 1907. What
is less certain is whether his design was
based on a model by the Nebiolo type
foundry in Turin. Monotype then followed
the ATF example, but made it somewhat
more angular and heavier.

From Basle to Berlin

The Haas type foundry in Münchenstein
near Basle took the same approach in 1924,
although keeping rather closer to the
original, and added an extra bold, an extra
bold italic and an extra bold condensed.
Haas' Bodoni was copied by the Amsterdam
type foundry Berthold and Stempel.
Linotype (1914-16) and Ludlow also
followed Haas, while Johannes Wagner
brought out a new face in 1961. Berthold's
Bodoni emerged as the most popular, and

still remains a kind of standard by which
other versions are measured. Some years
ago, IBM made Berthold's Bodoni its sole
house style on the recommendation of the
Swiss typographer and graphic designer
Karl Gerstner.

Berthold's artistic director, Günter Gerhard
Lange, was still not satisfied, however.
He came up with Bodoni Old Face after
analysing the body type sizes in numerous
original works. This Old Face is less
contrasting and not as smooth as Bodoni's
other versions, which makes it more suitable
for setting long texts in small sizes.

From Parma to Frankfurt

Bauer's Bodoni (1926) is in a position of its
own, since no other type foundry has copied
it. It is much softer and more elegant than
the others, making it mainly suitable for use

Het is niet met zekerheid bekend, waar en wanneer Frans Hals geboren werd. Waarschijnlijk is het, dat hij te Mechelen of te Antwerpen ter wereld kwam. Zijn vader was Franchois Hals, 'droochscheerder en lakenbereider', die op bescheiden wijze in zijn onderhoud voorzag. Zijn moeder heette Adriaentgen van Geertenrijck.

Gedurende de godsdiensttroebelen namen zijn ouders, evenals vele andere Vlamingen, de wijk naar de Noordelijke Nederlanden en vestigden zich te Haarlem. In 1591 werd daar de tweede zoon Dirric geboren, wiens doopacte van 19 Maart berust in het Gemeentearchief der Spaarnestad.

Frans kwam in de leer bij Karel van Mander, eveneens een uitgeweken Vlaming, een zeer ontwikkeld man, die zich als schilder, schrijver en dichter naam had verworven. Langen tijd had deze in Italië vertoefd en daardoor, als zoo menig tijdgenoot, zeer groote liefde voor de kunst van dat land opgevat. Samen met twee beroemde Haarlemsche kunstenaars, Cornelis Cornelisz. van Haarlem en Hendrick Goltzius, stichtte Karel van Mander in 1583 de Haarlemsche Academie, naar Italiaansch voorbeeld.

De jonge Hals deed dus als leerling zijn intrede in een sterk romanistisch georiënteerde omgeving. De voorliefde voor het klassieke liet zich ook op ander gebied gelden, getuige de literatuur van die dagen, waar Coornhert en Spieghel den toon aangaven. Deze inslag handhaafde zich gedurende de

Bodoni Normaal Romein No. 6206 corps 12 met 2 p. interlinie

LETTERGIETERIJ · HAARLEM

Display sheet, Johan Enschede & Zonen.

in the larger sizes, but less so for coarse-resolution laser printers.

A Bodoni for every taste

Whatever the manufacturer, - and even with the new technology, everyone has their own version - Bodoni is one of the most explicitly classical typefaces in any library. But, when using this royal typeface, you need to remember that the harmonic style, the balanced lines and clear contrast between black and white call for careful handling. Bodoni is not designed for civil service forms, nor is it very practical when it comes to getting the maximum information into the minimum of space. But when it is a question of making a (hopefully) readable text forceful and attractive, you cannot do better than follow Giambattista Bodoni's own example: lots of white space and generous line spacing, and don't make the type size too miserly. Then you will be assured of a product fit for a king.

Caslon

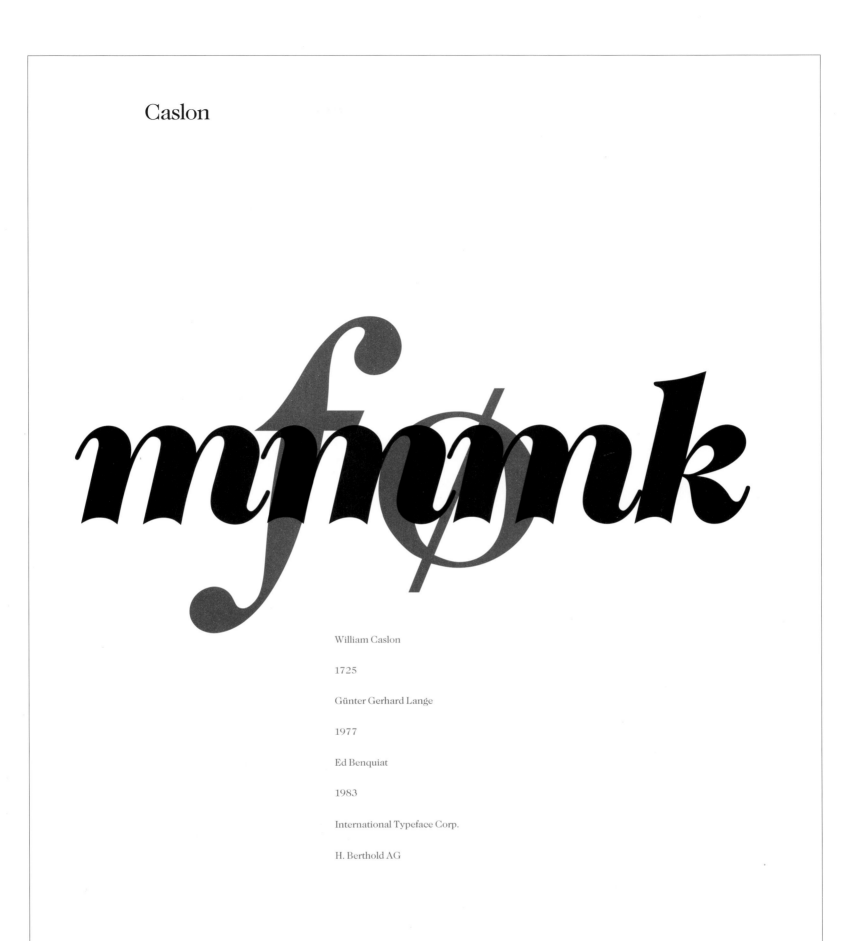

William Caslon

1725

Günter Gerhard Lange

1977

Ed Benquiat

1983

International Typeface Corp.

H. Berthold AG

ABCDEFGHIJK
LMNOPQRST
UVWXYZ
1234567890
&
abcdefghijklmn
opqrstuvwxyz
.,.:;!?„""'
·,·;·'„

42

normal normal regular	ABCDEFGHIJKLMNOPQRSTUVWXYZ abcdefghijklmnopqrstuvwxyz 1234567890/% (.,-:;!?)['‘„"""»«]—+=/$§*& ÆŒØÇæœøçáàäâéèëêíìïîóòöôúùüû
italique kursiv italic	*ABCDEFGHIJKLMNOPQRSTUVWXYZ* *abcdefghijklmnopqrstuvwxyz* *1234567890/%* *(.,-:;!?)['‘„"""»«]—+=/$§*&* *ÆŒØÇæœøçáàäâéèëêíìïîóòöôúùüû*
demi-gras halbfett medium	**ABCDEFGHIJKLMNOPQRSTUVWXYZ** **abcdefghijklmnopqrstuvwxyz** **1234567890/%** **(.,-:;!?)['‘„"""»«]—+=/$§*&** **ÆŒØÇæœøçáàäâéèëêíìïîóòöôúùüû**
italique demi-gras kursiv halbfett medium italic	***ABCDEFGHIJKLMNOPQRSTUVWXYZ*** ***abcdefghijklmnopqrstuvwxyz*** ***1234567890/%*** ***(.,-:;!?)['‘„"""»«]—+=/$§*&*** ***ÆŒØÇæœøçáàäâéèëêíìïîóòöôúùüû***
gras fett bold	**ABCDEFGHIJKLMNOPQRSTUVWXYZ** **abcdefghijklmnopqrstuvwxyz** **1234567890/%** **(.,-:;!?)['‘„"""»«]—+=/$§*&** **ÆŒØÇæœøçáàäâéèëêíìïîóòöôúùüû**
italique gras kursiv fett bold italic	***ABCDEFGHIJKLMNOPQRSTUVWXYZ*** ***abcdefghijklmnopqrstuvwxyz*** ***1234567890/%*** ***(.,-:;!?)['‘„"""»«]—+=/$§*&*** ***ÆŒØÇæœøçáàäâéèëêíìïîóòöôúùüû***

When in doubt, set it in Caslon

Biographical notes:
William Caslon was born in Cradley, Worcestershire in 1692, a traditional metalworking area. At 13, he was apprenticed to an engraver in London, presumably because his talents had come to a teacher's eye. In 1717, he became a citizen of London, and was thus entitled to practise a craft or trade. In 1718, he set up as an independent engraver. Two years later, he opened his first type foundry. In 1749, King George II made him a Justice of the Peace for the County of Middlesex in recognition of his services. He retired from business soon after and left his successful foundry to his son. He died at his country house in Bethnal Green on January 23rd 1766, aged 74.

WILLIAM CASLON.

44

The period after the invention of printing with moveable type was initially governed by scientists and publishers of Venetian origin, followed by French and Dutch typographers. These were men of the spirit rather than of money; they took Gutenberg's invention further and designed types which we still use as models today. The early punch cutters and type founders were not exactly outstanding as commercially-minded businessmen. It was not until the 18th century that the English came on the scene and created their own independent styles, although their ideas were initially largely based on those of the Dutch and French. Many of them saw themselves less as artists than as craftsmen, and showed that the craft of typecasting could even be profitable.

We know that William Caslon, too, used a Dutch model in designing his first typeface: the Roman of Christoffel Van Dyck (1607-1669). Whether Caslon was familiar with the ideas of the Enlightenment, which came to England from Holland at the end of the 17th century, we do not know, but true to English empiricism (one of the tenets of the philosophy of the Enlightenment, which uses simple ideas as building blocks which understanding can combine, compare and abstract to form new composite ideas) he used Van Dyck's principles to create his own typeface - the first genuine English Roman.

Given that Caslon was aware of Van Dyck's typefaces, he must have known of the French efforts to produce a royal style for their Sun King, Louis XIV. A committee of the Academie Française had carefully prepared the Romain du Roi by analysing and measuring other styles and seeing how they looked in print. Jaugeon, one of the three experts involved, developed a grid of 2304 small units as an aid to drawing the large original, from which Grandjean, an experienced punch cutter, then cut the punches freehand, adding the necessary judgement and experience. This pragmatic approach must have impressed Caslon, for he was neither a calligrapher nor an artist, but had trained as an engraver with a gunsmith.

Technology transfer

The advantages of Van Dyck's Roman over the French and, even more so, the Venetian Renaissance designs lay in the pragmatic way in which he increased the x-height in lower-case letters, straightened the serifs and filed off exaggerated points to make the type more resistant in printing and distribute the ink more evenly.

Nowadays, we would probably call using proven Dutch ideas 'technology transfer'.

*Note:
The philosophy of the Enlightenment was critical of institutions and tradition, and wanted to show Man as a 'rational' being the 'way out of his self-imposed immaturity' (Kant).

the top margin if
The demy quarto pag
ABCDEGHJKM

An extra prize for
The object was to a
ABCDEGHIJKM

*Comparison of Van Dijck's Antiqua
(left) and that of William Caslon,
shown in Monotype's display version.*

From gunsmith to type founder

William Caslon had already built up a successful business engraving all kinds of designs in rifles for wealthy customers. This also involved script, in this case the names of the owners of the rifles engraved in cursive style. In addition to his main business, he undertook other work, such as silver casting - another craft which might have been useful later in typecasting. Caslon's first encounters with the graphics business were the embossing stamps which he cut for bookbinders, and which they used to decorate and inscribe the spines of their books. Like the steel punches used in casting matrices, these were cut as embossed letters, whereas the designs on rifles were engraved in metal.

In fact, it was a bookbinder, John Watts, who engaged Caslon to design and cast type for book covers. One of these books then caught the eye of William Bowyer, a well-known London printer, who asked his bookseller who the talented engraver of the title was and so was given Caslon's name. The two Williams quickly became friends. Bowyer showed Caslon around some London printers. At some stage, he also showed him a type foundry, a business which was completely new to Caslon. After this visit, Bowyer asked Caslon whether he could imagine himself pursuing both the art and the business of typecasting. Caslon asked if he could sleep on it (at least, that's what the sources say). The next day saw the start of the career of one of England's most successful type foundries.

Initially, Caslon was supported financially by Watts, Bowyer and his son-in-law, James Bettenham, also a London printer. The initial capital enabled Caslon to survive the first few months until the quality of his products had proved itself and he could hold his own alongside established businesses. In 1720, his first year of business,

Caslon's contacts with his backers brought him an invitation to supply a new typeface to the Society for the Propagation of Christian Knowledge for printing a Bible in Arabic. Caslon had no experience to recommend him for the job, but he got it anyway.

Having finished the Arabic script, he printed a sample page so that he could sell it to other printers. At the foot of this sheet stood his name, 'William Caslon', in Roman letters designed specially for the purpose. Perhaps he had not given it much thought, but these few letters in themselves were enough to make a respected contemporary so enthusiastic about the new style that Caslon felt encouraged enough to actually create it. The result was the popular style we now know as Caslon Old Style.

Following this style, the first to bear his name, Caslon next cut a number of non-Roman and exotic styles, such as Coptic, Armenian, Etruscan, Hebrew and others. Caslon Gothic is his version of Old English, or Black Letter. All these typefaces had appeared before Caslon published the first extensive catalogue for his type foundry in 1734. This was a large sheet divided into four columns, with a total of 38 faces. Even

Design drawings for Romain du Roi.

DIT fyn de KEUREN der Stede van Oud-Hollandt ghelyck defe fyn vaft ende ftadigh ghemaect by *Schout ende Schepenen* van voorfz. ftede opten elffden maius v. d. Jaere onfes Heere dufent achthondert ende vyfendetnegentich

if you have never seen this sample, you will know the text Caslon used to display his alphabets. It is the extract from Cicero's speech against Catalina, which was used in almost all English type specimens and which Giambattista Bodoni made famous in his *Manuale Tipografico:* 'Quosque tandem abutere, Catilina, patienta nostra?'

In 1727, Caslon's type foundry moved into larger premises. Once his styles were used by virtually all major English printers and the royal printing works used nothing else, the business moved to the famous Chiswell Street Foundry, where Caslon's son and several generations after him ran the family business for 120 years.

The second type specimen appeared in 1742, this time with twelve types by the son, William Caslon II, who had just been made a partner in his father's business.

Good style from bad letters?

Caslon's success was certainly not due to any stylistic elegance or particularly exciting details; on the contrary, it was due to its pragmatism, which was more interested in overall appearance, technical suitability and legibility.

This suitability made Caslon more or less the English national style, and also won

friends in the American colonies. Despite the anti-British feeling prevailing during the War of Independence, it was used for setting both the Declaration of Independence and the Constitution.

After the founding of the United States, Caslon gradually sank into obscurity until, in 1858, Laurence Johnson, the owner of a Philadelphia type foundry, visited the Caslon works in London. He persuaded the director to cast him a complete set of Caslon, which he took back to the USA, where he made matrices by the galvanic process and marketed the result as Caslon Old Style. Sales were slow, however, until 1892, when a new magazine, *Vogue,* discovered it and made it an overnight success.

At about the same time, the American Type Foundry was established by the merger of 23 smaller foundries, including the one in Philadelphia which had imported the original Caslon some years before. ATF renamed this Caslon 471 and included it in its successful product range.

The popularity of the Caslon revival shows in the host of imitations which appeared in the years that followed. In its catalogue of 1923, ATF alone had over 12 different families called Caslon. The American Lanston Monotype brought out a copy of

** Footnote:*
"How long, Catilina, will you abuse our patience?"
As Roman consul in 63 B.C., Marcus Tullius Cicero discovered Lucius Sergius Catalina's conspiracy against the Senate and prevented it without resorting to arms. His four Catiline speeches became famous.

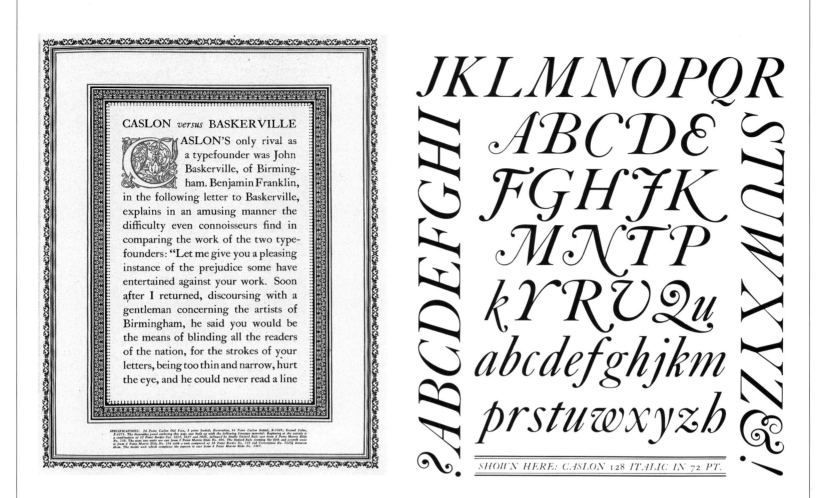

CASLON *versus* BASKERVILLE

ASLON'S only rival as a typefounder was John Baskerville, of Birmingham. Benjamin Franklin, in the following letter to Baskerville, explains in an amusing manner the difficulty even connoisseurs find in comparing the work of the two typefounders: "Let me give you a pleasing instance of the prejudice some have entertained against your work. Soon after I returned, discoursing with a gentleman concerning the artists of Birmingham, he said you would be the means of blinding all the readers of the nation, for the strokes of your letters, being too thin and narrow, hurt the eye, and he could never read a line

SHOWN HERE: CASLON 128 ITALIC IN 72 PT.

DIE DIREKTION DES ERZIEHUNGSWESENS
DES KANTONS ZÜRICH

BESTÄTIGT, DASS

HERR MAX BERHOLZER

VON SCHAFFHAUSEN, GEBOREN 1906

NACH ORDNUNGSGEMÄSSER ABSOLVIERUNG DES KANT. TECHNIKUMS
IN WINTERTHUR UND NACH BESTANDENER FÄHIGKEITSPRÜFUNG DAS

DIPLOM

DER ABTEILUNG FÜR MASCHINENTECHNIKER MIT „GUT" ERLANGT HAT.

ZÜRICH UND WINTERTHUR, DEN 8. APRIL 1930.

FÜR DAS KANT. TECHNIKUM:　　　　　　　　FÜR DAS ERZIEHUNGSWESEN:

DER DIREKTOR:　　　　　　　　DER SEKRETÄR:

*Three Caslons: Linotype (top left),
Monotype (top right) and D. Stempel
A.G.*

Caslon 471 as number 337. The English Monotype's version was called Caslon 128, Ludlow's Caslon True-Cut. Other versions went by the name of Caslon Adbold, Caslon Book, Caslon 137, American Caslon, Caslon No.3, Caslon 540 (a version of 471 with shorter descenders), Caslon 223 and 224.

ITC Caslon No. 223 is a headline style which takes its number from that of the house in which the designers, Lubalin, Smith & Carnase, lived. Some years later, when ITC asked Ed Benguiat to design the corresponding text face, they simply took the next number and called it ITC Caslon No. 224. The American printer Benjamin Franklin was an admirer of Caslon, and George Bernard Shaw is even known to have insisted that all his works be set in it. 'Caslon man at any rate,' his publishers called him. For a long time there was a rule of thumb amongst publishers, setters and printers in Anglo-Saxon countries: 'when in doubt, set it in Caslon'.

Of course, this maxim would be impossible today given the wealth of types available, but we recommend a look at the existing versions of this sensible typeface for anyone who wants to make long texts readable without too much effort.

Ungefähr zur gleichen Zeit war die **American Type Foundry** gegründet worden aus dem Zusammenschluß von 23 kleineren Gießereien, darunter auch jene aus Philadelphia, die etliche Jahre zuvor die Original-Caslon importiert hatte. ATF taufte sie um in Caslon 471 und nahm sie in ihr erfolgreiches Verkaufs-programm auf.

Die Popularität des Caslon-Revivals läßt sich an der Vielzahl der Imitationen ablesen, die in den folgenden Jahren erschienen. In ihrer Schriftprobe von 1923 hatte allein ATF mehr als 12 verschiedene Familien unter dem Namen Caslon verzeichnet. Die amerikanische Lanston Monotype brachte eine Kopie der Caslon 471 unter der Nummer 337 heraus. Bei der englischen Monotype heißt sie Caslon 128, bei Ludlow Caslon True-Cut. Andere Versionen heißen Caslon Adbold, Caslon Book, Caslon 137, American Caslon, Caslon No.3, Caslon 540 (eine Version der 471 mit kürzeren Unterlängen), Caslon 223 und 224.

Die ITC Caslon No.223 ist eine Titelschrift, die ihren Namen hat von der Haus-nummer, unter der die Entwerfer, Lubalin, Smith & Carnase, residierten. Als ITC Jahre später Ed Benguiat mit dem Entwurf der dazugehörigen Textschrift beauftragte, nahm man einfach die nächstfolgende Nummer und nannte die Schrift ITC Caslon No. 224.

Nicht nur der amerikanische Präsident und Drucker, Benjamin Franklin, war ein Freund der Caslon, vom irischen Schrift-steller George Bernard Shaw ist sogar bekannt, daß er darauf bestand, alle seine Werke aus Caslon setzen zu lassen. **Caslon man at any rate** nannten ihn die Setzer seiner Bücher · auf jeden Fall Caslon hieß das, und lange war unter Verlegern, Setzern und Druckern in den angelsächsischen Ländern die Faustregel gültig: **when in doubt, set it in Caslon** · im Zweifel Caslon.

Natürlich wäre ein solche Aussage angesichts der Fülle der angebotenen Schriften heutzutage nicht mehr haltbar, ein Blick auf die vorhandenen Versionen dieser vernünftigen Schrift wäre jedoch jedem anzuraten, der lange Texte ohne großes Aufsehen gut lesbar gestalten will.

Clarendon

Hermann Eidenbenz

1953

Haas'sche Schriftgießerei AG

1962

D. Stempel AG

H. Berthold AG

Clarendon

ABCDEFGHIJK
LMNOPQRST
UVWXYZ
1234567890
&
abcdefghijklmn
opqrstuvwxyz
–.,:;!?„""''–

ABCDEFGHIJKLMNOPQRSTUVWXYZ

abcdefghijklmnopqrstuvwxyz

1234567890/%

(.,-:;!?)[''„""»«]—+=/$§*&

ÆŒØÇæœøçáàäâéèëêíìïîóòöôúùüû

ABCDEFGHIJKLMNOPQRSTUVWXYZ

abcdefghijklmnopqrstuvwxyz

1234567890/%

(.,-:;!?)[''„""»«]—+=/$§*&

ÆŒØÇæœøçáàäâéèëêíìïîóòöôúùüû

ABCDEFGHIJKLMNOPQRSTUVWXYZ

abcdefghijklmnopqrstuvwxyz

1234567890/%

(.,-:;!?)[''„""»«]—+=/$§*&

ÆŒØÇæœøçáàäâéèëêíìïîóòöôúùüû

Egyptienne & Clarendon

Revolutionary breakthroughs or decline of print culture?

The story of Egyptienne styles began with a misunderstanding. In 1816, the first Grotesque appeared in the sample book of the London type foundry William Caslon IV under the name 'Egyptian'. It had constant stroke widths and was based on the circle. In the 1817 supplement to the 1815 sample book of the Vincent Figgins foundry, also of London, there appeared the first capitals of a completely new kind of Antiqua - an Egyptienne in our present-day sense - but under the name 'Antique'. In 1820, William Thorowgood, successor to Robert Thorne and his London jobbing Fann Street Foundry, also brought out these new styles, calling them Egyptian. It is assumed that the name originated with Thorne. Because of his fondness for everything Egyptian, he soon had his way, while the sans serif style subsequently became Sans Serif or Grotesque (Thorowgood). Print historian James Mosley claims that sans serif styles were already in use in printing by the end of the 18th century, while, prior to Figgins' type samples, nothing printed in Egyptienne is known. On the other hand, this style was already being used by sign painters. In any event, Egyptienne quickly became popular, unlike Grotesque, despite its new and monstrous appearance compared with the usual classical book faces. The fact that it still had serifs made it more popular with conventional printers. It soon spread abroad, from France to Germany and then to America. Its heyday was in the years 1840 to 1870, before the Neo-Renaissance styles and English print culture reasserted their influence.

Technology - advertising - Egyptienne

The new Egyptienne styles included some that were well designed and some that were poor, and many of their shortcomings seem lovable and vital to us today. Their ancestors were the French classical Antiqua, which shows in the straight, right-angled serifs, the static vertical axis and individual details of style, such as the flowing R. Like the sans-Serif style, which was based on early Greek inscriptions, it did away with the contrast between thick and thin strokes. The better designs show a minimal rejuvenation of the curves and a differentiated treatment of the serifs. Its beam-like, over-emphasised serifs make Egyptienne blacker and bulkier than the bold Antiqua styles - which is why it is so much less popular. These features were most apparent in the capitals, but caused problems in the lower-case letters. The small capitals often look as though they have been distorted electronically and poorly proportioned, as can be seen in Thorowgood's type sample of 1937. Thorowgood already had this style in 1825, so that we can safely assume that this version came from R. Thorne. The overall result was that the styles were highly individual and failed to match. It was not long before a more practical Egyptienne emerged.

In 1843, Henry Caslon's foundry brought out a wide-set but not over-bold Egyptienne with clear variations in stroke widths. It was called Ionic, and was the start of the family of 'English Egyptiennes' or Clarendon. The first Clarendon of that name appeared in 1845, by

Robert Besley, William Thorowgood's partner, in conjunction with punch cutter Benjamin Fox of Fann Street Foundry. It was designed as a bold condensed highlight face for use in reference works in conjunction with the standard classical faces. Besley called it the most useful, most carefully designed face a press could possess, whose delicate outlines made it far superior to the clumsy Egyptienne styles. This Clarendon gave the appearance of a narrow strip: a bold condensed style with grooved serifs, to which more styles were soon added, although the main model for the continental Clarendon styles was the wide cut.

Between 1839 and 1847, Johann Christian Bauer moved his foundry from Frankfurt to Edinburgh, bringing the latest Egyptienne styles back with him to his native land. He introduced Clarendon on the Continent at some time around 1850.

Clarendon was also the first typeface to enjoy copyright protection (for three years). Once this period was up, it not only spread worldwide but also ousted italics as highlight styles. Clarendon became a synonym for 'bold'. Newspaper highlights were now set in Clarendon bold rather than italics. Clarendon may originally have been intended for the exclusive use of the Clarendon Press at Oxford University, but this is only a rumour.

Bizarre

As an advertising style, Egyptienne was particularly vulnerable to imitation and fashion trends. The Scottish type founder Alexander Wilson designed an Egyptienne Outline decorated with hollow rings, which Figgins matched with a Half Skeleton Egyptian in 1847. This had a bold basic stroke in the lower half of the letters and the rings are completely black. It could even be taken for a product of digital type design, but merely goes to show that aimless experimentation is a mistake. Nonetheless, it must have caught the public's fancy, for Egyptienne then appeared in a variety of ornamental designs: distorted, shaded, decorated, light. The variations are legion.

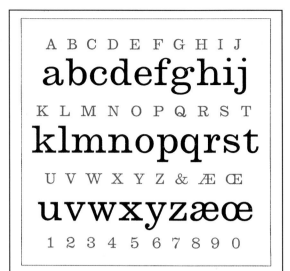

Monotype Clarendon.

One separate contemporary subgroup which emerged at the same time were the Italienne styles. Here, function went by the board, and decoration ruled. The serifs were striplike and over-bold, the basic strokes very thin. Some versions turned printing on its head, finally abandoning Western reading customs.

Egyptienne - the legible

Its simplified, solid style made Egyptienne predestined for newspaper printing and ultimately for typewriters. The serifed letters joined together to form legible lines of their own accord.

Traditionally, newspapers were set in classical faces, but their delicate style was poorly suited to the new high-speed rotary presses, losing on quality and legibility. Chauncey H. Griffith of Mergenthaler Linotype was looking for a solution, and asked for a typeface designed in accordance with purely technical as well as legibility criteria in mind. He called it Ionic No. 5 in imitation of the first Egyptienne styles. Mergenthaler brought it out in 1926, and it was a great success. Since the 80s, the once conservative newspaper business has been through an upheaval. People think of a new paper type, like for instance, the "Guardian." This now uses Nimrod, a Monotype face by Robin Nicholas: traditional enough to avoid upsetting readers but making possible a radical overhaul of the headlines, which are set in Helvetica Bold Extended. Some readers thought this showed a lack of patriotism and cancelled their orders.

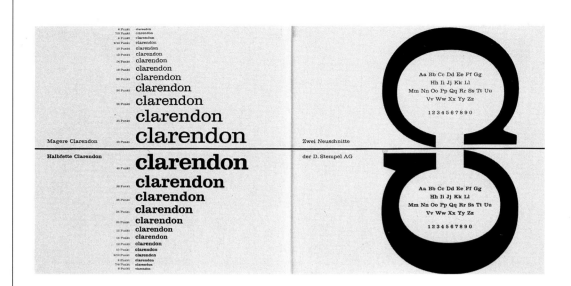

Even now, typewriters still use Egyptienne. When the typewriter companies brought this out, it enabled people not only to write letters and documents that looked as though they were printed but also to create attractive designs.
This consciously unpretentious design is now ubiquitous.

To celebrate the typewriter's centenary, ITC brought out American Typewriter 1974 by Joel Kaden and Tony Stan. They eliminated office blur, so that it still looked like a typewriter style, but much clearer.

The first revival

In the 20s, Europe saw an avant-garde revolt against traditional values, but also an overestimation of technology. New Objectivity, combined with social and political commitment, which was especially apparent in architecture, found its expression in the 'new typography', which drew on the store of fonts available at the time: Venus, Schelter Grotesque, Akzidenz-Grotesk and the new Grotesque styles such as Erbar or Futura. These geometrical sans-serif styles did away with superfluous ornamental bombast and emotional national rhetoric. Steel and framework, machinery and intellect became the idols.
The new typography and caught on in advertising and affected Antiqua, even in book printing. This pushed the type foundries into bringing out similar styles. In 1929, D. Stempel AG proclaimed the Neo-Egyptienne era with Rudolf Wolf's Memphis.

Although with some shortcomings in terms of style, it quickly spread, even in mass setting, forcing the other foundries to act. The New York Continental Typefounders Association imported Memphis and called it, appropriately, Girder.
In 1931, Intertype brought out Cairo, and Ludlow Robert Hunter Middleton's Karnak.
Rockwell also has its design history. In 1910, the Inland Type Foundry brought out Litho Antique.
Morris F. Benton extended this until ATF brought out Rockwell Antique in 1931. In that same year, Benton reworked Rockwell, which ATF then called Stymie. Thanks to its wide variety of fonts, it developed into the classic American style.
Stanley Morison of Monotype in England took a long time to decide to use Rockwell. He had no love for Egyptienne styles, and had more of a retarding effect. When it finally appeared in 1934, Monotype's Rockwell was based on the ATF/ Inland version, but completely redrawn and with new light and bold versions. It looks fresher and more modern than the American original. Both Rockwell and Memphis experienced a revival in the 60s and 70s, and are permanent favourites. In France, Deberney & Peignot brought out the lighter-footed Pharaon in 1933, with Stephenson & Blake a little way behind with Scarab in 1937.
When Alexander Lawson maintains that the Egyptienne revival in the 30s ended up - putting it simply - by adding serifs to Futura, this is much too naive, and overlooks the historical context and the very individual developments of the time. Perhaps the US was too fond of copying. While Futura harks back to early Greek models based on circles and squares, the new Egyptienne

54

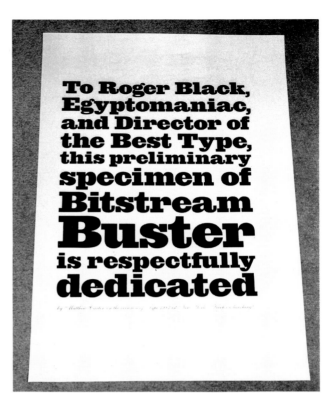

styles reveal their origins in the
classical forms, while some, such as
Memphis or Rockwell, show more
obvious geometric tendencies.
Most Egyptienne styles have little to
do with geometry. Even Beton by
Bauer, whose very name indicates
the spirit of the times, and which
Heinrich Jost designed in 1930-36, is
an independent modern
interpretation based on the 19th-
century Egyptienne, with nothing to
do with Futura or a Grotesque.
Although some characters were
overdone, it became the most
popular Egyptienne in the world,
much loved by the advertising
industry.
Another, even more striking
Egyptienne is City (1931).
Georg Trump must have started
working on this when he was still
professor at the school of arts and
crafts in Bielefeld. Its radical style
(curves became right-angles,
shortened serifs in the bold faces,
flattened curves leading sharply into
straight lines, the exotic K) offered
the discerning typographer a
surprising wealth of design
opportunities. It was adopted by the
Swiss chemical industry, and
Jan Tschichold also used it for the
title page of his book *'Typographical
Design',* using it with an English
cursive face.
One of the few Clarendon revivals of
the time was Jakob Erbar's Candida,
which Ludwig & Meyer designed in
1936. Candida is not based on the
previous Erbar Grotesque, nor does
it have anything in common with
geometric structures.
Although Egyptienne styles offered
the most constructivist styles, they
were unable to oust Grotesque.
Leading typographers used them
rarely and then only for highlights.

Second Revival

Clarendon's heyday in the 50s and 60s

Especially in Germany, the post-war
period tried to take up where
creative development had left off in
the 20s and 30s, but without the
ideology. Besides the Grotesque
faces, new, clear sans-serifs were
used. Under the influence of
New Objectivity, Egyptienne
emerged once more as a bridge
between Grotesque and Antiqua,
especially its functional version,
Clarendon. The most extensive type
families led to eye-catching
typography: they gave strong
negative lines and their easy-going
style could even be mixed with a
Caslon italic. For offset and intaglio
printing, they were heaven-sent.

After about a hundred years, the
English foundries of Stevens Shanks
& Sons and Miller and Richard
revived Clarendon in 1951. At the
same time, Hermann Eidenbenz
designed a bold Clarendon of the
same name as a highlight face for
the Haas foundry. He cleaned up the
English Egyptienne to give a
balanced, compatible appearance.

The Haas Clarendon came out in
medium and extra bold, and was a
great success. Since the Haas and
Stempel foundries were linked,
Stempel adopted Clarendon and

added other styles in the years
1961-63.

In America, ATF quickly followed
suit. From 1955 to 1960, Freeman
Craw worked on Craw Clarendon.
Thanks to its broad range, it too
enjoyed considerable success there.
Apart from some differences in
thickness and proportion, it is
modelled on Haas's Clarendon.
Once Stephenson Blake had
absorbed all the famous foundries
such as Caslon and Thorowgood, it
had an enormous range. Clarendon
Consort appeared in 1956; Consort
Bold Condensed is the Thorowgood
Clarendon of 1845. For the rest of the
fonts, Robert Harling made the
sketches, while H. Karl Görner did
the cutting. Today, Consort is
available in hot metal only.

'Swiss typography' has been
replaced by expressive American
advertising typography, and now
that the New Wave and the computer
revolution have arrived, Clarendon
is little in demand, and very seldom
seen. The width looks too parochial
and dated. Egyptienne, however,
continues to thrive.

Digital Egyptienne

As at the time of the Industrial
Revolution, the arrival of
photosetting sparked the search for
a robust typeface which would be
legible even if handled badly.
Egyptienne was seen as the answer.
In 1955-56, Adrian Frutiger designed
the first serif Antiqua for Lumitype/
Photon: Egyptienne F. for
photosetting. He was also working
on Univers at the same time, so that
there are many similarities.

In 1979, Frutiger revised Egyptienne
F. for the Linotype photosetting
systems. The next serif Antiqua was
Serifa: already serial, but still
designed for hot metal setting.

The American contribution to all this
was Avant Garde. The original
logotype was designed by Herb
Lubalin and Tom Carnase for the
magazine of that name, and they
extended it to the full range in 1970.
It was obvious that there was more

room to exploit Avant Garde's
business potential. In 1974, Lubalin
joined forces with Ed Benguiat to
convert Avant Garde to Lubalin
Graph. ITC was especially fond of it
for photosetting and digital systems.
This really was a case of just adding
the serifs. Today, Avant Garde has
lost favour with the older generation,
but is finding new supporters among
up-and-coming young designers.

Let us end this section with a
pleasant Egyptienne from recent
times. In 1986, Berthold brought out
Boton, by Albert Boton of France:
without French fussiness, well
proportioned, almost elegant and
easily legible even set en masse in 5
point. It owes its soft appearance
amongst other things to its oval
curves. The x-height is used to the
full. It is narrow set without
overdoing it. All traces of
constructivism have vanished.
Boton's balanced appearance owes
much to Günter Gerhard Lange,
Berthold's artistic director, who
ruthlessly eliminated individualistic
excesses in the interests of legibility.
Amongst young type designers, such
as Neville Brody, Erik Spiekermann,
Suzana Licko and Just van Rossum,
Egyptienne is enjoying a revival.
Each decade has its own style and
taste.

The history of Egyptienne shows the
role of function in type design.
Function is the yardstick against
which everything must be judged.
The art of using the small remaining
aesthetic leeway depends on the
skill and character of the designer -
and the client.

Concorde

C

C

C

Günter Gerhard Lange 1969, H. Berthold AG

y c

Concorde

ABCDEFGHIJK
LMNOPQRST
UVWXYZ
1234567890
&
abcdefghijklmn
opqrstuvwxyz
.,.;!?„""''
1234567890

ABCDEFGHIJKLMNOPQRSTUVWXYZ

abcdefghijklmnopqrstuvwxyz

1234567890 / %

(.,-:;!?) [',„"""» «] —+=/ $ § * &

ÆŒØÇæœøçáàäâéèëêíìïîóòöôúùüû

ABCDEFGHIJKLMNOPQRSTUVWXYZ

abcdefghijklmnopqrstuvwxyz

1234567890 / %

(.,-:;!?) [',„"""» «] —+=/ $ § * &

ÆŒØÇæœøçáàäâéèëêíìïîóòöôúùüû

ABCDEFGHIJKLMNOPQRSTUVWXYZ

abcdefghijklmnopqrstuvwxyz

1234567890 / %

(.,-:;!?) [',„"""» «] —+=/ $ § * &

ÆŒØÇæœøçáàäâéèëêíìïîóòöôúùüû

59

ABCDEFGHIJKLMNOPQRSTUVWXYZ

abcdefghijklmnopqrstuvwxyz

1234567890 / %

(.,-:;!?) [',„"""» «] —+=/ $ § * &

ÆŒØÇæœøçáàäâéèëêíìïîóòöôúùüû

Concorde
or, marketing matters too

Concorde

Some typefaces owe their existence to the artistic urge of the designer. A designer with a style in mind initially follows his own ideas. Only then does he look for a manufacturer who is prepared to produce that typeface, and who will perhaps insist on compromises to meet the demands of the market.

Others are created the other way round. A manufacturer sees a gap in the range of typefaces available, or a chance to improve an existing one. His ideas are governed by the market. Nowadays, we call this typeface marketing.

A designer with fixed links with a given manufacturer, such as Günter Gerhard Lange's 40 years with Berthold, will of course be more governed from the start by printing and market requirements than an independent artist.

Concorde is perhaps a prime example of this: for it was designed in-house jointly with Harris Intertype around 1968, designed and produced in very much the same way as Times and Life and other in-house typefaces.

It is interesting to see from old documents how designers and manufacturers see their typefaces compared with others and view their own work. Of course, they tend to analyse them in more depth than everyday users do.

Concorde, for instance, was subjected to a detailed comparison with Times and Life - although German law does not allow such comparisons to be used in advertising, but only internally.

So let us just look at the Times of the linecasters, Intertype (I) and Linotype (L). Comparing the 8-point size:

Medium

Times L. Visually, Concorde lower-case letters are the same height as Times, but the capitals are much smaller: Concorde 8-point is equivalent to Lino-Times 7-point. Although the x-height is the same, Concorde looks larger than Times. The spacing is more regular. The capitals do not stand out as much as usual, and also allow for much more harmonious capitals in the running text. Numbers are the same height as capitals. Lower-case ascenders are the same height.

Times I. Concorde is somewhat larger than Times (about 8.5 point). Concorde looks more even and less pointed.

Schon wieder eine neue Schrift! Na schön, was soll's.
Ich bin nun mal Grotesk-Anhänger.
Läuft doch ganz gut und klappt immer noch.

Die Leutchen bei Berthold
sind ganz schön mobil.

Ist ja auch ein bißchen öde, dauernd auf der gleichen Schrift herumzureiten.

Merke natürlich auch, die Amis steigen um.

Also optischer Wechsel.

Donnerwetter,

die Schrift hier sieht eigentlich gut aus!

**Klar und objektiv im Ausdruck,
dabei tadellos offene Formen,
kein Bild- und Textstörer.**

Die Halbfette ist ja wirklich irre.

UND DIE VERSALZEILEN,
EINFACH KLASSE! Sieht man jetzt immer häufiger.

Mal *Schrift
muß einfach
überzeugend
stehen.*

auseinanderschneiden
die Zeilen hier. Eigentlich schade um's Heft.

Wie heißt die Schrift doch gleich?
Ach richtig, CONCORDE *Klar!*

Die gibt's doch auch im Fotosatz? Richtig!

Probieren geht über sinnieren!

Besser blm 6 Concorde-Vormappe mit Schneideblättern anfordern.

Kostenpunkt 3,– DM.

**CONCORDE
kommen lassen
von Berthold.**

Schließlich läßt sich Schrift an Hand größerer Textmengen
und der Alphabete auf den Schneideblättern
am besten beurteilen.
Das zeigt sich immer wieder.

H. BERTHOLD AG 1 BERLIN 61 MEHRINGDAMM 43

61

ALSDANN . . .

...sahen wir einander lange in die Augen. Oh, das Frauenauge, welch eine Zaubergewalt liegt darin! Wie es einen verwirrt, an sich zieht, in Besitz nimmt und beherrscht! Wie es weltenweit erscheint; voll von Versprechungen, voll von Unendlichem! Man nennt das: sich bis auf den Grund der Seele schauen! O mein Herr, welch eine Aufschneiderei! Wenn man nur zeitig genug in diese sogenannte Seele schauen könnte, man würde geheilt sein, wahrhaftig. Schließlich war ich soweit, nämlich verrückt. Ich wollte sie in meine Arme ziehen. Sie aber rief: »Weg die Pfoten!«

Darauf kniete ich vor ihr nieder und öffnete ihr mein Herz; ich breitete vor ihren Knien mein ganzes Sehnen aus, all das da drinnen, an dem mir fast erstickt war. Sie schien sich über mein verändertes Verhalten zu wundern und betrachtete mich mit einem Seitenblick, als ob sie zu sich selber sagte: Aha, so muß man also mit dir umspringen; schön, wir werden weitersehen. In der Liebe, mein Herr, sind wir immer die Verschwender, und die Frauen die Händlerinnen.

Ich hätte sie besitzen können, ohne Zweifel; ich habe meine Dummheit später begriffen, aber was ich damals begehrte, das war ja gar nicht das; es war die ideale Liebe; ich hatte in Empfindungen geschwelgt, wo ich meine Zeit besser hätte ausnutzen sollen.

Als sie dann von meinen Beteuerungen genug hatte, stand sie auf; wir kehrten nach Saint-Cloud zurück. Wir haben uns erst in Paris getrennt. Auf der Heimfahrt machte sie ein niedergeschlagenes Gesicht. Ich fragte sie, was ihr fehlte. Sie antwortete: »Ich denke daran, daß es Tage gibt, von denen man nicht viele in seinem Leben geschenkt bekommt.« – Mein Herz schlug mir bei dem Sprüchlein, als wolle es zerspringen.

Wir trafen uns am folgenden Sonntag wieder, auch den Sonntag danach, und dann alle weiteren Sonntage. Ich führte sie nach Bougival, Saint-Germain, Maisons-Laffitte, Poissy – überallhin, wo die Liebespaare der Bannmeile auftauchen.

Das kleine Weibsbild war jetzt 'auf Draht' und machte in 'leidenschaftlich'.

Ich verlor schließlich vollständig den Kopf. Drei Monate später heiratete ich sie. Was wollen Sie, mein Herr, man ist Beamter, steht allein, ohne Familie, ohne jemand, der einem einen Rat gibt! Man stellt sich vor, daß das Leben mit einer Frau wunderbar sein wird! Und also heiratet man diese Frau da!

Dann aber schimpfte sie vom Morgen bis zum Abend; versteht nichts, kann nichts, schwätzt fortwährend, singt aus vollem Halse das Lied der Musette (oh, das Lied der Musette, ein unausstehlicher Schmarren!), schlägt sich mit der Kohlenträger, erzählt den Pförtnersleuten vertrauliche Familienangelegenheiten, vertraut dem Kindermädchen des Nachbarn Bettgeheimnisse an, reißt ihren Mann vor den Lieferanten herunter und hat, mein Herr, dabei den Kopf gespickt voll von so stupiden Geschichten, von so blödsinnigen Einbildungen, von so lächerlichen Ansichten, von so ungeheuerlichen Vorurteilen, daß ich vor Kleinmut anfange zu heulen, sobald sie nur den Mund aufmacht.«

Er verstummte, etwas außer Atem und sehr erregt. Ich sah ihn an. Da sich in mir das Mitleid mit diesem armen Einfaltspinsel rührte, sagte ich ihm noch rasch ein paar nette Worte. Gleich darauf legte das Boot an. Wir waren in Saint-Cloud.

Das junge Mädchen, das mein Herz in Flammen gesetzt hatte, erhob sich, um an Land zu gehen. Sie kam dicht an mir vorbei und blitzte mich mit einem verstohlenen Lächeln an, einem Lächeln, zum Verrücktwerden herrlich; dann sprang sie auf den Anleger hinüber.

Ich stürzte vor, um ihr zu folgen, aber mein Nachbar hielt mich am Ärmel fest. Ich riß mich mit einem kräftigen Ruck los; er packte mich an den Schößen meines Überrockes und zog mich rückwärts, wobei er fortwährend wiederholte: »Sie sollen ihr nicht folgen! Sie sollen ihr nicht folgen!« und zwar mit so lauter Stimme, daß alle Leute herschauten. Ringsum brach ein Gelächter los, und ich stand starr, rasend vor Wut, von dem lächerlichen Auftritt wie gelähmt da und rührte mich nicht vom Fleck.

DAS DAMPFBOOT FUHR WIEDER AB.

Das junge Mädchen, das auf dem Anleger stehen geblieben war, sah mich mit einer enttäuschten Miene davonfahren, während der Kerl hinter mir sich die Hände rieb und mir ins Ohr flüsterte:

»Lassen Sie es gut sein. Ich habe Ihnen soeben einen ganz gewaltigen Dienst erwiesen.«

Concorde Nova appeared in 1975, Berthold's exclusieve sampler for the '80s. Text from a short story by Guy de Maupassant. Design by Pascale Werkshagen. Won award from Type Directors Club of New York. (But Günter Gerhard Lange complained about the 'bloody Awful print').

Italics

Times L. Concorde looks larger and more compact. Individual shapes and widths are better than Times Italic. Proportions: the extra bold version of the nicely condensed Concorde Italic fits nicely with the upright face. The angle looks good but not unsettled.
Times I. On the whole, the uprights are too thin and uneven in width. Compared with the Linotype and Intertype versions, Concorde is very harmonious and even the most difficult letters work (especially lower-case f g k ß).

Bold

The stroke width in Concorde is lighter than in Times, but looks good. Concorde's counters (internal spaces) are larger and much more open, ensuring a clean print image, even when heavily inked on coarse papers.

Times I. This came off best, better even than the Linotype version. Concorde Bold's stroke widths are lighter and more open. Particular attention has been paid to the ties in the lower-case hkmnuwxy, and in rounding the counters in the a, e, g and s. The main roundels in the lower-case b, c, d, o, p and q are very oval, and fit better into the overall line image, leaving no visual gaps.

The staff at Berthold also like to compare their new Concorde with other 8-point typefaces such as Baskerville, Columbia, Garamond, Genzsch Antiqua, Imprimatur, Pressa or Weiss Antiqua. To the partners at Intertype, Günter Gerhard Lange concludes that the three Concorde faces promise well for sales of the new family. (Of course, he is referring both to Berthold's handsetting faces and Intertype's linecasting matrices.) And the most elegant typeface is worth nothing if it doesn't sell.

This analytic process shows very clearly to what extent the typeface designer is subject to market requirements without surrendering his search for quality.

Wegen des klaren und objektiven Schriftbildes und der gleichzeitigen Verfügbarkeit für den Hand- und Intertype-Maschinensatz. Die Grade von 6 bis 12 p sind in den Garnituren gewöhnlich, *kursiv* und **halbfett** in Form und Weite identisch.

Wegen der maximalen Offenheit der Punzen und der Durcharbeitung aller kritischen Figuren, die selbst auf weniger guten Druckträgern bei kräftiger Farbgebung ein optimales Ergebnis sichern.

Wegen der stabil ausgeprägten *Haarstriche und Serifen,* die selbst harter Beanspruchung ausgezeichnet standhalten und des *überhanglosen Gusses* der eine problemlose gute Verarbeitung ermöglicht.

Wegen der *ausgeprägten Mittellänge,* die der CONCORDE eine vorzügliche Lesbarkeit verleiht und der kleinen Versalien, die bei der Auszeichnung mitten im Text harmonischer als sonst üblich wirken.

Wegen der zügigen doch ruhigen *Kursiv* und der **Halbfetten,** mit der man kontrastreich arbeiten kann, ohne daß das Schriftbild unruhig oder fleckig wirkt. Selbst größere Textmengen aus der Halbfetten gesetzt wirken makellos ausgeglichen.

Wegen der Tatsache, daß die CONCORDE auch im Fotosatz auf *Staromat, diatype, diatronic* und auf der *Intertype-Fototronic* verfügbar ist und damit auch in diesem Satzbereich großen Spielraum eröffnet.

Deshalb ist die CONCORDE eine Allzweckschrift im besten Sinne des Wortes, deren ausgewogene Formen für alle Satzaufgaben mit Gewinn einzusetzen sind.

63

Ad copy by Günter Gerhard Lange.
Front page headline: 'Why is
Berthold's new CONCORDE
Antiqua the all-purpose type for
the printer?' The text covers all the
classical marketing ploys.
Positioning: all-purpose type.

On the contrary, the aim is to produce new typefaces which are even more readable and aesthetically pleasing than the existing ones.

Comparing Concorde with its direct competitors, this aim also seems to have been achieved in the long term.

Typeface designers and manufacturers, of course, tend to go into far more detailed analysis than the average user, but even the ordinary user should adopt this thorough, comparative approach when making long-term or wide-ranging type studies, such as when working on a corporate design programme. Only in this way can he be sure of making the right recommendations to the client for the longterm.

But back to Concorde. Young people today are taller than their forefathers, says Günter Gerhard Lange in his lectures, so it is not surprising that type-faces are also becoming narrower and taller. This led to the introduction of Concorde Nova in 1975: a slim, condensed version of the original shape.

And a word or two about Günter Gerhard Lange. Unlike other top-flight typeface designers, he spent his whole working life with Berthold AG. Not only has he been their artistic director for over four decades, his many highly enter-taining lectures on current international typography have also made him the company's chief propagandist, admired by setters and designers alike. In Europe and abroad, Berthold fans in particular have come to regard him as a household name in typography.

When Berthold had major economic problems in the mid-eighties, mainly as the result of an unfortunate hardware policy, its unsullied high-class typeface image was the origin of some injections of funds which kept the leaking ship afloat. And no-one more than Lange has been the driving force behind Berthold typefaces in the last four decades - even those designed by others but marketed under his direction.

Und noch ein Wort zum Entwerfer Günter Gerhard Lange. Im Gegensatz zu anderen hochkarätigen Schriftentwerfern blieb er sein ganzes Berufsleben lang der Berthold AG verpflichtet. Er war und ist nicht nur deren Künstlerischer Leiter über vier Jahrzehnte hinweg, sondern durch unzählige seiner unterhaltsamen Vorträge über internationale aktuelle Typografie auch der wichtigste Propagandist des Hauses, bewundert bei Setzern und Gestaltern. So wurde er in Europa, aber auch bis nach Übersee, vor allem für Freunde der Berthold-Schriften ein Inbegriff an Schriftkultur und typografischem Gewissen.

Als Berthold Mitte der achtziger Jahre, vor allem durch eine unglückliche Hardware-Politik, in eine schwere geschäftliche Krise geriet, war vor allem das ungetrübte hochwertige Schriften-Image von Berthold die Ursache für mancherlei Finanzspritzen, die das leckgeschlagene Schiff wieder in Fahrt brachten. Und niemand anders als Lange ist Verursacher und Synonym für die Berthold-Schriften der letzten vier Jahrzehnte- auch für die Schriften, die andere Künstler entwarfen, und die unter seiner Regie auf den Markt kamen.

64

Deepdene

Frederic W. Goudy

1929-1934

Lanston Monotype Corporation

H. Berthold AG

ABCDEFGHIJK
LMNOPQRST
UVWXYZ
1234567890
&
abcdefghijklmn
opqrstuvwxyz
–.,:;!?„""''—
1234567890

ABCDEFGHIJKLMNOPQRSTUVWXYZ

abcdefghijklmnopqrstuvwxyz

1234567890/%

(.,-:;!?)[',„""»«]−+=/$§*&

ÆŒØÇæœøçáàäâéèëêîìïîóòöôúùüû

ABCDEFGHIJKLMNOPQRSTUVWXYZ

abcdefghijklmnopqrstuvwxyz

1234567890/%

(.,-:;!?)[',„""»«]−+=/$§*&

ÆŒØÇæœøçáàäâéèëêîìïîóòöôúùüû

ABCDEFGHIJKLMNOPQRSTUVWXYZ

abcdefghijklmnopqrstuvwxyz

1234567890/%

(.,-:;!?)[',„""»«]−+=/$§*&

ÆŒØÇæœøçáàäâéèëêîìïîóòöôúùüû

ABCDEFGHIJKLMNOPQRSTUVWXYZ

abcdefghijklmnopqrstuvwxyz

1234567890/%

(.,-:;!?)[',„""»«]−+=/$§*&

ÆŒØÇæœøçáàäâéèëêîìïîóòöôúùüû

"I just think of a letter and mark around it"

Frederic W. Goudy (1865-1947)

Frederic W. Goudy's own list of products shows 116 typeface entries: all in all, he was responsible for designing some 123 styles.

Born in Bloomington, Illinois, Goudy was America's most productive and successful type designer, especially in the years 1915-1940. Not all his designs came to fruition: some failed to meet the supreme typographical demand, because over-individualism made them too much children of their times. This became apparent in the 30s, when the ambitious Goudy began to put quantity before quality to bring his list up to 100. He was also afraid of losing his eyesight. And when his wife Bertha died in 1935, he buried himself in his work to make up for his loss. Bertha M. Goudy had been a lifelong companion and a keen hand at setting a wide range of books. Later, she learnt to cut matrices as well.

With his new interpretations of Renaissance styles, Goudy gave American newspaper and magazine printers and advertising contemporary artistic styles which raised quality standards in mass production. At the time, good Antiqua styles were virtually unknown outside hand presses; commercial printers were still using the horrors of the 19th century. The creative type designer steeped in typographical history did not exist. Foundries and print shops made up their own styles, mostly by copying and ornamentation, with no regard for form or function. Goudy regarded himself as the first original typeface designer, at least in America, whose aim was to combine functionality and beauty in type.

Although he liked drawing and showed talent from an early age, he was over 30 years old when type became his life.

In 1895 with some help from a friend, Goudy bought a printing press; he first called it Booklet Press, then more ambitiously, Camelot Press. His prime interest, though, was improving typography and modernising advertising. He taught himself how to print, and his press caught the public's eye. He won a major contract, printing *The Chap-Book* for Stone & Kimball. Setting type economically was a problem. His solution was an inventive one, consisting of casting 9-point type on an 8-point base - an astounding invention to his fellow printers. After less than two years, he sold his stake in the press. In 1896, he designed his first typeface, a capital Camelot, and sent the drawings to the Dickinson foundry in Boston, which also cast type for American Type Founders Company. They paid him double what he asked. ATF took Camelot into its range and later added a lower-case alphabet.

In 1899, Goudy set up as a freelance designer and typographer in Chicago. He earned his living by producing advertising print, copy and book designs. He discovered an efficient method of production which enabled him to live by day without having to miss out on visits to the theatre, and then meet urgent deadlines at night. When designing a typeface, Goudy's first step was to sketch sample letters on lined paper, testing the proportions and spacing. He then produced pencil drawings, which he overdrew and corrected in ink. He only ever drew the main outlines, adding the serifs afterwards by turning the paper. In this way, he not only learned about type, but also acquired a routine. This fast, freehand approach gave all his types a direct, lively style. In 1900, he started teaching at the Frank Holme School of Illustration in Chicago. W.A. Dwiggins, later to be one of America's most famous designers and typographers, and who worked at the Village Press during its time in Hingham, Mass., was one of Goudy's students.

In 1903, Goudy founded the Village Press in Park Ridge, Illinois, to publish fine books. He also created a typeface of the same name for the purpose. Village Type is a type-like hand press type, based, like William Morris's Golden Type or Emery Walker's Doves Type, on the Venetian Jenson. In 1906, Village Press moved to New York, only to burn down in 1908. Although the Village Type matrices survived, Goudy himself never used that face again.

In 1920, the Lanston Monotype Machine

Company appointed Goudy artistic director. He made most of his machine-setting faces for Lanston, although some were for ATF and Monotype England.

In 1927, he became vice-president of the Continental Typefounders Association, New York, which specialised in importing modern European styles.
When Goudy moved his Village Press and Letter Foundry to Marlborough on the Hudson in 1923, he became the first designer to supply a full range of type services from design to matrix cutting and casting.
Since 1921, he had been thinking of creating his own typeface, to make up for the loss of handwriting. The death of Robert Wiebeking in 1927, who had cut all his faces for him up to then, was the spur to concentrate completely on matrix production. At over 60 years old, he set about learning his new craft.

In 1928, he brought out Goudy Text for Lanston Monotype, a Gothic Textura devoid of surplus ornamentation, giving an even, easy-to-read text. This was a great success.

At the age of 72, in between all his other work, he designed Friar purely for fun for a small private print run. It shows features of uncials and semi-uncials. Goudy's last style for Lanston Monotype, Goudy Thirty, a Rotunda, was created in the years 1941-1945.

Goudy's Neo-Renaissance typefaces brought classical type styles and their underlying humanistic philosophy and typographic achievements into the 20th century. In their new form, they were a good vehicle for conveying and forming thought and language.

For Goudy, the Antiqua structure was a vessel which he - often exuberantly - filled to bursting with life. Simply filling in Goudy Outline, for instance, produced Goudy Modern. To Goudy's lively mind, the Antiqua style offered a wealth of potential expression and refinement. Some people, however, claim that his styles are too similar, but the differences make themselves felt in the reader's subconscious. Goudy's definition of originality depended not on the shape of individual letters but on the effect of the page of text as a whole. If a style looked different as a whole, then it was original as far as he was concerned. Of course, a typeface can never conceal its origins: Goudy's signature is visible, in the same way as that of Georg Trump or Hermann Zapf.

After the Second World War, Goudy led the way in modern typeface design in the USA, mainly through the International Typeface Corporation. His classical sense of form, his striving for personal expression and beauty and his advertising background made him predestined to do so. ITC took his typically American philosophy of life, made it commercial and spread it worldwide via its extensive range of type.

To Europeans, Goudy Italian Old Style, with

Deepdene, at R.I.T. ready for setting

The first test setting and print of Deepdene Italic, September 1927.

DEEPDENE ITALIC : A NEW TYPE DRAWN & CUT BY THE DESIGNER OF DEEPDENE ROMAN. FEB. 21, 1929

THIS trial impression presents the first showing of Deepdene Italic. In September, 1927, Mr. Goudy produced Deepdene, the first type that he, with his own hands had ever cut in several related sizes. Its companion italic, in its lower case, owes nothing to historic forms [except only to the Aldine character on which all italics must necessarily be based].

Deepdene Italic probably is not a true chancery letter, but Mr. Goudy hopes it will be found worthy to stand alone, just as the older italic characters were intended to stand. The designer of the face has chosen to disregard tradition in an attempt to follow a line of his own; glancing neither to the right nor to the left, he drew each letter wholly without reference to work of other craftsmen. He feels that the result is a simple, reasoned design which is not without charm. With less of the pronounced jagged up-and-down movement of individual characters of the Blado italic, it is, therefore, less gothic than that famous letter; it does, however, exhibit a dis-

ciplined freedom of its own. Quite apart is the essential quality of legibility which it undoubtedly possesses.

The Capitals present no radical departures—indeed they could not without danger of eccentricity, but the swash letters which accompany them will give that degree of variety & a touch of elegance which will relieve any tendency toward primness. Notwithstanding the slight inclination of the face, it is a true italic, which after all, is not so much a matter of inclination as of character. It is an original design by Frederic W. Goudy who made also the master and working patterns from which the matrices have been cut by Mrs. Goudy. This proof [before final revision] is printed from type cast under his supervision in his foundery at Marlborough-on-Hudson, New York.

Fred W Goudy

AA BB CC DD EE FF GG HH IJ K L MM N O PP Q RR S T T U V W X Y Z &
a b c d e f g g h i j k l m n o p q r s t u v w x y z & fi fl ffi ffl ffi
! ' . , ; : - ?

its major variations from one character to another, is not all that attractive, although the book face Goudy Old Style is popular everywhere. Goudy created this Old Style and its associated italics for ATF in 1915-16. It was an immediate bestseller, and present-day advertising would hardly be conceivable without it. It has been used for years in headlines for advertising whisky and beer, fashion and finance. ATF's resident designer Morris Fuller Benton extended it to give one of the best-developed typefaces ever, available from any manufacturer.
Goudy protested to ATF that the descenders were cut, but it was precisely for this reason that it became so popular with printers, because it meant they could set columns closer.

"I abandon my amateur standing..."

The year 1911 was a milestone in Goudy's life and that of his Village Press. New York publishers Mitchell Kennedy engaged him to design and set H.G. Well's book, *The Door in the Wall*. The initial choice was ATF Caslon, but it proved to be too broad. Instead, Goudy proposed a new typeface, which he named after the client, Kennerley Old Style.
The phoenix-like Village Press now became the Village Letter Foundry. For the first time, a typeface designer also offered casting. In 1913, the Caslon Foundry acquired the British and European rights to Kennerley. In 1920, it was acquired by Lanston Monotype.

Kennerley was not only very popular, but also meant a step forward in aesthetic terms.
For the first time, printers had a good Renaissance style for everyday use.
Whether Goudy was inspired by Fell's typefaces or Jenson is irrelevant, for the result was a typically individual Goudy style.

Then the fashion turned to classical styles. Goudy created Goudy Modern, once again not just an eclectic imitation of Didot or Bodoni and with a more human face.
The stroke widths widths are less contrasting, giving a more even density like that of a bold face.

With Goudy, there was often a gulf between theory and practice. In his speeches and writings, he liked to say that the designer must keep in the background. But this principle is not very evident, especially in Garamond, which he designed for Lanston Monotype in 1921 - aa precise historical copy, all hot perspiration with none of Goudy's inspiration.

One of the freest typefaces which Goudy created from his wealth of experience was done for the University of California in 1935-38. He considered this exclusive style one of his most conventional: a mixture of attractive strength and movement which was relatively timeless, making it an ideal text face. In 1983, ITC reissued California as Berkeley Old Style.
Goudy did not like Grotesque faces: he only designed a few, mostly as minor contract work for ATF.

Deepdene

This was the first typeface which Goudy created on his own in 1928, when he was 62 years old but at the height of his creative powers. Deepdene is a bold, human type dedicated to the ideals of the Renaissance and embodying the feel of American life in the 30s, which is why it seems fresh, modern and full of character to us today. Goudy says that his ideas were based on those of a Dutch designer. It is assumed that he meant Jan van Krimpen and his Lutetia, which Johan Enschede & Zonen brought out in 1926. But this was only the external impulse: the results are entirely Goudy's own. Deepdene is closest to Kennerley Old Style of 1911, although Goudy's trademark, the Venetian e, crops up, a hallmark of Nicolas Jenson's Antiqua.

Deepdene is a strict, reserved Antiqua. It is the expression of Goudy's continuing development and his struggle to find the perfect form.

*Günter Gerhard Lange's correction sheets.
The test word 'Hamburgon' (in many cases 'Hamburgefons') contains all the important characters, and shows the ratio of ascenders to descenders and capital height.
Harmonising the line widths, x-height and style is the first stage of the job.*

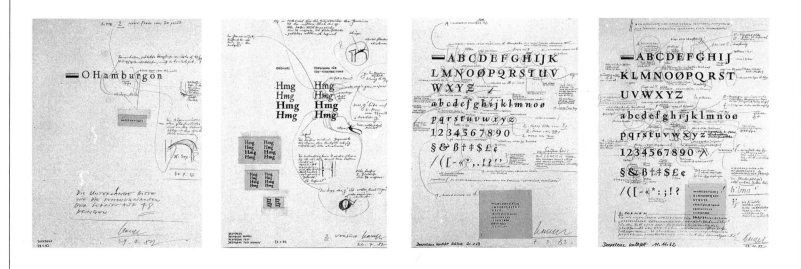

Deepdene Italic is another winner.
The matrices were cut by Bertha Goudy. This is a real italic in the sense of Aldus Manutius, a charming complement and highlight to the upright face. The individual letters are narrower than the medium face. Because of their calligraphic style, they need only a slight angle of inclination. Goudy uses two forms for the usual English hard and soft g. In this case it was good that Goudy was still using the smallest body possible, so that the lower-case letters nestle up to the capitals, giving the face a uniform image. Some of the old Goudy trademarks are here too: the open Q the flowing y and z and the long ascenders.

"The invention of Deepdene was a historic moment," says Günter Gerhard Lange, artistic director at Bertholds. Berthold has marketed Deepdene for photosetting since 1983, and for computer typesetting since 1989.

If you take the job seriously, adapting a hot-metal font for photosetting is a long, laborious process fraught with difficulties. It takes the artist's wholly unselfish sensitivity to read the designer's mind and the character of the font, with all its individual shapes and forms. This assumes an understanding of form, a detailed knowledge of typographical history and a feeling for the 'handwriting', the 'Zeitgeist', for the currents in society at the time it was created. To GGL subordinating his own personality in interpreting and adapting hot-metal type to photosetting is second nature. The golden rule is: the designer rules and the type works. "It's not my handwriting that should be visible, but that of Goudy." This is the most disciplined, subtle service to our written culture. Hot-metal typefaces from the handsetting era show differing proportions and forms in different sizes, while photosetting uses just one size as the basis for all the others. This causes considerable problems of detail which can only be solved by consummate skill and careful attention to both detail and the whole. It involves typographic decisions which not only affect the form but have far-reaching consequences for our written culture. " In 20 years, who will know which was the original Deepdene design? For that reason, only the optimum form, that which comes closest to the original in form and intention, can be the proper yardstick for our work. Computerised typeface design is undoubtedly a good thing, but too little care and understanding of form have led in recent times to a decline in typographic standards."

Deepdene embodies the strict will to form of the Roman capitals and the lowercase of the humanistic Antiqua of the 15th century. Is is not just a copy: thanks to Goudy's creative vitality, it is a truly 20th-century typeface. Goudy's original drawings and matrix cuts are clear evidence of his struggle for an authentic, powerful and harmonious individual form, which he often cut in many versions.
This constantly requires the imitator to decide which is the 'right' form, the one that matches all the other letters and figures.

Correction sheet for Deepdene. Small caps need their own original drawings, with the individual basic strokes bolder, the proportions wider and the serifs and narrow strokes more stable (corrections as at 22.12.82).

71

A TYPOGRAPHIC SOLECISM
✤

✤ THIS TYPE FACE has been designed by Fred W. Goudy for his own amusement. ✤ It is, in a manner of speaking, a typographic solecism. ✤ For his lower case letters he has drawn on the half-uncials of the fourth, fifth, sixth and seventh centuries, eighth century uncials, suggestions from types of Victor Hammer, Rudolf Koch and others. With these he has attempted to combine majuscules based on square capitals of the fourth century, and the rustic hands of the scribes, to which he has added his own conceits. ✤ If

❦IT WAS THE TERRACE OF
God's house
That she was standing on, —
By God built over the sheer depth
In which Space is begun;
So high, that looking downward

The Goudy Friar (above) and the first Village Type.

Like all other typeface designers before him, Goudy did not design Deepdene as a family. The x-height of the individual cuts shows gradual changes in proportion. Such fine typographic detail calls for careful analysis and makes adaptation difficult. This probably explains why other photosetting typeface manufacturers shrink from reissuing old faithfuls.

Berthold has the whole range of Goudy's Deepdene versions: medium and medium italic, bold and italic, plus small capitals, standard and medieval figures. Some of the italic capitals look like decorative letters. GGL always pays special attention to the small caps. Simply reducing the capitals would never do, for, in terms of form and proportion, small capitals always relate directly to the lower-case letters. Merely reducing the full-size capitals will never give proper small capitals: they would be too light and too narrow, and would be incapable of doing their job of highlighting proper names in the running text, because they would not stand out. In size, small capitals are not exactly the same height as lower-case letters; they are slightly larger, broader and have more prominent serifs.
Interpretation or redesign is also a useful opportunity for removing old faults due to laziness, lack of time or imperfect reproduction processes.

Formata

Bernd Möllenstädt

1984

H. Berthold AG

ABCDEFGHIJK
LMNOPQRST
UVWXYZ
1234567890
&
abcdefghijklmn
opqrstuvwxyz
_.,:;!?„""'—

normal
normal
regular

ABCDEFGHIJKLMNOPQRSTUVWXYZ

abcdefghijklmnopqrstuvwxyz

1234567890/%

(.,-:;!?)['',„""»«]—+=/$§*&

ÆŒØÇæœøçáàäâéèëêíìïîóòöôúùüû

italique
kursiv
italic

ABCDEFGHIJKLMNOPQRSTUVWXYZ

abcdefghijklmnopqrstuvwxyz

1234567890/%

(.,-:;!?)['',„""»«]—+=/$§*&

ÆŒØÇæœøçáàäâéèëêíìïîóòöôúùüû

demi-gras
halbfett
medium

ABCDEFGHIJKLMNOPQRSTUVWXYZ

abcdefghijklmnopqrstuvwxyz

1234567890/%

(.,-:;!?)['',„""»«]—+=/$§*&

ÆŒØÇæœøçáàäâéèëêíìïîóòöôúùüû

italique
demi-gras
kursiv halbfett
medium italic

ABCDEFGHIJKLMNOPQRSTUVWXYZ

abcdefghijklmnopqrstuvwxyz

1234567890/%

(.,-:;!?)['',„""»«]—+=/$§*&

ÆŒØÇæœøçáàäâéèëêíìïîóòöôúùüû

gras
fett
bold

ABCDEFGHIJKLMNOPQRSTUVWXYZ

abcdefghijklmnopqrstuvwxyz

1234567890/%

(.,-:;!?)['',„""»«]—+=/$§*&

ÆŒØÇæœøçáàäâéèëêíìïîóòöôúùüû

italique gras
kursiv fett
bold italic

ABCDEFGHIJKLMNOPQRSTUVWXYZ

abcdefghijklmnopqrstuvwxyz

1234567890/%

(.,-:;!?)['',„""»«]—+=/$§*&

ÆŒØÇæœøçáàäâéèëêíìïîóòöôúùüû

And not a straight line in sight

Formata, an easy to read Grotesque

Sketch for 'Hamburg' test word in medium and bold.

"A first birth is always difficult. Please make allowances," wrote Bernd Möllenstädt on one of the numerous correction sheets which came back to Berthold's type studio. When it was all over, the child was baptised Formata, a sans serif linear Antiqua of pliant mien.

Bernd Möllenstädt, the creator of Formata and manager since 1967 of Berthold's type studio at Taufkirchen near Munich, took three years altogether, apart from the initial steps, to turn Formata into an extended family. Today, it has 18 members, and there are others to come.

Man is the measure of all things, not the computer

Formata was the result of a long learning process under the wing of Berthold's artistic director, Günter Gerhard Lange. Unlike other recent typefaces, it doesn't look like a product of the computer age, in which a great deal of design and production processes have been automated. Here, the computer as a useful tool in the hands of creative people. The type's aesthetics are governed not by the strait-jacket of technology but by human sensitivity, and the eye as foolproof correcting agent. It is still the hand which transfers the designer's spiritual attitude

intuitively and unconsciously to the written form. Only this can give a living expression. After extensive preliminary tests, Bernd Möllenstädt drew complete character sets for two extra bold faces. These normal and bold faces were the basis for conversion to digital format.

GGL: "Neither language nor music nor architecture nor the creative arts can arise in a programmed wilderness. This would be the death of all human need to communicate, to realise oneself, in brief, to be creative."

Design - development - features

Essentially? Formata was based on a humanistic style sans serif. It was designed as a contrast to the usual linear, artificial rigidity and uniformity of Grotesque and to achieve an ideal reader-friendliness by its warmth and flow. On the one hand, the text sizes from the usual catalogue of forms for a sans-serif style should not attract attention, on the other, its characteristic features should come out in the larger sizes. This achieves two aims: it gives a pleasant, legible text face, which is not tiring to the eye, and an excellent high-light face.

After the initial, still highly calligraphic

Typical Formata details: no straight lines, varying widths, angled stroke ends, capped corners, ascenders higher than capitals.

Draughtsman's drawing of 'Hamburg' in five strengths from light to extra bold.

sketches in 1978, which were promptly shelved, the serious work began in 1980. Rough sketches appeared using the conical shape of the horizontal and vertical strokes from the earlier attempts. It is these strokes, which in the capital I, for instance, are different on the left-and right-hand sides, help give the style its attractive appearance. To make the latent softness more apparent in the smaller sizes and establish a family style in the larger ones, the corners were capped. This typicall typographical habit shows to best advantage in the headline sizes from 60-point upwards and especially in the light face.

Once the rough sketches had laid down the basic forms and proportions, the next step was to draught the test word 'Hanburg' in five upright faces, while at the same time fitting it into the 48-unit system. The next step was to add the test word in italics and determined the angle of slope on purely visual criteria.
To prevent the typeface degenerating under the distortions of electronics, they aimed at creating not just a sloping face but a genuine italic. Limiting itself to a few individual forms - such as a and g - Formata Italic is a moderate italic which fits well with the rest of the family and in upright text. But the set of the flow of individual characters is the sign of an

electronic and hence rigid pen: in other words, the italics betray the fact that Formata is a product of the digital age.

The intermediate bold stages were generated by interpolation with Icarus software. The results were then corrected manually and optically to give a balanced word picture and proportions, line strength and type body.

Formata also overcomes the problem that in words such as 'Illusion' and similar combinations a capital J is used instead of an I. Most Formata capitals are visibly smaller than the lower-case ascenders, a detail which helps German with its plethora of capitals. Nor is the figure 1 just a small l. You might think this went without saying in modern type design, but you would be wrong: if you don't believe me, look at Helvetica or the latest Grotesque styles.

The bolder a typeface becomes, the less legible it is, because it blurs internally. This was allowed for in Formata, so that, amongst other things, the extra bold face was omitted.

In the bolder faces, the x-height was also increased to keep the internal spaces open, and the proportions of the ascenders and descenders adjusted

Above:
Digital contour display on the graphics terminal.

Right:
The digitiser sets the curve, corner and tangent points.

Below:
Fine corrections made by the editor on the terminal.

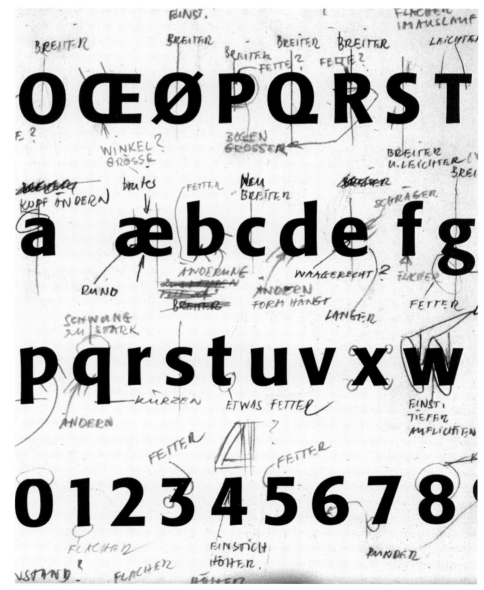

accordingly. In Formata, the x-height is relatively high, comparable with that of Frutiger or Jobbing Grotesque Book, but small enough to encourage the reader. In terms of basic proportion, Formata is relatively wide: especially in the smaller sizes, it aims at legibility rather than following the fashionable but difficult to read trend of other narrow, vertical faces. Even when condensed, Formata avoids this taint, but is a perfectly-proportioned condensed face, which works well as highlights. The figures are smaller than in the medium face, as is the spacing between them. The image width has been readjusted to suit the 48-unit system. Such touches make Formata a useful text face, even in the smaller sizes.

Overall, the line width is somewhat thicker than in other sans-serif styles, to give a strong print body, a fact which is especially helpful in the lighter faces. It doesn't flicker before the eyes or look 'styled'. Once again, the descenders are much longer than those of Helvetica or Univers, both of which still had to allow for the constraints of hot metal casting, i.e. the standard line of type. On the other hand, these are less pronounced than in Optima. The strong emphasis on the ascenders compared with the capital height is reminiscent of Gill or Optima.

The figures are all on the same set, so that they can be freely interchanged within a face or the entire family. This makes setting tables easier, but a little deficient on the aesthetic side. Nowadays, Möllenstädt prefers to adjust the figures to match each face, so that they suit one face only, not the whole family.

Finally, the individual forms were tested and adjusted in composite text: a procedure which has to be repeated many times, for the slightest change in an individual letter involves realigning the word as a whole.

After repeated corrections on the graphics terminal, the alphabet is printed out on the plotter and compared with the original. A complete character set is then cut in 40 mm capital height and reduced to 36 and 8 point. These sizes are then used for further fine corrections, for this stage often shows up shortcomings of form and thickness which must be spotted and removed. The eye reacts particularly sensitively to tangential transitions, when a straight line meets with a curve. Particular attention is paid to the sets in the unit system. This governs the set and the image width. In

Attention to typographical details improves legibility. Compare Formata with Helvetica. The capital I and lower-case l are clearly different, as are the lower-case l and the figure 1. As the boldness increases, the x-height increases with it, so that the ascenders and descenders have to be modified.

Before final production, checks are made to see if Formata has not inadvertently come to resemble existing styles after all, from Helvetica to Optima. Formata numbers all share the same setting, and so can be used with any of the family.

79

establishing the basic width, the width adjustment must be borne in mind. Test sizes are 8, 16 and 32 point. Since this adjustment is governed by the typesetting equipment, set definitions must make sure that the smaller sizes do not look too far apart or the larger ones too cramped. In Formata, the width adjustment performs well, the type 'shines', so that it works well without using the aesthetic software. Not every typeface can do this.

Finally, we come to the stage where the alphabets can be cut in 120 mm capital height in 'Ulano' film and copied to opaque film. This is the original artwork, the basis for all type sizes and the optomechanical type body. The Icarus data are then converted to Berthold's specific contour format, which is used to create the various digital type bodies.

Formata embodies the human urge for order and beauty. In the text sizes, it is pleasant to read, and works well. Its individuality comes out in the larger, bolder sizes, although it is sometimes too self-confident. Here, the typographer must handle it sparingly and delicately, to let its clear contours look like a solitaire in space. Once again, this shows that in the arts and crafts attention to detail creates a pleasing aesthetic appearance almost automatically. In its unimposing, attractive style, Formata satisfies the artistic urge.

Headline from "Spiegel" magazine. Formata bold condensed, with electronic distortions.

(right)
This is what the real Formata bold condensed looks like.

Futura

Paul Renner

1932

Fundición Tipográfica Neufville, S.A.

H. Berthold AG

Futura

ABCDEFGHIJK
LMNOPQRST
UVWXYZ
1234567890
&
abcdefghijklmn
opqrstuvwxyz
-.,.:;!?„""'—

normal	ABCDEFGHIJKLMNOPQRSTUVWXYZ
normal	
regular	abcdefghijklmnopqrstuvwxyz
	1234567890/%
	(.,-:;!?)['',„""»«]—+=/$§*&
	ÆŒØÇæœøçáàäâéèëêíìïîóòöôúùüû

italique	*ABCDEFGHIJKLMNOPQRSTUVWXYZ*
kursiv	
italic	*abcdefghijklmnopqrstuvwxyz*
	1234567890/%
	(.,-:;!?)['',„""»«]—+=/$§&*
	ÆŒØÇæœøçáàäâéèëêíìïîóòöôúùüû

demi-gras	ABCDEFGHIJKLMNOPQRSTUVWXYZ
halbfett	
medium	abcdefghijklmnopqrstuvwxyz
	1234567890/%
	(.,-:;!?)['',„""»«]—+=/$§*&
	ÆŒØÇæœøçáàäâéèëêíìïîóòöôúùüû

italique	*ABCDEFGHIJKLMNOPQRSTUVWXYZ*
demi-gras	
kursiv halbfett	*abcdefghijklmnopqrstuvwxyz*
medium italic	*1234567890/%*
	(.,-:;!?)['',„""»«]—+=/$§&*
	ÆŒØÇæœøçáàäâéèëêíìïîóòöôúùüû

gras	**ABCDEFGHIJKLMNOPQRSTUVWXYZ**
fett	
bold	**abcdefghijklmnopqrstuvwxyz**
	1234567890/%
	(.,-:;!?)['',„""»«]—+=/$§*&
	ÆŒØÇæœøçáàäâéèëêíìïîóòöôúùüû

italique gras	***ABCDEFGHIJKLMNOPQRSTUVWXYZ***
kursiv fett	
bold italic	***abcdefghijklmnopqrstuvwxyz***
	1234567890/%
	(.,-:;!?)['',„""»«]—+=/$§*&
	ÆŒØÇæœøçáàäâéèëêíìïîóòöôúùüû

Futura - a typeface of its time

Paul Renner around 1930, photograph taken by E. Wasow.

Many designers quote as their main reason for using a given typeface its alleged 'neutrality' in relation to the text. The prime example of this is Helvetica, whose main quality seems to be that it has no qualities. But, if we look at the history of typefaces, we find that even the 'timeless' are a product of their time, for designers are always exposed to influences which they reflect, consciously or not, in their work.

Elementary typography

In 1925 there appeared a special edition of *Typographische Mitteilungen* entitled 'Elementary Typography', published by Jan Tschichold (still working under the name of 'Ivan'). Here he first formulated his efforts to create a 'new typography'. When they appeared, Tschichold's radical ideas attracted considerable attention. As is often the case when someone says what many people are thinking or feeling without being able to put it exactly into words, they met with equal amounts of gushing enthusiasm and blank rejection. The author laid down ten commandments of elementary typography, which he summarised in an essay a few years later, in 1930:

"To achieve a typographical design, (one) can use any historical or non-historical typefaces, any kind of layout, any line arrangement. The only thing that matters is the design: the appropriateness and creative arrangement of the visual elements. This means that there are no limits such as the demand for uniform type or what types do or do not mix. It is also wrong to make a smooth appearance the only aim of design - there is such a thing as creative disorder."

The type of the New Age

Tschichold also had similarly high-flown ideas on the typefaces needed for this sort of design:
"Of the typefaces available, Grotesque or block face are the nearest to what the new typography needs, because they are simple in design and easy to read. But there is no reason why other easy-to-read faces should not be used, even 'historical' types in the present sense, if they clash with the other types used at the same time, i.e. the tension between them is designed."

From this it will be clear that Tschichold had very firm ideas about the new typography, but was by no means doctrinaire.

The right typeface by these criteria did not yet exist. Bauhaus leader Laszlo Moholy-Nagy put it this way in *Bauhausheft 7* in 1926: "Since

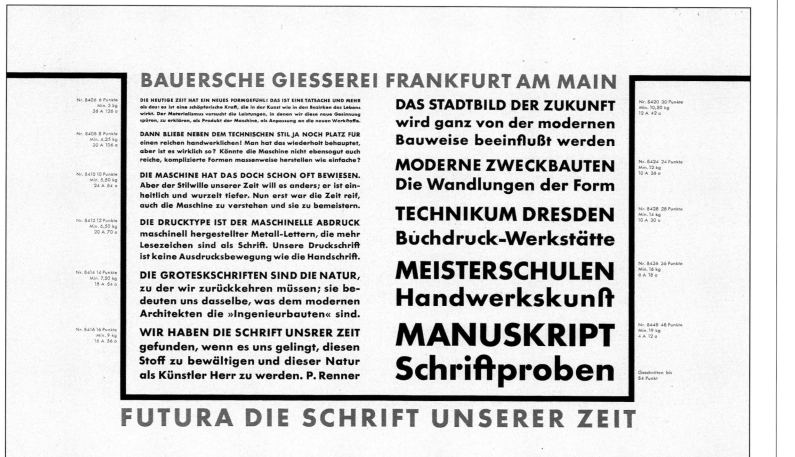

*Ad for Futura 1927. Some pages of a
sampler from the Bauer foundry.*

all existing Grotesque book styles lack basic style, Grotesque still has to be created." He followed this with his own ideas about how this style should look: "It should share the technically designed forms of engineering structures, cars, and aeroplanes, because for the moment we don't even have a working style in the right size. Exceptionally clear and legible, free of individualism, based on a functional appearance, without distortions or embellishments." In the same volume, other Bauhaus leaders set out their ideas on such a typeface: Herbert Bayer's "Attempt at a new typeface" and Josef Albers's "Stencil type as hoarding type". Any attempt to read material set in this style, however, shows how far removed these designs were from the expectations of the new typography.

Inspiration by the spirit of the time

At the same time, Paul Renner's designs for a new Grotesque style on constructivist principles were coming along well. Each was presumably unaware of the other, but the spirit of the times ensured that their intentions were the same.

Futura, too, was based on simple basic forms (circle, triangle and square) but Renner's experience with books had made him sufficiently tolerant to abandon constructed forms for ones which worked visually, and he did not cast aside the fruits of tradition in favour of a new dogma.
Paul Renner was 46 (i.e. no revolutionary tearaway) when he started designing his new typeface in 1924. By 1925, he had become head of the advertising graphics and typography department at Fritz Weichert's school of art in Frankfurt. Here, Renner had also got to know the work of the architect Ferdinand Kramer, who was responsible for the architectural Grotesque which the City of Frankfurt used for all its publications under the heading "Das neue Frankfurt". Kramer's Grotesque encouraged Renner to design his own.

aaaa ggg
Die heutige Zeitungsillustration
Die heutige Zeitungsillustration
1234567890 1234567890
Arbeitsgemeinschaft
Arbeitsgemeinschaft

The geometrical letter shapes could be defended on ideological grounds, but were not exactly suited to running text.

Two pages from "Futura – The Type of Today and Tomorrow". The Bauer Type Foundry Inc., New York, 1930.

*This invitation card shows Futura in its
original form, with medieval figures.*

Renner had been contracted to do so (more or
less) by the publisher Jakob Hegner. After a
visit to Renner's Munich workshop, Hegner
said that he too should design a typeface
which he (Hegner) had already engaged two
other famous painters to design and which
was to become the 'style of the time'.
However, the publisher's order for turning
Renner's drawings into letters never came, so
that it was some time before the drawings
reached Heinrich Jost, artistic director at the
Bauer foundry in Frankfurt, and finally the
owner, Georg Hauptmann. Although initially
hesitant, Hartmann accepted the challenge,
but it was still some time before the first
version of Futura appeared in 1928.

'Kramer Grotesk which Renner had used as a
model was not doggedly geometric, but nor
was it a historical style in the sense Tschichold
meant. The combination of abstract stylistic
strength with noble classical style is shared by
Futura. The name is said to have come from
Fritz Weichert. Renner was highly critical of his
own work, and later admitted freely that the
claim to be 'the typeface of our time' was
rather cheeky. In his view, the classical Antiqua
styles were just as easy to read as the classical
and modern ones.

Constructive & classical

The first samples of the new style made their
appearance at an exhibition by the school of
art in the autumn of 1925. In this first version,
some of the characters were still quite clearly
artificial. The conflict between geometry and
customary form later swung in favour of
traditional, less controversial design. We have
Renner to thank for bringing all the
aspirations of his time down to a single
denominator. Just how far the designer's
character was reflected in the typeface is
shown by a quote from Willy Haas:
"With his new Futura, Paul Renner shows a
non-historical, constructive solution which
looks uncommonly noble and pure, is equally
at home in classical and modern uses, and,
despite its strict design, does not bombard us
with doctrine but falls easily on the eye...So
much personal style with so much abstract
strength of form, such a fine, human, noble
mixture is not something we are used to
seeing very often."

In 1927, Renner became director of the
college of book printers in Munich, and it
acquired an international reputation in the
following years. With his political views, which
can best be described as liberal-conservative,
conflict was more or less 'wired in', so to speak.
For Renner, rigidity maintained by force was a

*'Futura' and 'Futura Schmuck', Bauer
Type Foundry, 1927.*

common feature of feudal, capitalist, fascist, communist and National Socialist systems. This led to philosophical discussions in the early 1930s on such burning topics as 'Antiqua or Gothic' or 'flat or sloping roofs'. Conservative groups, especially the National Socialist party and its cultural organisations, blasted the turn away from Gothic and advocacy of 'new building' as 'cultural Bolshevism'. Paul Renner took a clear stand in an article with this title in 1932. The conclusions of his statement were a clear declaration of war on the National Socialist *Kampfbund*.

"If we are concerned about German art, let us protect it from nationalist associations who want to fight for it with slogans and knuckledusters. They say they are fighting for German culture, but are ready at any time to betray the basic requirement of that culture, intellectual freedom, to fascism..."

The end of culture

After the National Socialists seized power in 1933, it was obvious that this attitude would have its consequences. On April 3 1933, although still head of the most respected school of art in the Reich, Renner was arrested on the orders of an officer of the ruling party as a 'cultural Bolshevik' and taken into police custody. His connections with connoisseurs of literature who still had some influence in party circles succeeded in getting him released the next day.

After this, Renner resigned from his position at the school under duress and retired to Lake Geneva, where he painted realistic pictures and worked on his book *Order and harmony in colour*. It did not appear until 1947, at the same time as the reprint of his 1933 book, *The art of typography*. As early as 1922, Renner had published *Typographie als Kunst*, which was regarded as a standard work. His style, Futura, was constantly extended between 1928 and 1939, with new versions even appearing after the war, in 1950-57.

Renner's other designs - Plak (1928), Ballade (1937) and Renner Antiqua (1939) were nowhere near as successful as Futura.

The typeface of our time

The typeface of its time, the Futura of 1928, on the other hand, has become a classic which scarcely shows its age. The same goes for Futura as for any other style which claims to be designed for the future, as Peter Behrens said in his foreword to the sample of his Behrens style in 1902:

"This means that nothing is worthier than the search for a typeface stamped with the spirit of our times. This means that inventing a new typeface means inventing a new way of writing which first has to be learnt. A new style can only develop organically, almost unnoticed, from tradition, in accordance with the changes in the spiritual and material spirit of the times as a whole. Only such a style will be lasting and more than just a whim."

Garamond

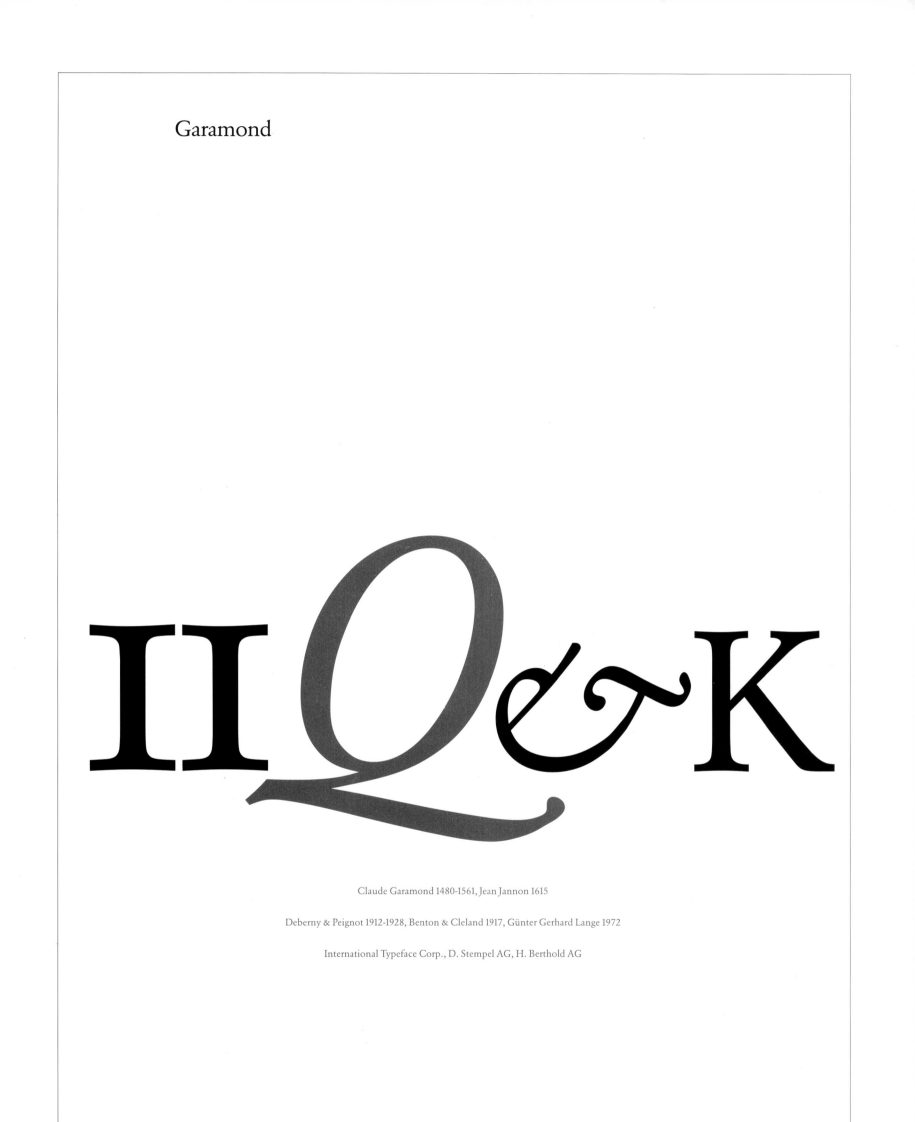

Claude Garamond 1480-1561, Jean Jannon 1615

Deberny & Peignot 1912-1928, Benton & Cleland 1917, Günter Gerhard Lange 1972

International Typeface Corp., D. Stempel AG, H. Berthold AG

ABCDEFGHIJK
LMNOPQRST
UVWXYZ
1234567890
&
abcdefghijklmn
opqrstuvwxyz
_.,.:;!?„"''—
1234567890

normal
normal
regular

ABCDEFGHIJKLMNOPQRSTUVWXYZ

abcdefghijklmnopqrstuvwxyz

1234567890/%

(.,-:;!?)[',„""»«]—+=/$§*&

ÆŒØÇæœøçáàäâéèëêíìïîóòöôúùüû

italique
kursiv
italic

ABCDEFGHIJKLMNOPQRSTUVWXYZ

abcdefghijklmnopqrstuvwxyz

1234567890/%

(.,-:;!?)[',„""»«]—+=/$§&*

ÆŒØÇæœøçáàäâéèëêíìïîóòöôúùüû

demi-gras
halbfett
medium

ABCDEFGHIJKLMNOPQRSTUVWXYZ

abcdefghijklmnopqrstuvwxyz

1234567890/%

(.,-:;!?)[',„""»«]—+=/$§*&

ÆŒØÇæœøçáàäâéèëêíìïîóòöôúùüû

italique
demi-gras
kursiv halbfett
medium italic

ABCDEFGHIJKLMNOPQRSTUVWXYZ

abcdefghijklmnopqrstuvwxyz

1234567890/%

(.,-:;!?)[',„""»«]—+=/$§*&

ÆŒØÇæœøçáàäâéèëêíìïîóòöôúùüû

gras
fett
bold

ABCDEFGHIJKLMNOPQRSTUVWXYZ

abcdefghijklmnopqrstuvwxyz

1234567890/%

(.,-:;!?)[',„""»«]—+=/$§*&

ÆŒØÇæœøçáàäâéèëêíìïîóòöôúùüû

Would the real Garamond please stand up?

Design attributed to Claude Garamond, 1545. Note the narrowing type and widely spaced numbers.

Aldus and Griffo were the greatest Italian creators of Renaissance Antiqua. But who created their French counterpart, French Renaissance Antiqua? Garamond? Scholars of printing have been disputing this matter for decades.

Aldus and Griffo's Antiqua typefaces were undoubtedly the first to combine Roman capitals and Carolingian lower case letters to give a new type of font, which we now know as Renaissance Antiqua. But further developments in Italy soon ran into the sand. In highly-fragmented 16th-century Italy, there were more pressing problems than inventing a new typeface.

In centralised France, conditions were more favourable for making progress in letterpress and typography. New, modified versions of Griffo and Aldus' typeface soon appeared.

But this still doesn't answer the main question: what hand did the famous 16th-century French typecutter and caster Claude Garamond have in creating Antiqua and Italica in the French Renaissance style? His name is inextricably linked with the origins of this style, but, depending on your viewpoint, you can either credit his person and art in accordance with tradition or reject them with scientific scepticism.

ABCDEFGHIJKLMNOPQ
RSTUVWXYZ abcdefghij
klmnopqrstuvwxyz & 1234
ABCDEFGHIJKLMNOPQ
RSTUVWXYZ abcdefghij
klmnopqrstuvwxyz & 12345

263. Garamont. F. W. Goudy; am. Monotype, 1921.

ABCDEFGHIJKLMNOPQRSTUV
WXYZÆŒÇÊÉÈÀÌÄÖÜabcdefgh
iklmnopqrstuvwxyz çàâéèêûùîïôä
öüßfifffff & 1234567890 .,-:;?!'')†—»
ABCDEFGHIKLMNOPQRSTU
VWXYZ Æ ŒÇÊ ÄÖÜ abcdefghi
klmnopqrstuvwxyz àâàæêéèçûùôîï äö
ü ß fifff & 1234567890 .,-:;?!'(—«

264. Garamond. Engl. Monotype, 1923.

ABCDEFGHIJKLMN
OPQRSTUVWXYZ&

ABCDEFGHIJKLMNOPQRSTUVWXYZ
abcdefghijklmnopqrstuvwxyz 1234567890
ABCDEFGHIJKLMNOPQRSTUVWXYZ
abcdefghijklmnopqrstuvwxyzffffl 1234567890

261. Poliphilus – Blado Italic. Engl. Monotype. 1923–1925.

ABCDEFGHIJKLMNOPQRSTUV
WXYZÆŒÇ ÄÖÜ 1234567890 &
abcdefghijklmnopqrstuvwxyzæœç
äöü ßff fififfffl ᵃᵉᵐⁿᵗ .,-:;?!'"()
ABCDEFGHIJKLMNOPQRSTUVW
XYZ ÆŒÇ ÄÖÜ ABCDEGLMN
PRTY 1234567890 & abcdefghijklm
nopqrstuvwxyzæaçäöü ßffffffffffl aᵉ

262. Garamont. Lettergieterij Amsterdam, 1917.

93

The start of this century saw a real
Garamond revival. Any self-respecting
typefoundry felt bound to make its own
Garamond range. In this case, samples
from the Amsterdam Lettergieterij and
Monotype (UK and USA).

ABCDEFGHIL
MNOPQui QuoR
STVAAEGFM
NQ Q & ℰ ab
cdefghilmnopqrſt
uxyz Z àéé ᵉ er ff fi
ij is ll rr s ß ſi ſp ſſ ſt st
ʋ ʋ ʋ us

This, the first 'Garamond Italic' is
probably by R. Granjon, 1543, although
no conclusive proof exists.

79. Französische Renaissance-Italika. R. Granjon, 1543.

ABCDEFG
HILMNOP
Q QuRSTVY
XWÆŒabcd
efghijlmnopqr
sſtuvxyzàáæãᴄ̄
ċёèˊffffffifliíòõôœſi
ſſſtu & 🌹

Garamond by Garamond, 1544.
Widely seized on by typeface
manufacturers as the basis for their own
products.

76. Französische Renaissance-Antiqua. C. Garamond, 1544.

I regard that man as devoid of understanding who rests capable of taunting another *with his poverty or of valuing himself on having been born in affluence.*

24

N·B.

As a contribution towards the revival of old styles which characterizes the printing of our day The Lanston Monotype Corporation, Ltd., in addition to reproducing the Garamond type for the first time in Europe, has cut a series of special italic ligatured characters, swash letters & special "final" sorts which will be valuable in instances where it is desired to create a very definite antique character. A number of these forms have for generations been unobtainable from any source, whether English, Continental or American. A display will be found on the following page

Double-page spread from Lanston Monotype sampler 1926.

A rather simple legend tells that Claude Garamond used Nicholas Jenson's Antiqua as his example for his famous *caractères de l'Université*, the epitome of Renaissance Antiqua, also known as Medieval.

But it has now been established beyond any doubt that the so-called 'caractères de l'Université' were not the work of Garamond or any other 16th-century typecutter.

Most of the credit for finding out what really happened must go to English researchers, mainly Stanley Morison, who discovered the link between the individual stages in the development of block letters in the 15th and 16th century and published his findings on Antiqua in *The Type of the Hypnerotomachia Poliphili* in the Gutenberg festschrift for 1925.

By comparing the Aldine Antiqua with Jenson's Eusebius and the first Garamond typeface, Morison concludes that wherever the Garamond differs from Jenson, it is, surprisingly, identical with the Aldine Antiqua of Pietro Bembo's tract *De Aetna* of 1495.

The horizontal bar of the lower-case e, the capital M without the Jenson-style serif inserts at the head of the uprights, and finally the inward serif only in the letter G, apart from the overall highly condensed and contrasting style of the two alphabets, also feature in the first Garamond typefaces which Parisian printers already included in their publications as early as the first quarter of the 16th century.

This shows beyond doubt that it was not Jenson but the Aldine Antiqua which served as the prototype for the further development of the Renaissance type Antiqua in French typography. The Antiqua of Pietro Bembo's tract largely matches that of the first Garamond fonts, which Garamond himself very probably revised subsequently in line with Poliphilus' Aldine Antiqua. In this revised form, the French Renaissance Antiqua was continuously reproduced by its numerous students and imitators in the next two centuries.

Garamond was born in 1480, and was already over 50 years old when Robert Estienne's typeface appeared. He also learnt his craft very early on, probably from his father or family circles. Claude Garamond claimed that he could cut printed stamps in Cicero size (12 pt) at the age of fifteen, while

ATF display samples 1912.

the smaller type sizes were entrusted to his older, more experienced comrades.

Garamond's real fame, however, and his position as a royal typecaster stem from a Greek publication from 1543, the so-called *grecs du Roy*, which King François I, a supporter of letterpress, engaged him to cut. The capitals in the medium sizes of this Greek typeface include letters from Robert Estienne's Antiqua of 1532, which may serve as evidence that Garamond was behind this historically significant Antiqua.

The first Antiqua which can be confidently dated and attributed to Garamond was a large typeface (Gros-Romain) which appeared in Eusebius and other publications by Robert Estiennes in 1544 in a style which appeared earlier, for example, in the composition of the work *Ioannis Ruelli De Natura Stirpium,* published by Simon de Colines in 1536.

This typeface also appears in a number of books; after 1545, their title pages increasingly showed Garamond as the publisher, alone or in conjunction with Pierre Gaultier and Jean Barbe.

We can now be relatively certain that

Title page in Garamond, "Lettergieterij Amsterdam".

Typography can be a tool and a teacher, and a provide of a livelihood, be a means for relaxation, a hobby, an intellectual stimulant and a spiritual satisfaction. It can to you.

Bradbury Thompson

Garamond was already around 65 years old when he supplied the type for these books to other Parisian printers and even those outside Paris and beyond the borders of France.

So much for history. Nowadays, there is every kind of Garamond imaginable, some attractive, some less so, and some which share only the name. Garamonds continue to decorate many prize-winning books. They are particularly easy to read. But there are also Garamonds which convey much of its unique elegance into our time and our media, including the personal computer. Over half a dozen different Garamonds are already available in PostScript format, from Adobe, Linotype and Monotype (for example).

As an example of modern Garamonds, we could take Jan Tschichold's Sabon. Just like the original French designer, he restricts himself to a few faces, namely an italic and a semi-bold which was neither known nor needed in Garamond's day. Tschichold's opinion was that there was no point in using more faces.

A word on Garamond italics. In his highly readable book, *Die Schrift,* Muzika says that there is somewhat more uncertainty here on Garamond's authorship. There is no doubt that he or his French contemporaries were the first to use italic capitals, whereas the Italians Griffo and Aldus still used reduced upright capitals in front of cursive lowercase letters.

When discussing Garamond today, lack of evidence limits us to noting that there are many Garamonds and that, as Goudy would say, they had all the good ideas in the old days. Thanks to Claude Garamond and colleagues for their splendid typefaces.

Even the old Garamond fits well into the computer age, as in this circular set type: proof that even old types are robust enough to take this sort of thing.

Gill

Eric Gill

1928-1930

Monotype Corp. Ltd.

H. Berthold AG

OgR

ABCDEFGHIJK
LMNOPQRST
UVWXYZ
1234567890
&
abcdefghijklmn
opqrstuvwxyz
.,:;!?,,"''

normal
normal
regular

ABCDEFGHIJKLMNOPQRSTUVWXYZ

abcdefghijklmnopqrstuvwxyz

1234567890/%

(.,-:;!?)[',„""»«]—+=/$§*&

ÆŒØÇæœøçáàäâéèêëíìïîóòôöúùüû

italique
kursiv
italic

ABCDEFGHIJKLMNOPQRSTUVWXYZ

abcdefghijklmnopqrstuvwxyz

1234567890/%

(.,-:;!?)[',„""»«]—+=/$§*&

ÆŒØÇæœøçáàäâéèêëíìïîóòôöúùüû

demi-gras
halbfett
medium

ABCDEFGHIJKLMNOPQRSTUVWXYZ

abcdefghijklmnopqrstuvwxyz

1234567890/%

(.,-:;!?)[',„""»«]—+=/$§*&

ÆŒØÇæœøçáàäâéèêëíìïîóòôöúùüû

italique
demi-gras
kursiv halbfett
medium italic

ABCDEFGHIJKLMNOPQRSTUVWXYZ

abcdefghijklmnopqrstuvwxyz

1234567890/%

(.,-:;!?)[',„""»«]—+=/$§*&

ÆŒØÇæœøçáàäâéèêëíìïîóòôöúùüû

gras
fett
bold

ABCDEFGHIJKLMNOPQRSTUVWXYZ

abcdefghijklmnopqrstuvwxyz

1234567890/%

(.,-:;!?)[',„""»«]—+=/$§*&

ÆŒØÇæœøçáàäâéèêëíìïîóòôöúùüû

Gill: Sans or with

> 99
> *Machines can do virtually anything, but the question is, not what they can do, but what they ought to do.*
> 99

Eric Gill

In 1916, Gill was exempted from military service because he was working on sculptures for the stations of the cross at Westminster Cathedral. Then he was asked to design a simple, geometric typeface to be used for all signage and directions on the London Underground. The job subsequently passed to Gill's old teacher, Edward Johnston, but Johnston's design served as the inspiration and later as the model for the typeface named after its designer: Gill Sans.

He retained the classical proportions, even emphasising them to some extent, such as in the double-deck g. In place of the R, he used his preferred character with its elegant downsweeping tail. Although Johnston was originally intended only for station names and signs, Gill Sans was intended as a text face from the start. This makes the differences more understandable.

Gill had already been experimenting with sans serif lettering for quite a while, mostly on shop signs. In October 1926, a Bristol book dealer, Douglas Cleverdon, asked him to paint a sign in that style. A few weeks later, Stanley Morison, artistic adviser to the Monotype Corporation, was visiting Cleverdon and noticed the sign. He was convinced that Gill could design such a sans serif face for Monotype too, which foreign type foundries could then market successfully.

A capital start

Up to then, Gill had only used capitals, and he knew that it would be much harder getting the details of the lower-case letters right. Using Johnston as his model made things much easier. As usual, the first drawings were quite different from the face that was finally cast, with Monotype's staff being behind many of the improvements.

When the first drawings for the capitals arrived in July 1927, Pierpont, the works manager, wrote, "There is much I would argue with in this design and little I would recommend." He seemed to object particularly to the marked descenders in the J and Q, but was instructed to solve this problem.

Morison, who was of course only an adviser to Monotype, left the development to Gill himself, who became increasingly enthusiastic about the production process, becoming an adviser himself in 1928. He even made corrections and drawings to some of the deleted versions of the family, such as Kayo, which he nicknamed 'Gill Sans Double Elephant'.

The end justifies the means

Although - or perhaps because - he had a very professional attitude, Gill often came

JOHNSTON

Edward Johnston's London Transport alphabet (1916) and Monotype Gill Sans (1929)

Gill medium by Johan Enschede & Zonen, 1968.

up with the most outlandish arguments to speed things up. For example, he convinced himself that, if customers wanted typefaces for such ghastly purposes as advertising, then they should have ghastly typefaces to go with them.

Eric Gill had his own distinct views on a lot of social issues in general, and these views were seldom in accordance with prevailing opinion. He was absolutely convinced, for instance, that the production process would alter his designs completely: in his own words, "the people on the process camera and the pantograph, the matrix engravers, the punch cutters and all the other machine operators had no ideas of their own and were totally dependent on their superiors." His response to this state of affairs was to simplify his designs as far as possible. Only this, he believed, would allow industrial production to achieve respectable results.

The *enfant terrible* of typography

Gill's private life was not exactly 'industry standard' either. His affairs with women were a constant topic of conversation amongst his colleagues. A recently published biography by Fiona MacCarthy devoted a number of pages to this subject, and aroused fierce discussion amongst those who would rather see men like Eric Gill on a pedestal as heroes of typography than as ordinary

mortals with all their vices and short-comings. Gill's view of his working situation was as follows: "We have opted for physics, not metaphysics".

His remarks on the division of labour between artist and craftsman or industry and crafts sound just as relevant today as they did 60 years ago. In predicting that imitation handcrafts would soon be on sale in London shops, that cows would soon be milked by machinery, even on the smallest farm, and that cottage larders would soon be stocked with canned food, Gill showed himself a keen-eyed prophet of the kind of a progress which would ultimately leave no room for people of his calibre. His views can be read in his *Essay on Typography,* a thin volume which first appeared in 1931 and has recently been reissued in reprint form. As well as being worth reading for his views, it deserves mention because it marks the debut of Joanna, the typeface named after Gill's daughter which was initially cast solely in 12-point specially for this book.

Ahead of his time

Seen in this context, it also becomes clear why, when it first appeared towards the end of the 1920s, Gill sans was not exactly what the British print establishment had been looking for. Its reception was similar to that which German typesetters and printers had

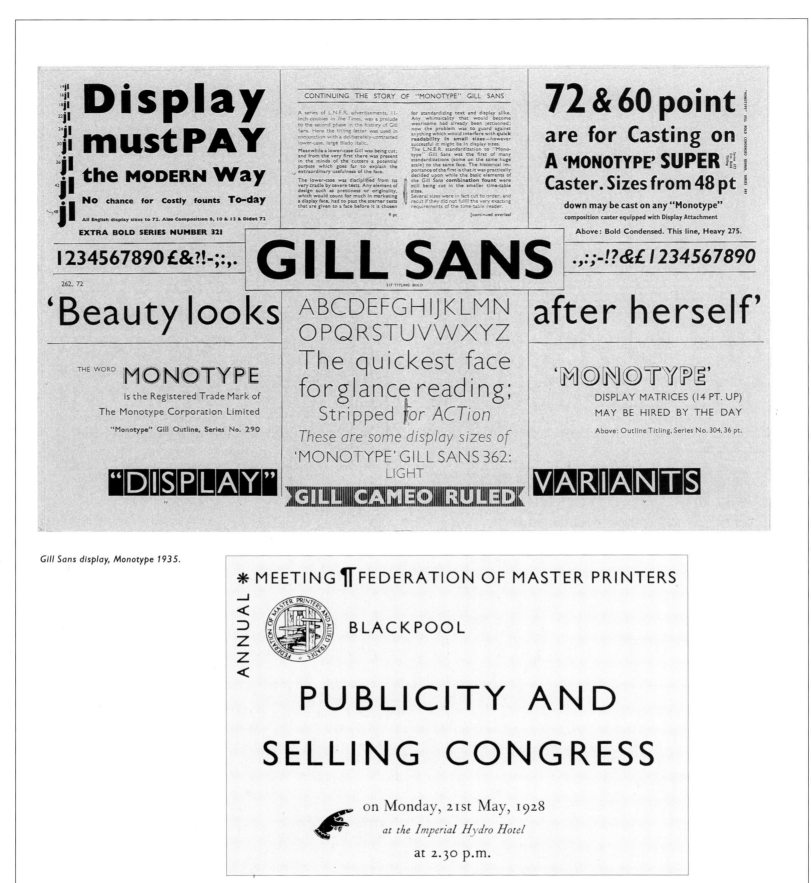

Gill Sans display, Monotype 1935.

*First appearance: Invitation, 1929,
designed by Stanley Morison (who
designed Times), set in Gill Sans. Its
simplicity took the British printing
industry conference by storm.*

given Futura the year before. The comments in the yearbooks on Paul Renner's design spoke of a fashion which would soon be forgotten.

The first version of Gill Sans, Series 231 Titling, was finished in time for the annual congress of the British Printing Federation in May 1928, where Stanley Morison gave an address and had the invitations set in the new face. The gathered luminaries were in uproar, although this did not prevent the appearance of the roman version (upper and lower case) as Series 262 in 1930. From then on, Gill Sans was a winner.

Sans serif, but not sans feeling

Gill Sans pure and simple, but not mechanical or artificial. As its name implies, it is a sans serif roman. Eric Gill was by no means responsible for the whole family, and even rejected some of them in horror.

In the 60 years since it first appeared, Gill has become a classic, pleasing both traditionalists and trendsetters. Its clear but not boring style is robust enough for any use, but at the same time so subtle that it always appears astonishingly fresh.
The only other designs by Eric Gill to establish themselves were Perpetua and Joanna, although they were not nearly as successful as Gill Sans.

From sculptor to typographer

Arthur Eric Rowton Gill was born in
Brighton in 1882. He began training as an
architect in 1900. Three years after he got
married (1904), he joined an arts and crafts
group in Ditchling, Sussex, where he initially
worked as a graphic designer and illustrator.
He later worked as a sculptor. Gill did not
publish his first typeface design, Perpetua,
until 1925, a year after leaving Ditchling and
moving to mid-Wales. In 1928, he moved to
High Wycombe, where he continued to
work as a sculptor and mason. In the
meantime, he founded his own hand press,
which he ran with his son-in-law René
Hague. Most of his typographical work was
done in conjunction with the Monotype
Corporation. He published a number of
books on industrial design and crafts.
Eric Gill died on 17th November 1940.

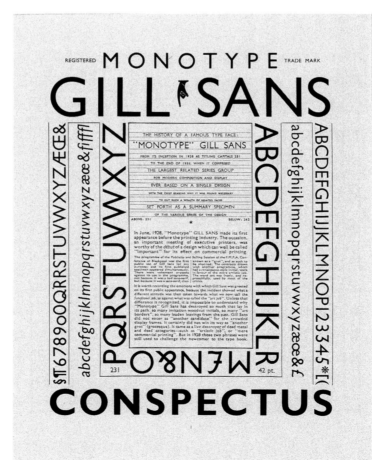

Golden Type

William Morris 1890 International Typeface Corporation 1990

ABCDEFGHIJK
LMNOPQRST
UVWXYZ
1234567890
&
abcdefghijklmn
opqrstuvwxyz
ˊˎ.,:;!?„""''‒
1234567890

ABCDEFGHIJKLMNOPQRSTUVWXYZ

abcdefghijklmnopqrstuvwxyz

1234567890/%

(.,-:;!?) ['',„""»«] −+=/$£*&

ÆŒØÇæœøçáàäâíìïîóòöôúùüû

ABCDEFGHIJKLMNOPQRSTUVWXYZ

abcdefghijklmnopqrstuvwxyz

1234567890/%

(.,-:;!?) ['',„""»«] −+=/$£*&

ÆŒØÇæœøçáàäâíìïîóòöôúùüû

ABCDEFGHIJKLMNOPQRSTUVWXYZ

abcdefghijklmnopqrstuvwxyz

1234567890/%

(.,-:;!?) ['',„""»«] −+=/$£*&

ÆŒØÇæœøçáàäâíìïîóòöôúùüû

Golden Type or, the dream of the perfect book

William Morris

"If I can," said William Morris, and Utopia became a reality. During an extraordinary active and versatile life, William Morris (1834-1896) realised some of his dreams and sowed many seeds which only yielded fruit later. His ideas and theories on such things as applied art and book design now seem contemporary once more.

Morris started by studying theology, and from there progressed to architecture, painting and poetry. He was especially fond of calligraphy, which he also illuminated and gilded. In 1889, he founded the Kelmscott Press, which revolutionised the book industry in England, Germany and the USA, and led in the long term to higher standards in the printing industry. It also introduced the art of bibliophilism - book printing for a small circle of connoisseurs who could afford expensive, superbly designed, limited edition books. This was not exactly 'art for the people', unfortunately. That only came later, via Germany and the Werkbund, when designers got together with industry and good industrial design emerged: consumer goods with style at reasonable prices.

Book architecture

The decline in print and book culture in the second half of the 19th century had its roots in the invention of fast-operating presses and mass production. The image of the printing industry was characterised on the one hand by poor imitations of Bodoni styles, and on the other by loud new advertising styles. Derived from classical styles, these Egyptienne styles when used in Akzidenz printing often produced the most peculiar results. By the time Morris turned his attention to book printing, the 'vulgar' styles he hated were already in decline.

Morris was no lover of the Greek mathematical spirit. He abhorred its regularity and artificiality, its extreme bold/light contrast, because they made reading difficult.

The Kelmscott Press was founded on an impulse in 1888, shortly after a lecture by Emery Walker (1851-1933) on medieval printers. Walker was a typecutter, caster, printer and expert on typographical history. Morris wanted him as a colleague, but warned, "But mind, I shall want to do everything my own way." Although Walker refused, he became Morris's tireless adviser and handled the fitting-out of his studios. The two men became close friends. Walker had a large hand in the typestyles, the typography and printing of the famous

Lecture III. Some Hints on Pattern-Designing.

I do not know a better way of getting at these reasons than for each of us to suppose himself to be in the room in which he will have to pass a good part of his life, the said room being quite bare of ornament, & to be there that he may consider what he can do to make the bare walls pleasant & helpful to him; I say the walls, because, after all, the widest use of pattern-designing is the clothing of the walls of a room, hall, church, or what building you will. Doubtless there will be some, in these days at least, who will say, "'Tis most helpful to me to let the bare walls alone." So also there would be some who, when asked with what manner of books they will furnish their room, would answer, "With none." But I think you will agree with me in thinking that both these sets of people would be in an unhealthy state of mind, and probably of body also; in which case we need not trouble ourselves about their whims, since it is with healthy & sane people only that art has dealings.

Again, a healthy & sane person being asked with what kind of art he would clothe his walls, might well answer, "With the best art," and so end the question. Yet, out on it! so complex is human life, that even this seemingly most reasonable answer may turn out to be little better than an evasion. For I suppose the best art to be the pictured representation of men's imaginings; what they have thought has happened to the world before their time, or what they deem they have seen with the

2

eyes of the body or the soul: and the imaginings thus represented are always beautiful indeed, but oftenest stirring to men's passions & aspirations, and not seldom sorrowful or even terrible. Stories that tell of men's aspirations for more than material life can give them, their struggles for the future welfare of their race, their unselfish love, their unrequited service: things like this are the subjects for the best art; in such subjects there is hope surely, yet the aspect of them is likely to be sorrowful enough: defeat the seed of victory, and death, the seed of life, will be shown on the face of most of them.

Take note, too, that in the best art all these solemn and awful things are expressed clearly and without any vagueness, with such life and power that they impress the beholder so deeply that he is brought face to face with the very scenes, & lives among them for a time; so raising his life above the daily tangle of small things that wearies him, to the level of the heroism which they represent. This is the best art; and who can deny that it is good for us all that it should be at hand to stir our emotions: yet its very greatness makes it a thing to be handled carefully, for we cannot always be having our emotions deeply stirred: that wearies us body and soul; and man, an animal that longs for rest like other animals, defends himself against the weariness by hardening his heart, & refusing to be moved every hour of the day by tragic emo-

3

Lecture III. Some Hints on Pattern-Designing.

Two pages from William Morris' "Some Hints on Pattern Designing", Longman & Co. London 1899. Meermanno-Westreenianum museum, The Hague, Holland

Kelmscott products. Walker was more at home in the crafts than in the arts, and after Morris's death put his ideas into practice by creating Doves Type and concentrating solely on typography.

To Morris, a book was like a work of architecture: his designs were always based on the double-page spread. He said one could even do without decorations completely and produce a perfectly good book, provided the double page was well-proportioned and balanced, like an architectural plan. Such a page layout could even make up for a poor typeface. By 'architectural', he meant that the page must be clear and easy to read, which could be achieved by using the right typeface. It did not matter whether the margins were wide or narrow: the main thing was that the page and print areas were properly proportioned relative to one another.

Morris was always for the genuine and against imitation. As a true artist, the principle he followed was 'fitness for use', or, in more modern terms, 'form follows function'. Ornamentation is not used as random decoration, but is related to its task and must form an organic part of the typographical whole. Morris also saw ornamentation as man striving for beauty, for man does not live by bread alone.

With Morris, there is often a gap between theory and practice. He set his type densely, without line spacing, giving a solid black type body. Then there were his Pre-Raphaelite ornaments, bordering and overflowing the text, giving an ornamental, splendid print image. The typeface loses its legibility, even though Morris said that 'the book is governed by its contents'. Morris's romantic, Gothic view of art gained the upper hand, pushing the actual purpose of the book into second place.

After disappointing attempts with existing Neo-Renaissance types, Morris looked for a typeface of his own for the Kelmscott Press. He searched for 'pure form, strict and free of unnecessary outgrowths, solid, steady lines', which he considered the basic faults of classical types. Nor should type be cut or set closely, as the type styles of the time were for reasons of economy.

Walker drew Morris's attention to Nicolas Jenson's printed works from the years 1470-76, and produced photographic enlargements five times the original size to help Morris study them. Starting with these models, Morris and Walker then created new models for punch cutting. This was done by the English punch cutter Edward Philip Prince (1846-1923) in 14-point. By the end of 1890, Golden Type was finished. It took its name from the Kelmscott book it was designed for: 'The Golden Legend', an English translation by

William Caxton of the 'Legenda Aurea' by Jacobus de Voragine.

In Golden Type, Morris attempted to fill print tradition with a new artistic spirit. This was not very successful. His second style, the broken Troy Type, on the other hand, shows superb artistry and craftsmanship in a single mould. Here he was really in his element.

Looking at Golden Type in detail, we find to our astonishment that, in style and expression, it is very close to Jenson. Even the diamond-shaped full stop is there. This minor detail is clearly visible in Doves Type and most other hand press styles of the time. There are many other artistic peculiarities, such as the mixing of different serif styles. In the lower-case ascenders, they are very slanting and jut out to the right, and are combined with ungrooved, straight-set foot serifs. The M and N stand out. The serifs are continuous and straight-set. The left slanting stroke runs upward separately next to the left-hand base stroke into the serifs. The stroke width is very heavy, with very little difference in thickness. Some of these details are present in embryo in Jenson's original works, but modified, so that they are really more Egyptienne-like. Whether the M and N are the work of Morris or of Emery Walker (after all, he was the expert on typography) is difficult to say. It is true that Morris wanted to give expression to his artistic will, but these details are also present in Walker's Doves Type. The Jenson Antiqua has come down to us in a number of versions: Morris decided on a blacker type. For this reason, Golden Type lacks grace, and looks more cumbersome than the original Jenson.

At first sight, Golden Type looks Jenson-like but, especially in typography, it displays a Gothic ornamentalism. For this reason, Kelmscott Press productions are not representative of the style of the period, but must be seen simply as the outstanding achievement of an individual artist. It is this bibliophylic 'gesamtkunstwerk' which gives Golden Type its meaning and effects on other type designers. Kelmscott rose and fell with Morris: once his will was published in 1898, the press closed its doors.

Golden Type's influence

Kelsmcott Press and its exclusive styles inspired others to start hand presses. Particular mention should be made of Doves Press, founded by T.J. Cobden-Sanderson (1840-1922) and Emery Walker in 1899. It used just one face: Doves Type, designed by Emery Walker, a continuation of Golden Type or an adaptation of the Jenson Antiqua. Light, full of movement, it is evocative of the period around the turn of the century. Along with Doves Type, Walker used a functional, minimalist typography. The only ornamentation allowed was the calligraphic

initials and capitals by Edward Johnson and Graily Hewitt. All the time that Doves Press was in business (until 1917), Cobden-Sanderson refused to use any ornamentation, fulfilling Morris's ideas on architectural book design. Doves Press was the model for a flourishing book culture.

When private presses spread to Germany, Morris's ideals prevailed, mainly through Walker's offices. The printer and publisher Carl Ernst Poeschel travelled to see him and took the English approach to typography back home with him. He published these rules as 'Rhytmische Typographie', and put them into practice at Insel Verlag and his own Janus Presse. Emery Walker, Edward Johnston, Graily Hewitt and Eric Gill designed his Archduke Wilhelm Ernst edition of the German classics.

In 1900, Fritz Hellmuth Ehmcke opened his Steglitz studios in Berlin, followed by the Rupprecht Press in Berlin. Both were aimed at the artistic and typographical purity of Morris and Walker.

Rudolf Koch was perhaps one of the closest to Morris. His styles too are philosophical and Gothic and opposed to mechanisation. In 1921, he founded the Offenbach studios along Morris's lines, covering all craft areas.

In the USA, both the Kelmscott Press and Golden Type were very influential. At first, Americans were keen to take up Morris's ideas and the English hand press movement, although often as a hobby, but they overdid the eccentricity and weakness of form. Frederic W. Goudy, America's most creative type designer, used Golden Type as the model for an advertising style in 1903 which, although it never appeared itself, became the first type for Goudy's own press, Village Type. Although modelled on Golden Type, it is a lively, individual style, with more in common with Papst, Goudy's previous advertising style. Goudy's Antiqua styles filled a vacuum. They were immediately accepted, and quickly raised typographical and printing standards in books, newspapers and advertising.

The American book designer Bruce Rogers, (1870-1957) the 'typographic playboy of the Western world', was at once both like and unlike Morris. His first design was Montaigne, for Riverside Press, a neo-Jenson Antiqua. He was not satisfied with this, however, and, inspired by the help and knowledge of his friend Walker, he produced a refined version, Centaur, in 1914. Morris's influence is now barely discernible.

One of the earliest Golden Type models was Jenson, which ATF brought out in 1893. In 1913, there followed Closter Old Style, with

I BEGAN PRINTING BOOKS WITH THE HOPE OF PRODUCING SOME WHICH HAVE A DEFINITE CLAIM TO BEAUTY. At the same time they should be easy to read and should not dazzle the eye, or trouble the intellect of the reader by eccentricity of form of the letters.

WILLIAM MORRIS, 1889

WE SHALL UNDERSTAND MORRIS BEST IF WE THINK OF HIM AS A CRAFTSMAN

AS ONE WHO COULD NEVER SEE RAW MATERIAL WITHOUT WISHING TO MAKE SOMETHING OF IT, AND WHO AT LAST SAW SOCIETY ITSELF AS A VERY RAW MATERIAL WHICH SET HIS FINGERS ITCHING.

WILLIAM MORRIS: HIS WORK AND INFLUENCE
A. CLUTTON-BROCK, 1914

ITC Golden Type from
"ITC Masterworks".

Morris Fuller Benton's drawings staying close to the original Jenson. For mechanical typesetting, Closter Old Style was the embodiment of the Neo-Renaissance, and spread by being copied or imitated by other presses. European mechanical typesetting also showed many Renaissance styles.

Morris's artistic and craftsman like striving for overall quality took book production to a high level and led to a considerable jump in the standards of industrial book and typeface design. Since then, Golden Type and, above all, its successive Renaissance styles have established a functional, aesthetic form. So it was not the 'Gothic' Morris, but the artists of his time who instinctively opted for Antiqua who had the lasting effect.

Letters should be designed by artists, not by engineers

Morris's statement cannot be repeated often enough. Nearly 100 years later, nothing much has changed. The relative accessibility of electronic technology has led to another drop in print and typography standards. The wealth of forms which the computer can produce in a short time are very seductive. Belt and braces are no substitute for ideas. Nowadays, people put more trust in the computer than in the human hand or eye. Once the computer has churned something out, they accept it unquestioningly as the last word. The computer

reduces the creative act of mind, hand and eye to 'variations'.

In November 1989, ITC brought out Golden Type - now largely an anachronism - in medium, bold and extra bold. But not italics, which neither Jenson nor Morris had used. Nonetheless, they deserve praise for rescuing the typographical and cultural significance of Golden Type for the digital age, although this is somewhat uncertain, given that technology goes out of date rapidly and soon no-one will know how to use it. If electronic data goes missing, people will be forced to resort to the original paper.

We owe Golden Type's reappearance to three young type designers, Sigrid Engelmann, Helga Jörgensen and Andrew Newton. At first, they found it curious (because of the dot on the i) and pretty in a nostalgic sort of way. But they soon discovered Morris's principles of craftsmanship, and thought them important and valid. As all three of them worked at URW in Hamburg using the ITC typeface range, they got together and decided to digitalise Golden Type in their spare time. They had access to the technology, but before they started work they astonished the William Morris Society by asking it for permission.

Then they reconstructed a bold drawing from an enlarged print and digitalised it. Thus armed, they spent a week in Cambridge University

Testseite Golden Type Original, Bold und Black
12 Punkt

In the area of typeface production, CAD digitizing systems are
just becoming more and more important. All computer controlled
typesetters, modern copiers, matrix printers and video texts
require typefaces in digital form. Numerically controlled
output devices such as foil-cutting machines, milling

In the area of typeface production, CAD digitizing systems are
just becoming more and more important. All computer controlled
typesetters, modern copiers, matrix printers and video texts
require typefaces in digital form. Numerically controlled
output devices such as foil-cutting machines, milling

**In the area of typeface production, CAD digitizing systems are
just becoming more and more important. All computer controlled
typesetters, modern copiers, matrix printers and video texts
require typefaces in digital form. Numerically controlled
output devices such as foil-cutting machines, milling**

112

Testpage of Golden Type made with
Ikarus M by URW.

library, comparing their work with Morris's original dies, prints and drawings. The drawings by the three graphic designers were on tracing paper: imposing this on the lead letters enabled them to make minor corrections to proportions and details. They found that the original Kelmscott prints were not as black as those of Cambridge University Press from 1930 to 1953, which sometimes used Golden Type. This led them to add a light face which ITC marketed as 'Original'. Back in Hamburg, they redrew and redigitalised once more, extending Morris's 83 individual forms to around 289 drawings for each font, and added two fonts with small capitals. At the request of ITC, they also designed an extra bold face for highlights. ITC's Golden Type is a very faithful reproduction which even includes its eccentric features and uses three fonts to allow for the varying degrees of printing black. In contrast to book printing, it now had an even style and spacing, something Morris would only have shaken his head at. This digital smoothness is neither Morris, Jenson nor new. But if it reminds people of Morris's social beliefs and intentions, his artistry and significance, and makes people think, it will not have been in vain.

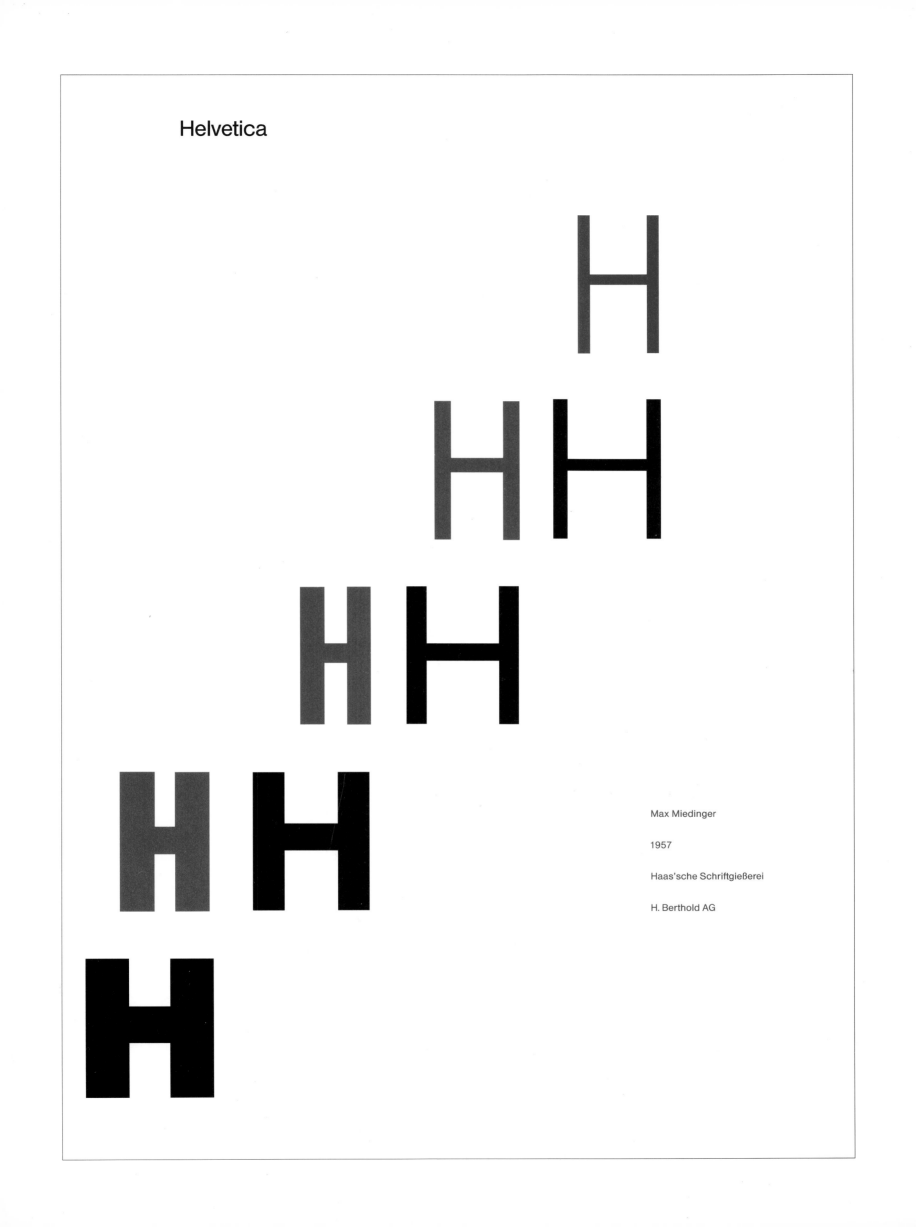

Helvetica

Max Miedinger

1957

Haas'sche Schriftgießerei

H. Berthold AG

ABCDEFGHIJK
LMNOPQRST
UVWXYZ
1234567890
&
abcdefghijklmn
opqrstuvwxyz
−.,:;!?„"''—

normal normal regular	ABCDEFGHIJKLMNOPQRSTUVWXYZ abcdefghijklmnopqrstuvwxyz 1234567890/% (.,-:;!?)[''„""»«]—+=/$§*& ÆŒØÇæœøçáàäâéèëêíìïîóòöôúùüû
italique kursiv italic	ABCDEFGHIJKLMNOPQRSTUVWXYZ abcdefghijklmnopqrstuvwxyz 1234567890/% (.,-:;!?)[''„""»«]—+=/$§*& ÆŒØÇæœøçáàäâéèëêíìïîóòöôúùüû
demi-gras halbfett medium	**ABCDEFGHIJKLMNOPQRSTUVWXYZ** **abcdefghijklmnopqrstuvwxyz** **1234567890/%** **(.,-:;!?)[''„""»«]—+=/$§*&** **ÆŒØÇæœøçáàäâéèëêíìïîóòöôúùüû**
italique demi-gras kursiv halbfett medium italic	**ABCDEFGHIJKLMNOPQRSTUVWXYZ** **abcdefghijklmnopqrstuvwxyz** **1234567890/%** **(.,-:;!?)[''„""»«]—+=/$§*&** **ÆŒØÇæœøçáàäâéèëêíìïîóòöôúùüû**
gras fett bold	**ABCDEFGHIJKLMNOPQRSTUVWXYZ** **abcdefghijklmnopqrstuvwxyz** **1234567890/%** **(.,-:;!?)[''„""»«]—+=/$§*&** **ÆŒØÇæœøçáàäâéèëêíìïîóòöôúùüû**
italique gras kursiv fett bold italic	**ABCDEFGHIJKLMNOPQRSTUVWXYZ** **abcdefghijklmnopqrstuvwxyz** **1234567890/%** **(.,-:;!?)[''„""»«]—+=/$§*&** **ÆŒØÇæœøçáàäâéèëêíìïîóòöôúùüû**

The faceless typeface

aáàâäåãbcçdeéèêëfgğh
ííeìeîeïejijklmnñoóòôöõøp
qrsşțuúùûüvwxyzæœß
ABCDEFGHIJKLMNOØP
QRSŞTUVWXYZÆŒ&«‹›»
1234567890$£†§.,:;!?'-()*

Original version of Helvetica designed in 1957 by Max A. Miedinger by order of and in collaboration with Haas Typefoundry.

Anyone with a basic knowledge of the subject might end up thinking that Helvetica is less a typeface than a natural phenomenon. In Germany at least, Helvetica is more common than clean air: no other commandment is followed by the German industry as strictly as the unwritten one:

**I am Helvetica
Thy typeface
Thou shalt have no other typeface before me.**

How could a typeface which is actually quite mundane, and which has even been called 'faceless', be so successful? In the final analysis, Helvetica has all the aesthetic qualities of a suburban terrace house: respectable, inconspicuous - part of the environment, in fact. So how did this 'faceless typeface' come about?

It all began in Switzerland

As early as 1949, Eduard Hoffmann, head of the Haas type foundry in München-stein near Basle, was planning a new Grotesque. His model was Schelter Grotesque, virtually the official Bauhaus typeface. Since Haas was still marketing Normal Grotesk (normal Grotesque) at the time, it was initially decided not to proceed with the expensive, tedious

project of bringing out a new one. But, a few years later, when even Swiss designers had started making increasing use of Berthold's Akzidenz Grotesk (which then re-entered Germany as 'Swiss Typography'), and another competitor had appeared in the shape of Folio, Hoffmann took up the idea once again.

He knew exactly what the new typeface should look like, and entrusted the design work to the Zurich graphics designer Max Miedinger († 1980), who at that time was dealing with customers as Haas' typeface agent. Miedinger was an expert on Grotesque typefaces, and knew what his customers wanted. His sketches on graph paper were discussed, assessed and corrected with Hoffmann and then passed to the in-house punchcutting works for casting in lead.

Grotesque but new

The project went by the name of 'Neue Haas Grotesk'. It made its first appearance in 1957, when the bold face appeared at the international print fair 'graphic 57' in Lausanne. The light (now 'medium') face appeared in 1958, and the extra bold in 1959. The Swiss handsetting typeface market was not all that large,

ABCDEFGHIJKLMNOPQRS
TUVWXYZ
abcdefghijklmnopqrstuvwxyzß
1234567890
.,:;-!?„"()[]«‹›»/*'—†§£$&+

ABCDEFGHIJKLMNOPQRS
TUVWXYZ
abcdefghijklmnopqrstuvwxyzß
1234567890
.,:;-!?„"()[]«»/ *'−†§£$&+

Comparative settings of the original Helvetica (above) and Haas Unica.

and Stempel AG held over half the shares in Haas, and was itself a subsidiary of Linotype AG. Its aim therefore was to market Neue Haas Grotesk in Germany as well, but mainly to bring it out as a face for machine-composition and open up a much larger market than was available for hand-setting alone. In a survey of type customers, Haas had found considerable demand for the mechanical typesetting version, although no-one at Linotype was initially all that convinced, especially since their range already included 'Neuzeit Grotesk', which seemed to cover the same market.

A household name is born

At Stempel, which was to some extent Linotype's hand-setting subsidiary, there were some who knew that Max Miedinger's design had struck a chord. Heinz Eul, later sales director, wrote a letter to the directors suggesting the name 'Helvetia' rather than the cumbersome Neue Haas Grotesk. Eduard Hoffmann was not convinced, especially since there was a famous sewing-machine works in Switzerland already marketing its products under that name. 'Helvetische Grotesk' would probably sound too much like an insurance company. In the end, Hoffmann came up with 'Helvetica' - just

one letter more than the original idea and, as we now know, an ideal name for a product intended for the international market.

So that was the name under which the new typeface appeared in 1960. In response to increasing demand, Stempel had already produced duplicates of the Haas matrices and cast its own version of 'Neue Haas Grotesk' for the German market.

When Linotype decided to adopt the new face for mechanical typesetting in 1960, it had to rework the whole thing from scratch. The most noticeable feature of Neue Haas Grotesk was its narrow spacing. Before then, no manufacturer had ever dared question the golden rule of typesetting, which said that the distance between two letters must be the same as the internal space of the lower-case m. By itself, this subtly narrower spacing made a text in Helvetica stand out clearly from any other typeface, although its compact overall appearance led to problems in matrix production.

The limits of the possible

In Helvetica, the matrix sidewalls are pared to the minimum, although, when typecast, it still looks considerably wider

Neue Haas Grotesk

Helvetica

Helvetische Grotesk

Helvetica

*Helvetica Compact capitals (on
smaller base) and Plakat bold, bold
condensed and compact (in wood
and resin). D. Stempel sample ca.
1962.*

Helvetica
Compact Versalien
auf kleinerem Kegel

Sonderguß für den Satz
dicht übereinanderstehender
Zeilen

Helvetica Plakat halbfett in Holz von 5 bis 48 Cic.,
in Kunstharz von 5 bis 20 Cic., in Hartaluminium von 6 bis 16 Cic.
Helvetica Plakat schmalhalbfett in Holz von 6 bis 48 Cic.,
in Hartaluminium von 6 bis 16 Cic.
Helvetica Plakat Compact in Holz von 6 bis 40 Cic.,
in Hartaluminium von 6 bis 16 Cic.

Helvetica Plakat halbfett
Helvetica Plakat schmalhalbfett
Helvetica Plakat Compact

than the original lead castings. In the so-called duplex magazine, two typefaces - roman and bold, for instance, or roman and italic - must have fully matching widths.

No wonder, then, that within a few years there were so many Helvetica faces around: unlike 'Univers', which came out at around the same time, Helvetica was never planned as a full range of mechanical and hand-setting faces. The Haas version was joined by the Stempel copy, then the linecast faces and then the matching hand-setting faces.

After the first three weights came Helvetica Light, designed by Erich Schulz-Anker, at that time artistic director at Stempel AG, in conjunction with Arthur Ritzel, who later went on to design 'Rotation', the newspaper face. The extended faces, which were virtually *de rigueur* in the early sixties for jobbing work and stationery, came from this team. Haas' business-card faces, which appeared as late as in the seventies, (extra extended, light and semi-bold) are now back in vogue - in hot-metal!

Helvetica was just what designers in the early seventies were looking for: a faceless typeface, bland, as neutral as Switzerland itself and about as exciting.

Design was supposed to be timeless: the typeface was supposed to be completely subordinate to the text and not liable to affect its interpretation in any way. Compared with Helvetica, Akzidenz Grotesk had too many laughter lines, the new Folio was too ornate, and Univers, which had also just appeared, was almost suspiciously elegant and, in any case, not widely available in Germany.

Heinz Eul visited all the major companies and succeeded in selling their advertising managers and designers Helvetica as their house style. First was Lufthansa under Otl Aicher, then BASF, which kept some 300 printing works and a number of designers and agencies in work. The creative world knew a band-waggon when it saw one, and agencies were soon insisting that their layout studios stock up with Helvetica.

When photosetting came in at the end of the sixties, there was no turning back - anyone who made typefaces or type-setting systems had to offer Helvetica. If not under licence from Linotype, they just copied it and brought it out under another name. If Claro, Geneva, Holsatia, Swiss, Triumvirate and the rest weren't quite the genuine article, this didn't seem to bother some people. After all, in buying Helvetica, most of them were

**Lufthansa
Bayer Hoechst
BASF MAN AEG
Opel BMW
Bundesbahn
Bundespost**

120

opting less for a typeface than for an easy life.

'Helvetivers'?

Faced with a plethora of imitations and their now unwieldy own range of versions, some imperfections of form and the arrival of the new digital typesetting systems, Stempel was forced to redesign the whole range. It then launched this as Neue Helvetica in 1982, using numbers to designate the different members of this highly extended family according to in the method initiated by Adrian Frutiger for Univers. Haas itself had the Basle "Team 77" analyse advantages and disadvantages of both Univers and Helvetica and then design a new typeface - Haas Unica.

No experiments

For designers and typesetters who are not bothered about the history of typography (especially in DTP), Helvetica is the ideal 'fast food' - low in calories, scarcely any nutritional value, but widely available and cheap. On the other hand, the wide range of styles can still offer a new source of expression for those without years of experience with type-faces who don't want to plough through thousands of faces to find what they're

looking for, but prefer to overlook personal preferences and the whims of fashion and stick to something which is rarely quite right but never wrong.

News Gothic

M.F. Benton

John L. Renshaw

1958

American Typefounders

H. Berthold AG

ABCDEFGHIJK
LMNOPQRST
UVWXYZ
1234567890
&
abcdefghijklmn
opqrstuvwxyz
_ .,:;!?„""''—

normal
normal
regular

ABCDEFGHIJKLMNOPQRSTUVWXYZ

abcdefghijklmnopqrstuvwxyz

1234567890/%

(.,-:;!?)[',""»«]—+=/$§*&

ÆŒØÇæœøçáàäâéèëêíìïîóòöôúùüû

italique
kursiv
italic

ABCDEFGHIJKLMNOPQRSTUVWXYZ

abcdefghijklmnopqrstuvwxyz

1234567890/%

(.,-:;!?)[',""»«]—+=/$§&*

ÆŒØÇæœøçáàäâéèëêíìïîóòöôúùüû

demi-gras
halbfett
medium

ABCDEFGHIJKLMNOPQRSTUVWXYZ

abcdefghijklmnopqrstuvwxyz

1234567890/%

(.,-:;!?)[',""»«]—+=/$§*&

ÆŒØÇæœøçáàäâéèëêíìïîóòöôúùüû

italique
demi-gras
kursiv halbfett
medium italic

ABCDEFGHIJKLMNOPQRSTUVWXYZ

abcdefghijklmnopqrstuvwxyz

1234567890/%

(.,-:;!?)[',""»«]—+=/$§*&

ÆŒØÇæœøçáàäâéèëêíìïîóòöôúùüû

How did Grotesque come about?

news **gothic**

for fresh typography

Page 125: Between Bodoni and Grotesque: decline of Latin written culture in the 19th century. Toscaninienne, the bastard son of Egyptienne and Grotesque. The first Grotesque styles were also raw material for messing about.

Bodoni/Didot/Walbaum period, the dawn of the machine age in the 19th century unleashed a flood of experimentation. In typefaces, serifs were seen as one way of creating new designs, from the hairline serifs of the bold classical Antiqua via the heavy, rectangular ones of Egyptienne and the high square cut of Italienne to the split serifs of Toscanienne. The twilight of the print culture had started. That seemed to exhaust the possibilities.

That left just one alternative: leaving them out altogether. And so it came to pass: and that was the escape from complete decay. This brought two thousand years of development full circle, for sans-serif capitals had been known from Roman inscriptions and even earlier, from Greek monumental lettering. Anyone who thinks that sans serifs are a product of our times should remember their history. As they say, it's all been done before.

The first of these sans serif styles appeared in 1816, as a single series of capitals at William Caslon's type foundry. The lower-case letters were not added until 1834, in William Thorogood's Grotesque.

Since the mid-19th century, Grotesque families have now been created in whole families of varying degrees of boldness based on the same drawings.

While all the other styles of that period just look curious now or - as with Egyptienne - scarcely usable, Grotesque has undergone a process of constant renewal and rejuvenation right up to the present. The milestones in its European history were

– Berthold's Jobbing Grotesque around 1900
– Monotype's Gill sans and Bauer's Futura in the 20s
– Helvetica and Univers - as extended families - in the 50s
– Syntax, Frutiger and other sans serifs based on Renaissance Antiqua in the 60s and after

Once upon a time, it was rare in Europe to come across the outstanding sans serif faces from across the Atlantic.

But with the arrival of American advertising agencies, this changed, at least in advertising. In the constant search for new ideas and images, the art directors looked to American advertising and made sure that the typefaces it used found a foothold here too.

Sometimes this had some strange results. Rudolf Koch, for instance, who was mainly famous for his black-letter styles, had designed a very interesting sans-serif face, which was marketed by Klingspor. In the 60s, art directors proudly discovered a brand-new American style called 'Cable', only to have older typesetters tell

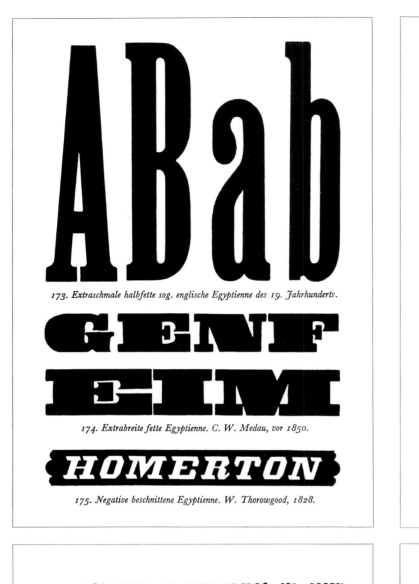

173. Extraschmale halbfette sog. englische Egyptienne des 19. Jahrhunderts.

174. Extrabreite fette Egyptienne. C. W. Medau, vor 1850.

175. Negative beschnittene Egyptienne. W. Thorowgood, 1828.

176. Beschnittene Egyptienne des 19. Jahrhunderts.

177. Skelett- und Halbskelett-Egyptienne des 19. Jahrhunderts.

178. Ornamentale flächige Egyptienne des 19. Jahrhunderts.

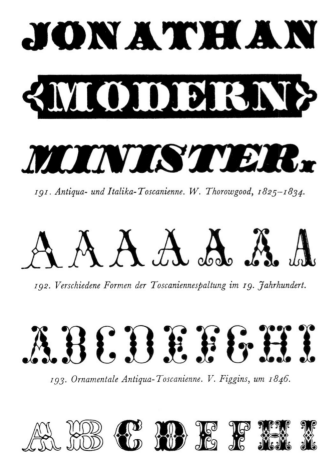

191. Antiqua- und Italika-Toscanienne. W. Thorowgood, 1825–1834.

192. Verschiedene Formen der Toscaniennespaltung im 19. Jahrhundert.

193. Ornamentale Antiqua-Toscanienne. V. Figgins, um 1846.

194. Flächige ornamentierte Antiqua-Toscanienne des 19. Jahrhunderts.

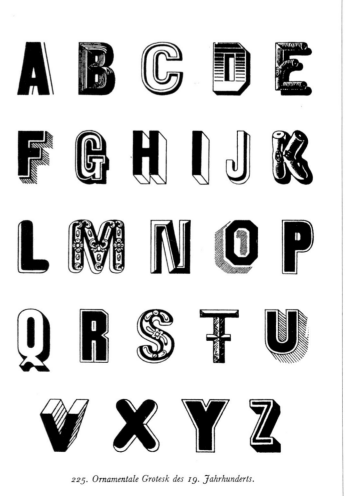

225. Ornamentale Grotesk des 19. Jahrhunderts.

American Type Founders' News Gothic,
1912.

Hamburgon
Hamburgon

Franklin Gothic Medium (above) and
News Gothic bold (below) by
Berthold AG.

One of the first sans-serif styles:
Grotesque Bold, 19th century.

A B C D E F G
H I J K L M N
O P Q R S T
U V W X Y Z
1 2 3 4 5 6 7 8 9 0
a b c d e f g h i j
k l m n o p q r s
t u v w x y z &

them that this was in fact a reimport of Rudolf Koch's old Kabel. In this way, the venerable old typemaster found unexpected fame in advertising with what was apparently a brand-new American Grotesque.

A much more constant role, however, is played by two American Grotesque families, both from the same company, American Type Founders. They are Franklin Gothic, which many European designers prefer to European sans-serif styles, and its somewhat sweeter sister, News Gothic. Both were designed by M.F. Benton, and are particularly common in ads and other advertising media.

The reason why Europe prefers the American version may be that we prefer the 'old-fashioned' a and g with their double belly (more like Antiqua) to the often excessively geometric versions of the continental Grotesques.

Benton drew News Gothic for ATF at some time around 1908, initially in medium, condensed, and extra condensed as part of his work on modernising the 19th century sans serif styles which ATF had inherited from its predecessors. In this process, News Gothic ended up as the lighter sister of Franklin Gothic in the new Grotesque family.

In the 30s, after the appearance of Futura and Cable these new American Grotesque styles seemed rather outdated; but they were rediscovered in the late 40s and experienced a major revival. Linotype now brought out a comparable Trade Gothic family, Intertype issued News Gothic and News Gothic Bold in 1955, Ludlow extended the Records Gothic family, and ATF and Monotype completed their News Gothic family. Even Berthold came out with its own attractive Grotesque family: the bold version was by John L. Renshaw of ATF (1958), the bold italics are of 1986 vintage, and are clearly a Berthold product. Of course, PostScript versions of Franklin and News Gothic are now available on the market. Graphic designers and typograp-

hers can produce layouts on a Mac or PC in their favourite News Grotesque, and not just Futura or Helvetica.

So why have so many companies plumped for News Gothic? They all want to be all things to all men, and leave no room for their competitors. So now the onetime 'underdog' News Gothic is everywhere and freely available. As Adrian Frutiger said, "Typefaces are like wines. You always end up choosing the same one - but it's nice to have so many grands crus to choose from." It would be a poor world indeed if we only had a few typefaces to choose from.

Like other classical sans serif faces, News Gothic has the usual problem: although in large quantities it is more difficult to read than serif faces, it is widely used, even in books. Publishers have obviously decided that visual appearance is more important than the reader's convenience. They assume that readers will take the trouble to read long texts in this cold, 'modern' style.

We find this somewhat arrogant attitude at its peak in the golden years of Swiss typography. In stylising and simplifying all the rules of typography, the masters of this genre ended up with one basic style, jobbing Grotesque - almost a synonym for that period.

Today, when electronic media rule and people have to give serious thought to keeping the reader interested, despite the clear appearance of the sans serifs, the Antiqua styles, especially those of the Renaissance, are regaining popularity. Most books which win prizes in different countries each year are not set in a Grotesque style, but Grotesque is still widely used in advertising. In many cases, the unthinking assumption that a grotesque is the right choice for technical products is reason enough to use it instead of an Antiqua. Attractive sans serifs such as News Gothic will be with us for a long time to come.

128

g or g?

GOTHIC

NEWS

versus Helvetica & Co.

Morris Fuller Benton

Poppl Pontifex

Friedrich Poppl

1981

H. Berthold AG

ABCDEFGHIJK
LMNOPQRST
UVWXYZ
1234567890
&
abcdefghijklmn
opqrstuvwxyz
–.,.:;!?„""'—
1234567890

normal normal regular	ABCDEFGHIJKLMNOPQRSTUVWXYZ abcdefghijklmnopqrstuvwxyz 1234567890/% (.,-:;!?)[''„""»«]—+=/$§*& ÆŒØÇæœøçáàäâéèëêíìïîóòöôúùüû
italique *kursiv* *italic*	*ABCDEFGHIJKLMNOPQRSTUVWXYZ* *abcdefghijklmnopqrstuvwxyz* *1234567890/%* *(.,-:;!?)[''„""»«]—+=/$§*&* *ÆŒØÇæœøçáàäâéèëêíìïîóòöôúùüû*
demi-gras **halbfett** **medium**	**ABCDEFGHIJKLMNOPQRSTUVWXYZ** **abcdefghijklmnopqrstuvwxyz** **1234567890/%** **(.,-:;!?)[''„""»«]—+=/$§*&** **ÆŒØÇæœøçáàäâéèëêíìïîóòöôúùüû**
gras **fett** **bold**	**ABCDEFGHIJKLMNOPQRSTUVWXYZ** **abcdefghijklmnopqrstuvwxyz** **1234567890/%** **(.,-:;!?)[''„""»«]—+=/$§*&** **ÆŒØÇæœøçáàäâéèëêíìïîóòöôúùüû**

The long road to the finished product: Poppl Pontifex

Many people think a little genius is all it takes to design a good typeface. It may be true that the appearance of characters calls for more than the visual talents of the average graphic designer, but genius on its own is not enough. For typography is an indifferent mistress, as Günter Gerhard Lange says. And, even if you can draw attractive illustrations or make well-organised type layouts on paper, that doesn't mean you have the hand and eye for abstract characters to achieve world-wide success.

The main mistake is to assume that the typeface the manufacturer brings out is the same as the artist's original design. From the original idea to the marketable product (whether we are talking about hot metal or modern digital types) is often a long road, with many design and correction hazards where the designer must show discipline and staying power.

To prove this, let's look at the birth of a typical typeface, as described in detail by Gertraude Poppl in *Berthold Aktuell* 1/90 under Types & Typo.

The subject here is one of Berthold's most successful new designs of recent times, Poppl-Pontifex.

Friedrich Poppl was Professor of Type and Typography at the Wiesbaden college of design when he embarked on a medieval Antiqua in 1973. After eighteen years' typographical experience, seven as a designer of title page styles, he felt he could meet the challenge of a complete type family to meet the requirements of sophisticated manufacturers. Poppl was prepared for a long period of development work.

Departing from his usual large-format title page designs and calligraphic sheets, he turned his attention to the running text. For many months, the ideal 9-point size, about 2 1/2 mm, and some hundreds of characters, occupied his thoughts.

His aim was a restrained, timeless, highly legible type, upright and italic. For Poppl, 'timeless' meant not calm and objective to the point of boredom, but pure, clear, balanced.

Finally, he designed the first of his alphabets on the long march. His fear of blurring led to round serifs, for he obviously knew too little of the degree of precision photosetting had achieved.

Poppl created his first running text

The first word samples on the road to Pontifex. Lange: 'The ends of the serifs are too thick, and the run-ins too strong'. The designer soldiered on...

OQRKBUM

OQRKBUM

OQRKBUM

OQRKBUM

OQRKBUM

Five stages of development in five lines. The bottom line is the final draft design.

adpmnoz kftr

adpmnozßkftr

adpmnozßkftr

adpmnozßkftr

adpmnozßkftr

body by simulating the style on paper, sticking film strips with images of his alphabet between two plates of Plexiglass. Reducing this sample showed him what corrections were needed and where.

Poppl then produced the obligatory model word for the basic style: Hamburgefons (this covers all the important letter shapes). He also developed models for a bold and italic version; he was aiming, not for a single style, but for a whole family.

Lastly, the three model words served as the basis for discussions with Berthold's art director and planning group.

Even though Professor Poppl was a professional, these discussions were by no means just a formality. Berthold's experts, led by Günter Gerhard Lange, advised him, "Tighter, more classical, smoother". They also called his first draft 'pasty' - a thorn in the flesh of the sensitive typographer.

But Poppl didn't make a fuss; he reworked his alphabet. The serifs were now angular.

But now they looked shorter and bulkier. He didn't like it. He changed the ends of the letters, making them longer and narrower, to give them elegance. He was also aiming at preventing setters from following their normal fashion of setting letters too closely. He wanted a high x-height with light internal spacing. Compared with other medieval faces, this produced a style which looked bigger for the same size. The lower-case ascenders were obviously much taller than the capitals. The capitals' line

width made them blend unobtrusively into the print body. Of course, all this meant a complete redrawing.

The new models showed just how much effect serifs have. At G. G. Lange's suggestion, letters such as h, g, m, n and o were now somewhat narrower, and all had the strict bearing of angular letter ends. At last Poppl was sure he could subject himself to the judgment of Berthold's artistic director once more.

But Lange was still not satisfied. He had found faults, even if only a few, in terms of the overall design. Seven lower-case and two upper-case letters had to be narrowed still further. Poppl was doubtful, for these instructions of course meant a lot of corrections to other figures. He accepted the commercial reasons, but was afraid that the type could lose its classical dimensions.

From November 1973 to April 1974, unwearied and cautious, the designer finally started on improving his type in five small development stages. And not just for the medium face, but the whole family. He had particular success with the italics, thanks to a happy choice of inclination and his experience as a calligrapher.

To anyone other than a typeface designer, the differences between the different stages would be virtually invisible, but Poppl now drew thirty-eight letters narrower without surrendering the character of the style he was after.

Friedrich Poppl is famous as an enthusiastic drawer of eccentric word-pictures; his temperament shows in his

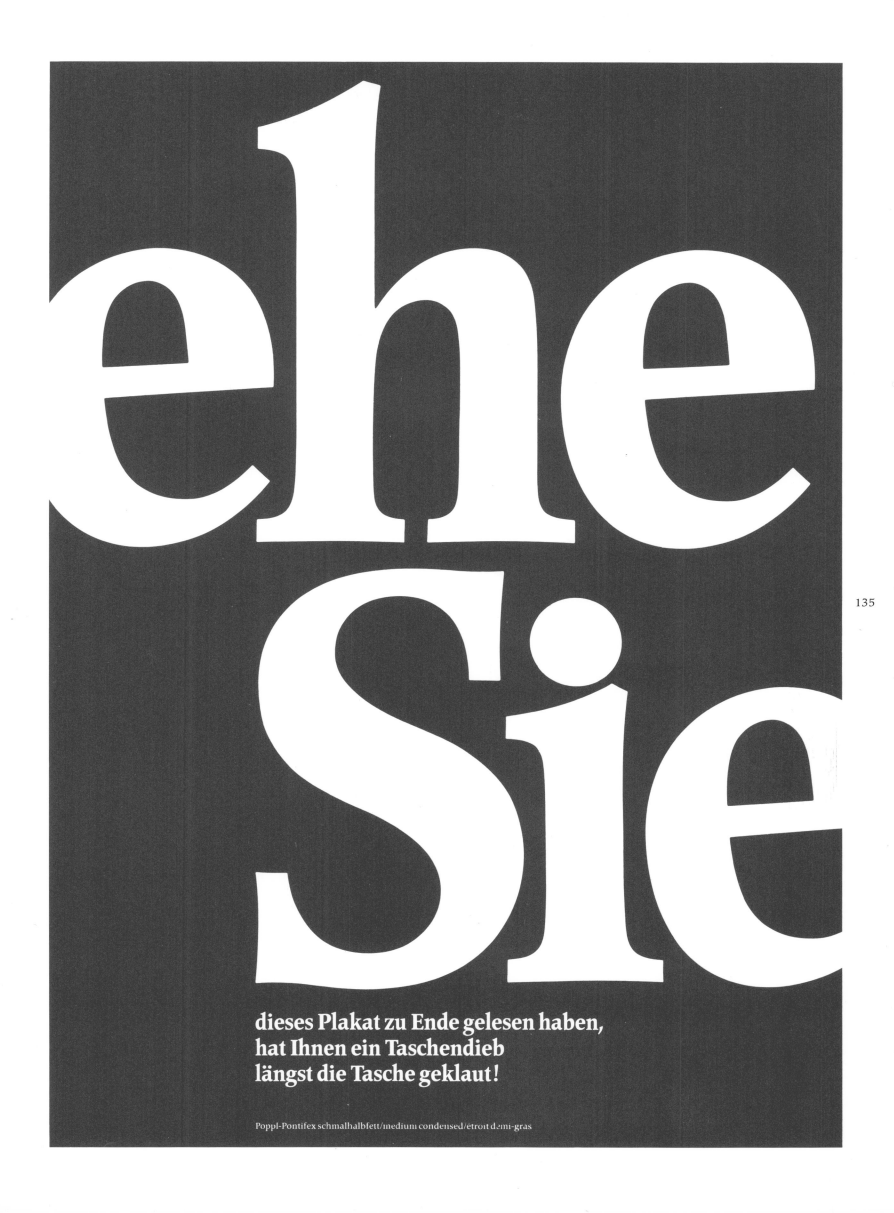

135

ehe
Sie

**dieses Plakat zu Ende gelesen haben,
hat Ihnen ein Taschendieb
längst die Tasche geklaut!**

Poppl-Pontifex schmalhalbfett/medium condensed/etroit demi-gras

calligraphy. Nonetheless, he now worked in a persistent, disciplined fashion on his vision of the ideal, restrained medieval form, which was not to be fashionable or short-lived.

After the positive draft of the fifth attempt, Poppl finally made the design drawings. He submitted them to Berthold's artistic director in 47 mm capital height size. He drew three faces - medium, bold, italic - in around a year, in his spare time, between teaching.

Finally, on 23 April 1974, Günter Gerhard Lange confirmed receipt of the three times 113 characters needed for the full photosetting keyboard. His praise was fulsome: "The best thing you've ever done!"

In the same letter he said that he would now check each character for variations in thickness and design errors. To Poppl's relief, all that happened was that a few stroke thicknesses had to be changed.

Why didn't Poppl see these mistakes himself? Perhaps we can compare this with an author checking his own work: ultimately, it's impossible to stand back and look objectively. The maker misses his own mistakes.

Poppl designed without stopping, allowing himself no respite in case it risked disturbing the smooth flow of the type. In the constant struggle for optimum design and harmony, strict stroke evenness was initially of little importance. He wanted to keep the overall view, details were secondary. Under those circumstances, it is easier for an outsider to see the last few mistakes.

Poppl was 50 years old when he designed Pontifex. He felt the urge to turn his years of typographical experience into a working typeface. He was ready to compromise but determined not to surrender an iota of his idea. In Günter Gerhard Lange, he had a congenial colleague and promoter of his work.

For his part, Poppl used his persistence to merge his own ideas with those of his colleagues to produce new ones. Of course, this involved not a little self-mastery. The labour of Sisyphus that the detailed corrections were led ultimately to a spiritual marathon, then

in the end to a type face of lasting value and restrained force, Poppl Pontifex, now a protected trademark worldwide. Perhaps the best memorial anyone could wish for.

Who, apart from specialists obsessed by the 26 letters of the alphabet, of which there are perhaps a handful in the whole world, would let themselves in for such labours? Designing a brochure or newspaper is much more amusing and more likely to produce something that wins prizes. Sprinters as opposed to marathon runners. Hats off to the ascetics among the graphic artists. To design a typeface, you need to be cut off a certain block yourself.

Rockwell

Monotype Corp.

1934

H. Berthold AG

ABCDEFGHIJK
LMNOPQRST
UVWXYZ
1234567890
&
abcdefghijklmn
opqrstuvwxyz
-.,:;!?,,""''—

normal normal regular	ABCDEFGHIJKLMNOPQRSTUVWXYZ
	abcdefghijklmnopqrstuvwxyz
	1234567890/%
	(.,-:;!?)[',,""»«]−+=/$§*&
	ÆŒØÇæœøçáàäâéèëêíìïîóòöôúùüû

italique kursiv italic	*ABCDEFGHIJKLMNOPQRSTUVWXYZ*
	abcdefghijklmnopqrstuvwxyz
	1234567890/%
	(.,-:;!?)[',,""»«]−+=/$§&*
	ÆŒØÇæœøçáàäâéèëêíìïîóòöôúùüû

demi-gras halbfett medium	**ABCDEFGHIJKLMNOPQRSTUVWXYZ**
	abcdefghijklmnopqrstuvwxyz
	1234567890/%
	(.,-:;!?)[',,""»«]−+=/$§*&
	ÆŒØÇæœøçáàäâéèëêíìïîóòöôúùüû

italique demi-gras kursiv halbfett medium italic	***ABCDEFGHIJKLMNOPQRSTUVWXYZ***
	abcdefghijklmnopqrstuvwxyz
	1234567890/%
	(.,-:;!?)[',,""»«]−+=/$§*&
	ÆŒØÇæœøçáàäâéèëêíìïîóòöôúùüû

gras fett bold	**ABCDEFGHIJKLMNOPQRSTUVWXYZ**
	abcdefghijklmnopqrstuvwxyz
	1234567890/%
	(.,-:;!?)[',,""»«]−+=/$§*&
	ÆŒØÇæœøçáàäâéèëêíìïîóòöôúùüû

Rockwell or, the typeface as commodity

Rockwell

Rockwell

Rockwell

Rockwell

Rockwell

Rockwell

Rockwell

Rockwell

Rockwell

Usually most people probably think of a typeface designer as a kind of eccentric artist who wakes up one morning with an idea for a new typeface and cannot rest until he has put his vision down by pencil, feather or even by chisel on paper or stone. No doubt such designers exist, and a print or rather type face may spring from inspiration; but it always serves one purpose: not just to be read, but further also to be sold.

This means that the draft design has to be finished, published, advertised and supplied, whether as hot metal letters or as digital information on disk. Turning to history, Napoleon once mocked the English as 'a nation of shopkeepers', but his scorn also contained a touch of envy. After all, in spite of the Continental blockade, he did not succeed in subduing them.

It was all Napoleon's fault

It was also Napoleon - at least indirectly - who let the British into Egypt after surrendering it at the Peace of Amiens. Soon they were sending back their first booty to London, sparking off a vogue for all things Egyptian. As with any other fashion, this was soon reflected in the products of local typecasters. Typefaces called 'Egyptians' appeared in their catalogues; we still know them today as Egyptienne. Whether this arose from their resemblance to the strip-like rows of hieroglyphics or the chunky Egyptian building style, or was just an attempt to jump on the Egyptian bandwagon, we do

not know. But there were a few absurdities: the first sans-serif face in the Caslon catalogue of 1816 was called Egyptian, while a serif face by Figgins the year before was called Antique.

Each type foundry offered at least one version of each face. When Linotype and then Monotype launched their typesetting machines on the market, they had to meet print buyers' demands accordingly. In developing their own ranges, they usually used historical models; after all, there was nothing new under the sun.

Egyptian style

Monotype introduced an Egyptian (serial number 173) in 1913. That year also saw the first totally new creation, Monotype's Plantin 110, for which Frank Hinman Pierpont had obtained copies of a Roman from the Plantin museum in Antwerp. This was cut by Claude Garamond in the second half of the 16th century for the scholar-printer Christophe Plantin, but never used in his lifetime. He chose this model for its legibility and 'honesty', as he put it.

Monotype Plantin 110 was one of the first faces designed specially for use on coated papers, and hence ideally suited to offset printing. For book printing, with its gutter margin and coarser paper, appeared later the somewhat lighter Plantin Light 113. In 1899, Pierpont became works manager at Monotype in Salfords at the age of 39. As an engineer,

390—42 Line ·4576

Fashions change with

Quads formed blocks
ABCDEGHJKMNQRSTU

abcdefghjklmopq
ABCDEGHKLMNQS

abcdefghijklmn
ABCDEFGHJKLN

abcdefghkm
ABCDEGHIJK

each operation and

TAKE THAT HAVE

390—48 Line ·5268

abcdefghs
ABDEGHJK

That class slopes

THAT RISE IN THE

390—60 For use on the Super Caster only Line ·6651

One family has

FARMED AT

390—72 For use on the Super Caster only Line ·793

Most of these

FIELDS AN

he had an instinctive mistrust of new typefaces for which there was no specific call from the market.
So when he came to develop Rockwell, the most successful Egyptienne of them all, he went about his task with great care.

It's all been done before

Stempel in Germany has brought out Memphis in 1929, designed by Emil Rudolf Weiss and named after a city in Egypt. The next year, ATF in the USA brought out Stymie, by Morris Fuller Benton (although there was already a typeface of that name by Lanston Monotype, which in turn had its origins in the Litho Antique of 1910), while Ludwig & Mayer in Frankfurt launched Welt, designed by Hans Wagner. In line with the Egyptian trend, this face was also available as Luxor (another city in Egypt) and as Ramses from the Fonderie Française in France. Georg Trump brought a new interpretation with his City (Berthold 1930) which was closer to Art Deco than acient Egypt.

The Bauer type foundry also brought out an Egyptienne, which was designed by Heinrich Jost and launched in 1931 under the somewhat unromantic name of Beton. In the same year, the Ludlow company of America took a more Egyptian line, bringing out its version of a serif Antiqua designed by R.H. Middleton. It was called Karnak, after the village in Upper Egypt three miles from Luxor in the site of the ancient city of Thebes. Under the ruins on the east bank of the Nile is a temple to Osiris; so it is no coincidence that Gustaf Jaeger called his Egyptienne, designed for Berthold in 1984 Osiris.

All quiet on the English front

The years 1929-1931 saw a number of new additions to the family of serif faces. Monotype alone had nothing new to offer but the Egyptian 173 we mentioned above. In 1932, F.H. Pierpont ordered his in-house type design studio to create a new version. The results were available by spring the next year: some experimental letters in the 371 series, still called Memphis. This design was

141

LONDON: THE MONOTYPE CORPORATION LTD PARIS: SOCIÉTÉ ANONYME MONOTYPE BERLIN: SETZMASCHINEN-FABRIK MONOTYPE G.M.B.H.

based on the Rockwell Antique Series 189 by the American Lanston Monotype. In terms of line thickness, however, the new face followed Stempel's Memphis to achieve a similar colour. It was also modelled on Lanston's Stymie, although mainly the thinner italics as the basis for an italic style à la Egyptienne. The light and bold weights were cut along with the regular weight at the same time, in early 1934. Work on the bold condensed series 359 started at the end of 1934. quickly followed by the condensed series 414 and extra bold series 424.

Type maketing

Frank Hinman Pierpont's pragmatic attitude to typeface design, governed, largely by the demands of the market, was highly successful. By the time of his death, in 1937, almost all of what we now think of as the classic Monotype faces had appeared, including Times New Roman and Gill. Although the name Rockwell originated in the United States, it is now associated solely with the English Monotype face, a much improved version of the original Lanston-Egyptienne.

Today, more than ever, it is not enough just to design an original typeface. The path from the design to digital conversion and fonts for computer typesetting systems is much shorter and hence cheaper than the old engraving and casting. But whether it ends in well-designed letters which work equally well as a text face or as individual, words still depends on many factors. And even though, as is often the case today, the typeface designer digitalises his own work or designs on screen, it still takes a lot of talent, experience and patience to turn a good idea into a true type family. Even then, the most original and superbly produced typeface will not be a success unless it reflects the spirit of the time. Above all, it must be publicised and marketed. This means that, nowadays, marketing is just as important as technology. With over 2000 styles available, no-one can find their way around unaided, and assistance is provided by the manufacturers, who promise that their product sells better

48 PT. DISPLAY MATRICES LINE T-5268

abcdefghijklmnopqrstuvwxyzabc
ABCDEGHJKLMNPQRSTUVWXYZ

60 PT. DISPLAY MATRICES LINE T-6651

abcdefghjklmopqrstuvwxyz
ABDEGHJKMNQRSTUWXY

72 PT. DISPLAY MATRICES LINE T-7930

abefghjklnoqrstuvwxyz
ABDEGHJKMNQRSUW

The following accents Á À Â Ä Æ É Ì Ê Ë Ï Í Î Ï Ó Ò Ô Ö Ø Ú Ù Û Ü Ç Ñ á à â ä æ é è ê ë ï í î ï ó ò ô ö ø ú ù û ü ç ñ ß ij are available in all sizes

36 PT. DISPLAY MATRICES LINE T-3884

Quads formed blocks
ABCDEGHJKMNQRSTU

42 PT. DISPLAY MATRICES LINE T-4576

abcdefghjklmopq
ABCDEGHKLMNQS

48 PT. DISPLAY MATRICES LINE T-5268

abcdefghijklmn
ABCDEFGHJKLN

60 PT. DISPLAY MATRICES LINE T-6651

abcdefghkm
ABCDEGHIJK

72 PT. DISPLAY MATRICES LINE T-7930

abcdefghs
ABDEGHJK

The following accents Á À Â Ä Æ É È Ê Ë Ï Í Î Ï Ó Ò Ô Ö Ø Ú Ù Û Ü Ç Ñ á à â ä æ é è ê ë ï í î ï ó ò ô ö ø ú ù û ü ç ñ ß ij are available in all sizes

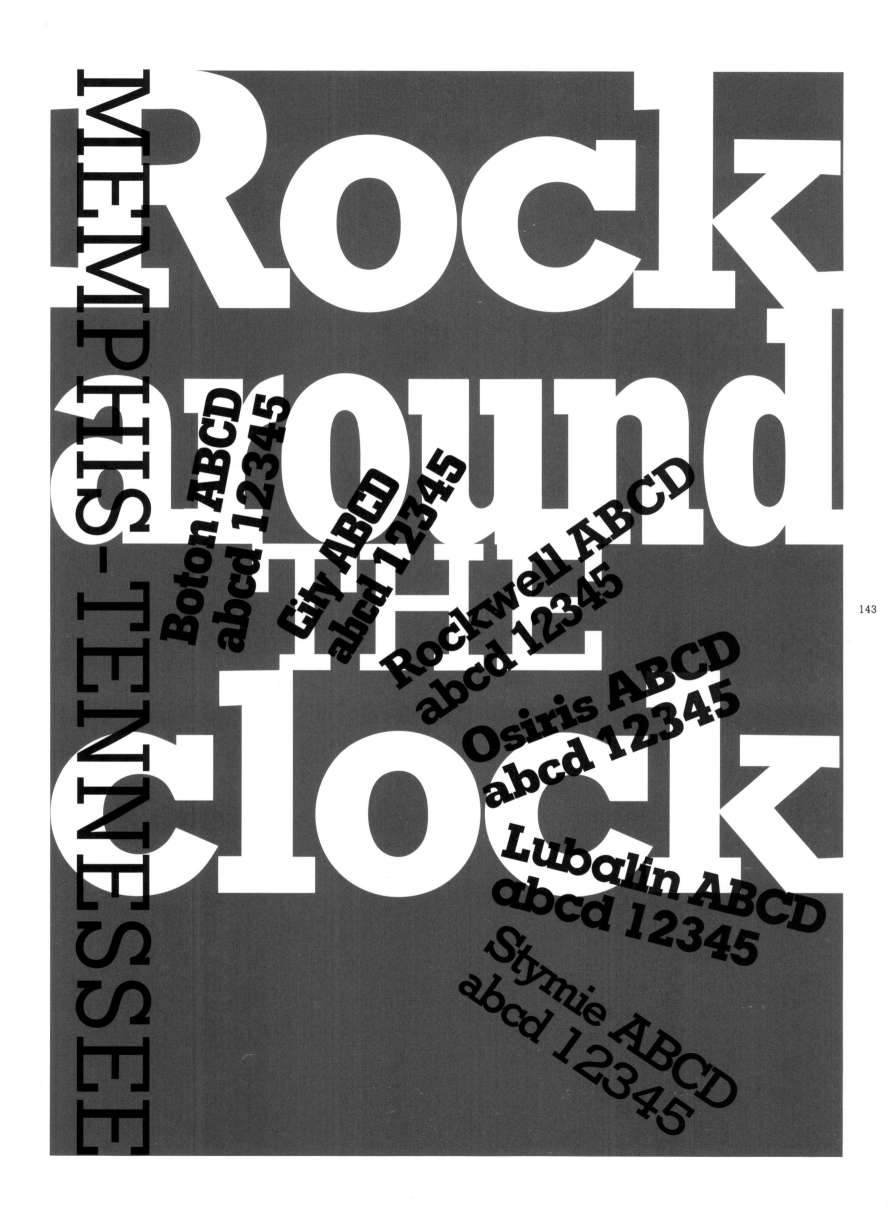

Rock Around the Clock

MEMPHIS-TENNESSEE

Boton ABCD
abcd 12345

City ABCD
abcd 12345

Rockwell ABCD
abcd 12345

Osiris ABCD
abcd 12345

Lubalin ABCD
abcd 12345

Stymie ABCD
abcd 12345

*Rockwell Shadow by Monotype in
'Display'.
Below:
Calligraphy and Rockwell (from
"Calligraphy in the Graphic
Arts").*

than the competition's. Unfortunately, this does not always have anything to do with the quality of the design or care in its realisation.

The difference between idea and marketing goes back a long way. At Monotype and elsewhere, it was the shopkeepers, not the artists, who had the last word. Napoleon may have scorned the English, but they did at least succeed in bringing art and commerce together.

Stone

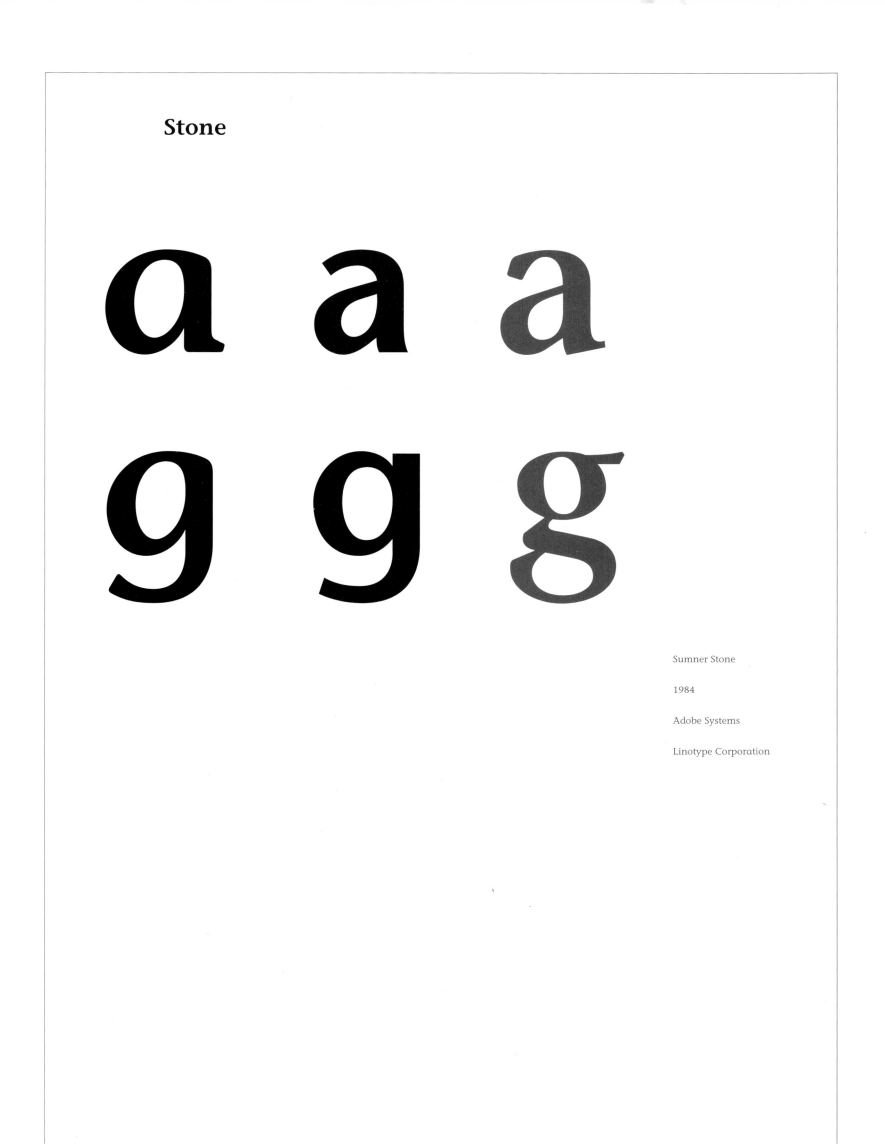

Sumner Stone

1984

Adobe Systems

Linotype Corporation

ABCDEFGHIJK
LMNOPQRST
UVWXYZ
1234567890
&
abcdefghijklmn
opqrstuvwxyz
-.,.:;!?„""''_

normal normal regular	ABCDEFGHIJKLMNOPQRSTUVWXYZ abcdefghijklmnopqrstuvwxyz 1234567890/% (.,-:;!?)[''„""»«]–+=/$£*& ÆŒØÇæœøçáàäâíìïîóòöôúùüû
italique kursiv italic	*ABCDEFGHIJKLMNOPQRSTUVWXYZ* *abcdefghijklmnopqrstuvwxyz* *1234567890/%* *(.,-:;!?)[''„""»«]–+=/$£*&* *ÆŒØÇæœøçáàäâíìïîóòöôúùüû*
demi-gras halbfett medium	**ABCDEFGHIJKLMNOPQRSTUVWXYZ** **abcdefghijklmnopqrstuvwxyz** **1234567890/%** **(.,-:;!?)[''„""»«]–+=/$£*&** **ÆŒØÇæœøçáàäâíìïîóòöôúùüû**
italique demi-gras kursiv halbfett medium italic	***ABCDEFGHIJKLMNOPQRSTUVWXYZ*** ***abcdefghijklmnopqrstuvwxyz*** ***1234567890/%*** ***(.,-:;!?)[''„""»«]–+=/$£*&*** ***ÆŒØÇæœøçáàäâíìïîóòöôúùüû***
gras fett bold	**ABCDEFGHIJKLMNOPQRSTUVWXYZ** **abcdefghijklmnopqrstuvwxyz** **1234567890/%** **(.,-:;!?)[''„""»«]–+=/$£*&** **ÆŒØÇæœøçáàäâíìïîóòöôúùüû**
italque gras kursiv fett bold italic	***ABCDEFGHIJKLMNOPQRSTUVWXYZ*** ***abcdefghijklmnopqrstuvwxyz*** ***1234567890/%*** ***(.,-:;!?)[''„""»«]–+=/$£*&*** ***ÆŒØÇæœøçáàäâíìïîóòöôúùüû***

Get Stoned

In typographic design, craft deals with points, lines, planes, picas, ciceros, leads quads, serifs, letters, words, pages signatures, paper, ink, color, printing, and binding. The vocabulary of form (art) includes, among others:

Good design, good typography, Swiss or otherwise, is a fusion of information and inspiration, of the conscious and the unconscious of yesterday and today, of fact and phantasy, work and play, craft and art.

space proportion scale, site, shape, rhythm, repetition, sequence, movement, balance, volume, contrast, harmony order, and simplicity.

Paul Rand

Examples of Stone family used by Adobe (of. pp. 149/152)

Some designers boast of never having used more than half a dozen typefaces in their lives. Admittedly, you can use a single classic family to meet the needs of normal printing, because that family will include upper- and lower-case letters, uprights and italics, and small capitals, giving four ways of highlighting the running text.

There is a certain educational value in limiting oneself to a single typeface: it is a challenge which all designers should face before allowing themselves the adventure of unlimited choice.

But it is also true that hardly anyone nowadays would claim to be satisfied that they were meeting the complex demands of visual communication with the relatively modest means which suffice for book design. I am not even considering the advocates of so-called 'timeless design', who use Helvetica for everything, but who mostly just create timeless monotony. On the other hand, the fact that there are thousands of typefaces available often makes it impossible to see the wood for the trees and decide which one meets your particular needs.

Keeping it in the family

A family of typefaces such as Stone really does kill two birds: it is impossible not to create a harmonious whole as long as you stay within the family, however different the individual members may be. Unfortunately, the ideal model bears little resemblance to normal family life; and Stone is more like an extended family with a number of branches, who have certain things in common but otherwise lead their own lives. As in real life, this extended family includes all types, from the slim and svelte to the heavy extra bolds.

Over 30 years ago, Adrian Frutiger's Univers showed that a family of typefaces can run to 21 different styles and still form a harmonious whole. This may have ceased to be true with the somewhat larger extended family, but it showed how wide the range was within a single style. No doubt Frutiger

could have added an serif version, in almost 20 versions from condensed to extended and light to bold, if computers had been around at the end of the fifties to make his life easier. But perhaps he had no wish to take things to the limit, unlike Otl Aicher, whose magnum opus, Rotis, in four different versions - as well as the serif and the sans, there is a Semi-serif and a Semi-sans - would have been inconceivable without a computer.

It's all been done before

The idea of including different type-styles within a single family is not as new as Aicher makes out.

As long ago as the 30s, Jan van Krimpen designed a sans-serif version of his own typeface Romulus and in 1930 Stempel AG brought out Rund-funk Grotesk as a bold sans serif highlight face to go with Rundfunk Antiqua, specially designed for setting programme details and ads in very small sizes.

In the 70s, Gerard Unger brought out Demos and Praxis one with serifs, one without, but both using the same basic design. In 1979, Ed Benguiat added Benguiat Gothic to his ITC Benguiat. Before then, both Cheltenham and ITC Souvenir had gained a sans-serif version, not always by the designers of the original versions and not always to their unalloyed delight.

In 1985, Charles Bigelow and Kris Holmes designed Lucida and Lucida Sans - the first typefaces specially designed for use on low-resolution printers.

...but never in such detail

So even if Stone was not the first type-face to have an extended family, it was the first to have three versions in both upright and italic. With three stroke widths in each case, this gives a total of 18 members. They all share the same basic design, the same capital height, the same x-height and the same stroke widths. Each version is based on the same skeleton. Despite

Hamburgefons

Hamburgefons

Hamburgefons

Hamburgefons

Hamburgefons

Hamburgefons

Hamburgefons

Hamburgefons

Hamburgefons

Hamburgefons

Hamburgefons

Hamburgefons

Hamburgefons

Hamburgefons

Hamburgefons

Hamburgefons

Hamburgefons

Hamburgefons

abcdefghijklmnop
ABCDEFGHIJKLM
1234567890 .,;:''

abcdefghijklmnop
ABCDEFGHIJKLM
1234567890 .,;:''

ABCDEFGHIJKLMNO
abcdefghijklmnopq
1234567890.,:;!?''

ABCDEFGHIJKLMNOP
abcdefghijklmnopqr
1234567890.,:;!?''

ABCDEFGHIJKLMN
abcdefghijklmnop
1234567890.,:;!?''

ABCDEFGHIJKLMNO
abcdefghijklmnopqr
1234567890.,:;!?''

150

their major differences, each member of the Stone family shows a certain resemblance.

For them to work well, on the other hand, each version must be clearly distinguishable. The lower-case **a**, for example, looks similar in Stone Serif and Stone Sans, but different in Stone Informal. The lower-case g shares a common basic form in Sans and Informal, but not in Serif. These variations are appropriate to the style in each case and provide variety in use.

Letter writing on computer

Apart from the two traditional styles, serif and sans, Stone Informal was not based on a model, except perhaps handwriting, as the name implies. It is intended primarily for use in situations where non-proportional typewriter styles prevail, such as in letter writing.

Letters written in Times New Roman or Helvetica, as is increasingly the case since the arrival of the laser printer, often lose the personal touch and start looking like official forms. 'Looking like print' can have a thoroughly negative effect if it stops letters looking as though they were typewritten.

Form follows technology

Since there was no historical model for this new kind of typeface, Sumner Stone had to come up with something new. He took as his model the dynamic forms of handwriting, as can be seen clearly in the lower-case letters abdgpqhmn, with the a and g being based on italic rather than printed forms. In spite of its informal aspects, Stone largely follows the structure of normal running faces, especially in terms of serifs, making it readable even in long texts. As Type Director at Adobe Systems, Sumner Stone of course had all the computerised typeface design facilities at his fingertips, although he still had to use some hand-drawn sketches, which were then developed into pencil drawings, some 15 cm high, for digitalisation. Sumner Stone estimates that, out of some 4000 drawings, not more than 100 were

produced on paper: he drew the rest on screen. Paper proofs of the first characters were used as the model for the italics, and large-scale printouts of some characters as templates for designing others.

The bold faces are based on the normal ones: moving the curve points, which we are familiar with from CAD programs such as Adobe Illustrator, can be used to change stroke widths and other shapes. In this way, the extra bold characters were developed from the normal ones, with the bold being a cross between the two. This relatively simple computerised method has now been used for typeface design for some time, saving hundreds of hours of tedious manual work, although at the expense of a certain physical homogeneity in the results. Although Sumner Stone designed the typefaces which bear his name for artistic rather than technical reasons, they are a reflection of the environment in which they were created. Nowadays, typeface designers have no idea what equipment their products will be used on: it could be a high-resolution recorder at over 2540 dpi (i.e. 100 lines per centimetre) or a 300 dpi laser printer. As Sumner Stone examined interim corrections on a laser printout and Adobe's PostScript licence business dominates the market, Stone family typefaces go particularly well here. Although based on traditional forms, the letters are never too thin or elaborate to make a good impression on less professional output media.

One for all...

Since typefaces have to work both as running text and for highlights and headlines, and the same outline data applies to all type sizes, the letters must be functional and legible in small sizes and retain their elegance when large. This compromise has already been the undoing of many typefaces, especially the high-contrast classics, such as Bodoni, which becomes almost illegible when small because the fine lines are lost. On a laser printer, Stone looks just right, while high-resolution

lighting reveals that the normal face could easily have been somewhat stronger. The Stone extended family is by no means complete: the condensed versions are still in preparation. ITC - the International Typeface Corporation - has acquired the licences for Stone from Adobe and is offering it to other manufacturers as ITC Stone.

A future classic

A typeface takes five years to become known, and another five before it is accepted. Stone appeared in 1988, so that we cannot expect it to be widespread until 1993. By then, there will be so many members in the family that no typographer will be able to do without it. As the first complete family from the people who brought us Post-Script, its place in the history of typography is assured, although Sumner Stone left Adobe in the summer of 1990. He now has his own 'Stone Foundry', one of the new breed of type 'foundries' which have mushroomed in the wake of Macintosh and PostScript, and which have neither factory, nor directors nor even a management. We will be hearing more of these new typeface manufacturers who are also their own designers.

Swift

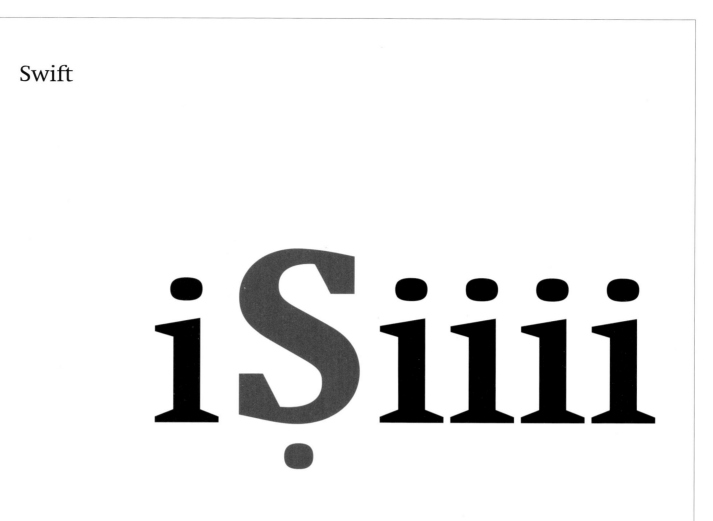

Gerard Unger

1981

Dr.-Ing. Rudolf Hell GmbH

ABCDEFGHIJK
LMNOPQRST
UVWXYZ
1234567890
&
abcdefghijklmn
opqrstuvwxyz
-.,.:;!?„""''‚—

normal normal regular	ABCDEFGHIJKLMNOPQRSTUVWXYZ abcdefghijklmnopqrstuvwxyz 1234567890/% (.,-:;!?)['`„""»«]–+=/$£*& ÆŒØÇæœøçáàäâíìïîóòöôúùüû
italique kursiv italic	*ABCDEFGHIJKLMNOPQRSTUVWXYZ* *abcdefghijklmnopqrstuvwxyz* *1234567890/%* *(.,-:;!?)['`„""»«]–+=/$£*&* *ÆŒØÇæœøçáàäâíìïîóòöôúùüû*
gras fett bold	**ABCDEFGHIJKLMNOPQRSTUVWXYZ** **abcdefghijklmnopqrstuvwxyz** **1234567890/%** **(.,-:;!?)['`„""»«]–+=/$£*&** **ÆŒØÇæœøçáàäâíìïîóòöôúùüû**
maigre mager light	ABCDEFGHIJKLMNOPQRSTUVWXYZ abcdefghijklmnopqrstuvwxyz 1234567890/% (.,-:;!?)['`„""»«]–+=/$£*& ÆŒØÇæœøçáàäâíìïîóòöôúùüû
italique maigre kursiv mager light italic	*ABCDEFGHIJKLMNOPQRSTUVWXYZ* *abcdefghijklmnopqrstuvwxyz* *1234567890/%* *(.,-:;!?)['`„""»«]–+=/$£*&* *ÆŒØÇæœøçáàäâíìïîóòöôúùüû*

Swift or, "The essence of reading: not just to know more, but to experience more" (Gerard Unger)

Let's imagine for a moment that Gerard Unger is the long-awaited 'juggler' who has come to free newspaper types from the taint of 'too much engineering and not enough art' (Harold Evans) and reconcile the demands of technology and legibility with good type style. Let's have a closer look at Swift, a newspaper style which Unger designed for Dr.-Ing. Rudolf Hell GmbH of Kiel in 1984-87. But first, a look at the history of newspaper styles.

Unlike the delicate book faces, newspaper styles are primarily a matter of function, in terms of printing technology on the one hand and legibility on the other. Aesthetics are secondary. Once, high-speed presses and then letterpress and intaglio presses thickened forms to the point where they were unrecognisable; today, however, high-speed offset tends to make them thinner. Another factor is that people usually read newspapers on the move, under poor conditions: shaking, bumping, pushing and poor lighting.

Initially, newspapers were set in whatever was the leading book face at the time. In the 19th century, this was the classical forms of Bodoni. This only changed when Chauncey H. Griffith of the American Mergenthaler Linotype Company looked at the problems of printing, stereotypy and legibility. He was looking for robust shapes which would be resistant to the ravages of technology, and came across Clarendon, a variation on the Egyptienne of 1817. The English type foundry of Henry Caslon first brought this out as Ionic in 1843. Griffith's immediate model was Lanston Monotype's Ionic No. 156. Under his leadership, there emerged over the years a total of five faces in this 'Legibility Group': the first was Ionic No.5 in 1926, followed by an improved and widely used Excelsior in 1931 and Corona, the last of

the series, in 1941. These styles quickly caught on, because they performed their tasks much better than the delicate Bodoni styles. The trouble was that their over-even line widths, vertical axes, and bold, straight serifs gave them a monotonous, static effect. Developed by technicians, they lacked artistic inspiration.

Stanley Morison took the opposite approach in developing a typeface for *The Times*. He started from the easy-to-read late Renaissance forms, especially Plantin: diagonal axes, clear but not exaggerated line contrast, and the classical straight serifs, although rounded off. These factors made the typical, exclusive Times New Roman an aesthetic classic among newspaper styles. It was too fine for rotary offset, but modern offset printing makes up for this, if handled professionally.

After the Second World War, new newspaper styles emerged, especially in Europe. It is noticeable that, since the introduction of photosetting, even the conservative tendency in printing has been inclined to use a wider range of forms and be more individualistic. Some names stand out here. There are such varied characters as Berthold and Intertype's Concorde of 1968, which was then 'matched', to put it discreetly, by Stempel/Linotype's Rotation of 1972 or Mergenthaler Linotype's Olympian of 1970, from more recent times, News Plantin (1978) and Nimrod (1980) by Monotype, Hell's digital Edison (1984), Linotype's Centennial (1986), which is also used as a newspaper style and, the last word for the moment, Swift (1987).

Legibility

The inspiration for Swift came from a throwaway: an extra bold version of Unger's Hollander which seemed to be

156

Corrections by Gerard Unger, 1987.
f bold italic and £ bold condensed

Comparison:
Above: Exelsior, Swift, Times;
Below: Times and Swift.

eee
en en

unsuitable. Newspaper styles are always somewhat bolder, because copying, printing, uneven dark-grey printing ink and the poor quality paper used rob them of contrast. So the extra bold style still offered other possibilities.

A newspaper's appearance is governed by the linear type body. En masse, the small print becomes an image in itself, and its quality of style governs how quickly or slowly the reader gives up trying to read it. Swift tends towards individual emphasis and the pictorial, while taking account of technical and reading requirements. By consciously making an emotional appeal to the reader, it makes sure that he takes the information in. Good or bad news is no longer simply passed on as neutral, which of course it is not, but in a much more differentiated style. A style such as Swift gives a newspaper its own identity with which readers can identify.

Let us now take a look at some legibility criteria and see how they apply to Swift.

- A generous x-height allows for open inner spaces, which counteract the black print body and avoid the risk of blurring in printing. If, however, this means making the ascenders and descenders too short, we must make

Extra Daily Swift

New news face

News flies. Newspapers are produced at breakneck speed and have a short life—the paper they are printed on is cheap, grey and rough. *Swift* is open, sturdy and sharp, making print alive and legible even when conditions are difficult. Under less rushed circumstances Swift is also at home in supplements, magazines, travel guides, dictionaries, paperbacks, catalogues …

Named after bird

Lightning-fast swifts draw lines and exciting arcs in the air—an example for the designer's hand and pencil. Their long, graceful wings and short, firm bodies give striking silhouettes, echoed in these letters with their large serifs and pronounced shapes.

Un oiseau très particulier
Le martinet mesure environ 16 cm de long. Son envergure est

Neue Zeitungsschrift

Meldungen fliegen. Zeitungen werden in rasantem Tempo produziert und haben ein kurzes Leben – das Papier ist billig, grau und rauh. Die *Swift* ist offen, kräftig und scharf und bildet auch unter schwierigen Bedingungen weiterhin lebendige und gut lesbare Zeilen. Unter weniger gehetzten Verhältnissen fühlt sich die Swift auch heimisch in Beilagen, Zeitschriften, Reiseführern, Wörterbüchern, Taschenbüchern, Katalogen …

Nach einem Vogel benannt

Pfeilschnelle Mauersegler *(englisch: swifts)* ziehen Linien und spannende Bögen durch die Luft – Vorbild für Hand und Zeichenstift des Designers. Ihre langen, zierlichen Flügel und kurzen, kräftigen Rümpfe bilden markante Silhouetten, die diesen Buchstaben mit ihren gestreckten Serifen und ausgeprägten Formen verwandt sind.

Un nouveau caractère journal

Les nouvelles volent vite. Les journaux s'impriment à toute allure. Ils sont éphémères. Leur papier est bon marché, gris, rude. *Swift* est ouvert, robuste et net. En toutes circonstances il donne des lignes claires et lisibles. Donnez-lui un peu de temps et il fera très bien l'affaire dans les périodiques, les suppléments, les brochures de tourisme, les dictionnaires, les livres de poche, les catalogues …

Swift comme martinet

Le vol du martinet *(en anglais: swift)* est vif comme l'éclair. Ses droites et ses courbes inspirèrent la main et le crayon du dessinateur. Les ailes longues et gracieuses, le corps robuste et ramassé se retrouvent dans ce caractère, son corps et ses longs empattements.

Le peintre futuriste Giacomo Balla (1871-1958) s'intéressait particulière-ment à la représentation du temps, du mouvement et de la vitesse. Lui aussi était fasciné par le vol des martinets dans le ciel de Rome. Dans ses dessins comme dans ses peintures il a fixé leur vol aussi bien que ses propres mouvements sur le balcon (les lignes blanches ondoyantes) et quelques éléments d'architecture.

First advert for Swift by Dr.-Ing. Rudolf Hell GmbH, design by Gerard Unger

the line spacing wider. The idea that a large x-height saves space is a fiction. If, on the other hand, the ascenders and descenders are of normal proportions, the type can be set somewhat more compressed, since this automatically preserves the white space between lines.

- To prevent reader fatigue, we need clear contrasts between the basic and hairlines, although the hairlines must not be too thin, otherwise they will burn out.

- To give columns a uniform grey scale value, it is useful if the capitals are slightly smaller than the ascenders.

- Serifs play a particularly important role in newspaper setting: they carry the reader's eye along horizontally and should therefore be strong and robust. They link individual letters to make words and lines.

- Finally, a style's spacing is vital for fluent reading. Small sizes are usually set wider than large ones, but not too wide, otherwise they will interrupt the reader's flow.

Swift as an arrow

In developing Swift, Unger first made a thorough examination of printing and reading conditions, and made comparisons with existing newspaper styles. That is not the only reason I find Swift an intellectual style: a representative of the analytic, abstract mind of the 20th century which has penetrated the world of the micro and expects an appropriate wealth of detail. Forget purity of style and internationalism! Twentieth-century typefaces are hybrid mixtures: some more so, some less. Against this background of pluralism, Swift's high degree of originality stands out.

Print tests and simulations cover details such as pointed roundings in the verticals, shallow curves and open interiors. Overall, swift is so open that the x-height is large but does not have to be used to the full. The corresponding increase in the descenders has a positive effect on legibility. Above all, Swift owes its active character to the interplay of contours and inner space, including even the negative spaces between letters. In terms of alignment, there are three widths which emerge: the small sizes are somewhat

The 'Heraldo de Aragon' (left)
On the right, the trade magazine 'Pers:',
design by Gerard Unger.

wider, the medium sizes normal and the headline sizes narrower once more.

Swift is based on Dutch late Renaissance types, and so has smaller capitals. Especially in German, this makes pages or columns look more balanced and homogenous, since the capitals give more air and do not leap out at the reader. It also uses the diagonal shadow axis of the times, which helps legibility, as with Times.

Unger is not afraid of hands-on contact, but welcomes it, and draws his serifs relatively large. They often run into those of neighbouring letters. In the capitals, the serifs are powerful, unchamfered and three-cornered. They act as guide lines. The serifs on the ascenders are bevelled off to make them easier on the eye. This triangular shape is a determining factor, but proportioned such that the aesthetics does not break down.

The italics should be as attractive as the uprights and not flabby and feeble. For this reason, they have particularly sharp ties. One unusual feature are the ink traps: that is, the ends of the curves in the verticals have flat bottoms so that the ink can spread over two corners. Once again, the inner spaces in the italics have been designed to avoid filling. This makes the set lighter and clearer than in the uprights - a feature common to all italics of classical origin. Swift Italic is not just a sloping upright, but a true italic face. The individual lower-case forms show its origins in handwriting, and the capitals also are proportioned to suit.

For reasons of economy, newspapers usually reduce the original copy. If you reduce Swift by 5% - but not more - it is as narrow as Times, and with less gaps. Unger and Swift are robust enough to withstand such treatment.

With Swift, we can never be entirely sure whether it is the individual handwritten forms of the designer which govern its function or technical requirements which govern aesthetics. This is Unger's balancing act.

On the other hand, typeface designers never create from a vacuum. They are aware of type tradition, feel relationships, develop preferences, take stances. One of Unger's main sources of inspiration was William A. Dwiggins (1880-1956), one of the most creative American bookface and typeface designers. Dwiggins, typographic adviser to Mergenthaler Linotype, corresponded with Griffith for years, for whom he passionately wanted to develop a more legible alternative newspaper style, free of the monotonous shackles of technology. This failed to happen for a number of reasons: Unger picked up the

abcdef
ghijklm
nopqrst
uvwxyz

Philobiblon

Eine Vierteljahrsschrift

für Buch- und Graphiksammler

Jahrgang 31 Heft 4 Dezember 1987

MATTHEW 10, 11 *The Twelve are commissioned*

my Father in heaven; [33] and whoever disowns me before others, I will disown before my Father in heaven.

[34] 'You must not think that I have come to bring peace to the earth; I have not come to bring peace, but a sword. [35] I have come to set a man against his father, a daughter against her mother, a daughter-in-law against her mother-in-law; [36] and a man will find his enemies under his own roof.

[37] 'No one is worthy of me who cares more for father or mother than for me; no one is worthy of me who cares more for son or daughter; [38] no one is worthy of me who does not take up his cross and follow me. [39] Whoever gains his life will lose it; whoever loses his life for my sake will gain it.

[40] 'To receive you is to receive me, and to receive me is to receive the One who sent me. [41] Whoever receives a prophet because he is a prophet will be given a prophet's reward, and whoever receives a good man because he is a good man will be given a good man's reward. [42] Truly I tell you: anyone who gives so much as a cup of cold water to one of these little ones because he is a disciple of mine, will certainly not go unrewarded.'

11 When Jesus had finished giving instructions to his twelve disciples, he went from there to teach and preach in the neighbouring towns.

Recognizing the Messiah

[2] JOHN, who was in prison, heard what Christ was doing, and sent his own disciples [3] to put this question to him: 'Are you the one who is to come, or are we to expect someone else?' [4] Jesus answered, 'Go and report to John what you hear and see: [5] the blind recover their sight, the lame walk, lepers are made clean, the deaf hear, the dead are raised to life, the poor are brought good news—[6] and blessed are those who do not find me an obstacle to faith.'

[7] When the messengers were on their way back, Jesus began to speak to the crowds about John: 'What was the spectacle that drew you to the wilderness? A reed swaying in the wind? [8] No? Then

what did you go out to see? A man dressed in finery? Fine clothes are to be found in palaces. [9] But why did you go out? To see a prophet? Yes indeed, and far more than a prophet. [10] He is the man of whom scripture says,

Here is my herald, whom I send
 ahead of you,
and he will prepare your way before
 you.

[11] 'Truly I tell you: among all who have ever been born, no one has been greater than John the Baptist, and yet the least in the kingdom of Heaven is greater than he.

[12] 'Since the time of John the Baptist the kingdom of Heaven has been subjected to violence and violent men are taking it by force. [13] For until John, all the prophets and the law foretold things to come; [14] and John is the destined Elijah, if you will but accept it. [15] If you have ears, then hear.

[16] 'How can I describe this generation? They are like children sitting in the market-place and calling to each other,

[17] We piped for you and you would not
 dance.
We lamented, and you would not
 mourn.

[18] 'For John came, neither eating nor drinking, and people say, "He is possessed"; [19] the Son of Man came, eating and drinking, and they say, "Look at him! A glutton and a drinker, a friend of tax-collectors and sinners!" Yet God's wisdom is proved right by its results.'

[20] THEN he spoke of the towns in which most of his miracles had been performed, and denounced them for their impenitence. [21] 'Alas for you, Chorazin!' he said. 'Alas for you, Bethsaida! If the miracles performed in you had taken place in Tyre and Sidon, they would have repented long ago in sackcloth and ashes. [22] But it will be more bearable, I tell you, for Tyre and Sidon on the day of judgement than for you. [23] As for you, Capernaum, will you be exalted to heaven? No, you will be brought down to Hades! For if the mir-

10

Above:
'Philobiblon' jacket in Swift. The lowercases are originally blue. Design by Max Caflisch.
Right:
'The Revised English Bible', Typography Paul Luna, 1990.

threads and took Dwiggins' ideas and attempts further, in a modern idiom. By 1930, Dwiggins had already created very strict designs with sharply cut off roundings and shallow curves. His main aim was to create type that was perfectly legible, even when small. The stylishness of Swift is approached by typefaces of the '50s and '60s such as Vendome and Trump. Clear, well-contoured forms, which obviously stimulated Unger and went against the Dutch nature. Unger is averse to the flexible, easy-going style of American type design. The name 'Swift' says it in itself: the symbol is a bird, skimming like an arrow through the air, with three-cornered wings, living its life on the wing. In the book sizes, this gave a meaningful, perfectly legible newspaper style, with an individual style disciplined by function. It is tight, modern and full of dynamic character, but not overpowering. With qualities like this, it can also hold its own outside the newspaper environment. In the larger sizes, Swift tends towards the sculptural and abstract; it verges on the wooden - Unger, the 'Masereel'. of typefaces.

Syntax

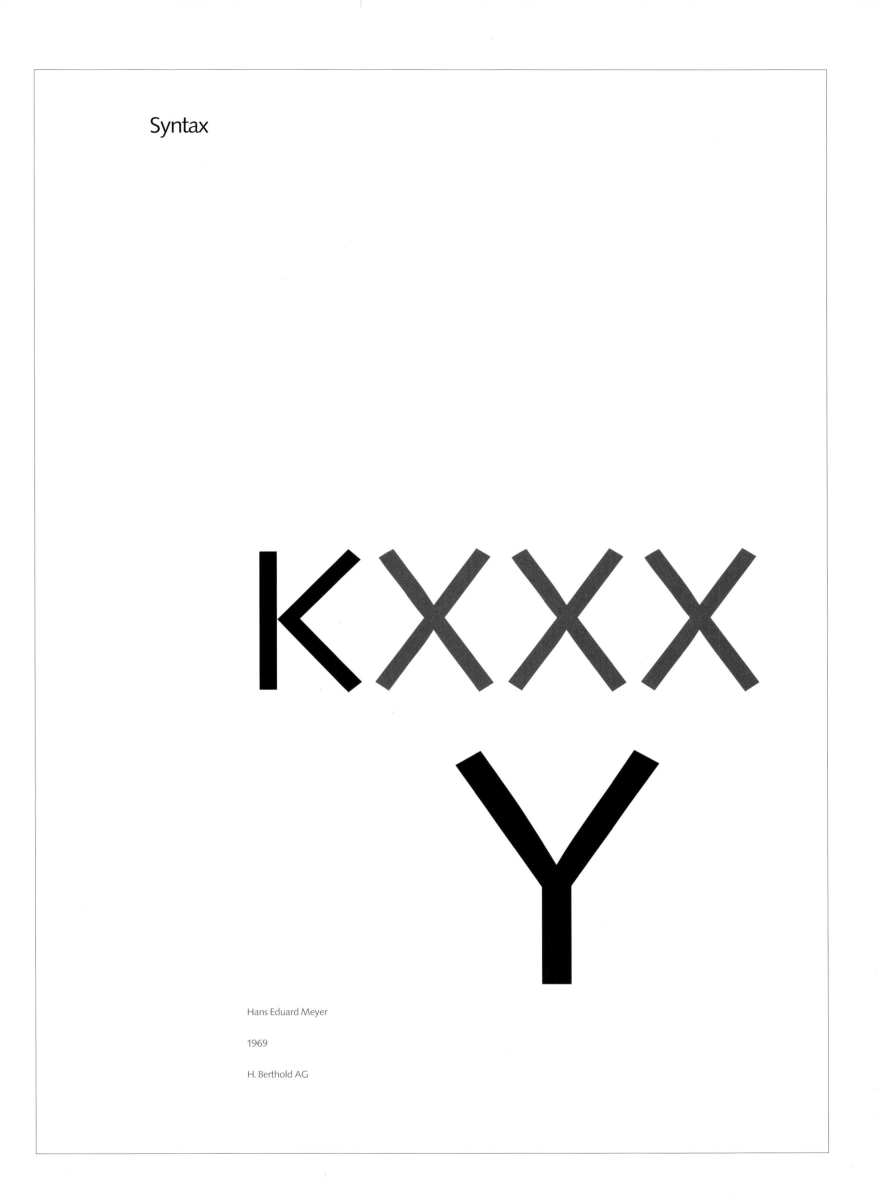

Hans Eduard Meyer

1969

H. Berthold AG

ABCDEFGHIJK
LMNOPQRST
UVWXYZ
1234567890
&
abcdefghijklmn
opqrstuvwxyz
_.,:;!?„""'—

normal
normal
regular

ABCDEFGHIJKLMNOPQRSTUVWXYZ

abcdefghijklmnopqrstuvwxyz

1234567890/%

(.,-:;!?)['',„""»«]—+=/$§*&

ÆŒØÇæœøçáàäâéèëêîìïîóòöôúùüû

italique
kursiv
italic

ABCDEFGHIJKLMNOPQRSTUVWXYZ

abcdefghijklmnopqrstuvwxyz

1234567890/%

(.,-:;!?)['',„""»«]—+=/$§&*

ÆŒØÇæœøçáàäâéèëêîìïîóòöôúùüû

demi-gras
halbfett
medium

ABCDEFGHIJKLMNOPQRSTUVWXYZ

abcdefghijklmnopqrstuvwxyz

1234567890/%

(.,-:;!?)['',„""»«]—+=/$§*&

ÆŒØÇæœøçáàäâéèëêîìïîóòöôúùüû

gras
fett
bold

ABCDEFGHIJKLMNOPQRSTUVWXYZ

abcdefghijklmnopqrstuvwxyz

1234567890/%

(.,-:;!?)['',„""»«]—+=/$§*&

ÆŒØÇæœøçáàäâéèëêîìïîóòöôúùüû

Syntax the first Renaissance-style sans serif

Roman monumental lettering: a Grotesque from the 1st century BC!

How do you make a Grotesque as easy to read as a Renaissance Antiqua? Apart from Eric Gill, the first person to find an answer to this question was probably Hans Eduard Meier, with his Syntax Antiqua.

At the end of the 1920s, Paul Renner's Futura came closest to the goal of making a typeface largely out of geometrical components while at the same time making it attractive and readable. But Renner knew that his Futura would not be the last word in the development of sans serif faces. After all, sans serif faces had not started with Grotesque in the 19th century, but in Rome, 2000 years before, as we will see.

However, Renner was writing as early as 1930, in his work *Mechanised graphics:* "Whether typefaces of the future retain the character of Grotesque styles or return to the style of the older Antiqua, we now enjoy an independence from the historic models which we can use to build on this new beginning. The fact that a style shows the contrast of thick and thin strokes is not in itself a necessity which derived from the requirements of punchcutting. You will understand that I regard the medieval forms as the heart of European typefaces. If, basing our ideas on these medieval forms, we finally draw the consequences of the invention of lettercasting after four hundred years, we will inevitably arrive at the style of our times, the specific style of mechanised graphics."

Renner pointed the way, but did not follow it himself. He was too tied to the tools of his time - compass, set square and ruler. The derivation of the linear sans serif face from the forms of what until then had been known as 'medieval' Renaissance Antiqua would have to wait - until the 1960s and the advent of Syntax. In spite of Gill Sans, which also showed similarities to the classical Antiqua styles.

Schwitters on typography. Obviously
set in the '60s, in Syntax. The front and
back covers used the two-colour line
design from MERZ No. 11.

'Never do what anyone else has done
before. Always do things differently':
Kurt Schwitter's guiding principle.
It still applies to typography and
advertising. Only type designers are

still stuck with the lower-case letters
of Charlemagne and the capitals of
Roman stonemasons: the reader's eye
is slow to adjust to new styles.

Kurt Schwitters
Thesen über Typographie

Typographie kann unter Umständen
Kunst sein.

Ursprünglich besteht keine Parallelität
zwischen dem Inhalt des Textes und seiner
typographischen Form.

Copyright by Ernst Schwitters, Lysaker, und
Verlags AG »Die Arche«, Peter Schifferli, Zürich.
Herausgegeben, gesetzt und gedruckt
von der D. Stempel AG, Frankfurt am Main.
Schrift: Syntax Antiqua mager.
Für den Umschlag dieser Publikation fand das
zweifarbige Linienmotiv der Rückseite
der Zeitschrift MERZ Nr. 11 Verwendung.

165

Many advances in the development of type-styles and their use in this century have come from the Swiss. Faces such as Futura or Helvetica were worldbeaters, although it has to be said that there was a certain amount of luck involved. In this case, there was the fact that both typefaces clearly appeared at the right time - the timing was right, as the marketing people in the States say. Another success was Syntax, the sans serif design by the Swiss typography lecturer Hans Eduard Meier. But it was never the success that Helvetica was. A question of timing, perhaps? But first things first...

Hans Eduard Meier, born in Horgen, near Zurich, in 1922, was trained as a typesetter and after the war worked for UNESCO and as a freelance graphic designer in Paris. In 1949, he returned to his old college, the Zurich school of arts and crafts, to teach the history of type type design, drawing and nature study.

His initial designs for a new type started in 1954. His aim was to combine the clarity of Grotesque types with the warmth and legibility of Renaissance Antiqua. This was a completely new idea at the time, although, as we have already seen, some of Gill's letters pointed in this direction.

As a result, D. Stempel AG of Frankfurt, already owned by Linotype, decided in 1968, despite the existence of a large number of Grotesque styles, to use the new style for hand setting (hot metal was in its last stages).

This was quickly followed by Linotype hot metal matrices and then adapted for photo-setting. Syntax is now even available as a PostScript face from Linotype. Although its success was modest in comparison with of Helvetica or Univers, Syntax was still a definite success, and this was undoubtedly due to its combination of legibility, even in the smallest sizes, and universality. Tt could

Pages from 'Stempel Syntax Antiqua',
1972.

be used with anything set in a sans-serif or Antiqua style.

In his book *Formanalyse und Dokument- ation der Syntax-Antiqua* (Frankfurt, 1969), Erich Schulz-Anker writes: "What was novel about Syntax was its underlying design principle. Its characters are based on the first true typesetting face, Renaissance Antiqua. The formative processes of handwriting remain in the letters of Renaissance Antiqua its dynamism. This principle also underlies the design of Syntax Antiqua, giving it its form and expression. Although Syntax's linear structure shows similarities with the usual (static) linear styles, in terms of form it is totally different."

This shows the specific features of a classical Antiqua: the individual shapes are more pronounced, the word-shapes more exciting, the sentences livelier than in conventional Grotesque styles.

For the capitals, Meier went even further back, to the origins of Latin characters. He took these directly from the early Roman tablet style, with no serifs or varying line thicknesses, i.e. totally linear and hence to some extent the precursor of our Grotesque.

One remarkable feature is that the endstrokes always ended at right angles to the direction of the stroke - as is roughly the case with Syntax capitals.

Let us try to follow Meier's train of thought on the historical development of form. He reduced the characteristic features of all type styles to two factors:

1. The principle of form (static or dynamic)
2. The elements of form (serifs, even or alternating strokes).
Meier combined dynamism as the principle and alternating strokes to produce Syntax. Since then, other typeface designers have followed the same route. The obvious example that springs to mind is Frutiger, which was also first marketed by Linotype. But Meier was the forerunner of a new trend.

It did not take long for sensitive typographers and designers to appreciate the grace and legibility of the new typeface. Jan Tschichold, for instance: "Excellent, highly legible, well-proportioned. Better than the similar Gill Sans." Or Max Caflisch: "I am pleased at the appearance of this Antiqua, one of the best new typefaces around."

Stempel's Syntax Antiqua Extra Bold.

ABCDEF GHIJKLMNOPQ RSTUVWXYZ Syntax Antiqua extrafett abcdef ghijklmnopqrstu vwxyzß 1234567890

D. Stempel AG 6 Frankfurt 70 Postfach 701160 Telefon (0611) 610391

But is Meier justified in calling his sans serif
Syntax a Syntax Antiqua? Schulz-Anker has
this to say: whatever formal importance one
allows to serifs, they are only secondary
design features, which have often been
modified in the development of type as a
means of stylistic interpretation. As far as the
characters are concerned, they are not a vital
component, either in terms of origin or style.
The development of Syntax capitals from the
Roman sans serif linear style is not therefore
an omission, but a concentration on the
essentials of a style, its basic form and
function as characters.

In a word: Antiqua styles do not need serifs.

Times New Roman

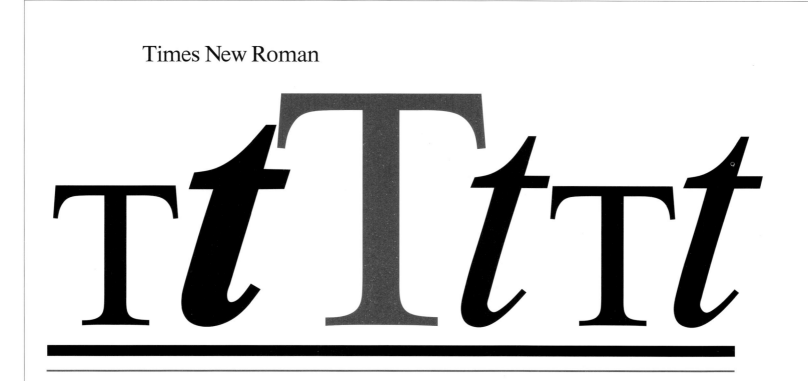

Stanley Morison

1832

Monotype Corporation Ltd.

H. Berthold AG

ABCDEFGHIJK
LMNOPQRST
UVWXYZ
1234567890
&
abcdefghijklmn
opqrstuvwxyz
–.,:;!?„""''—
1234567890

normal
normal
regular

ABCDEFGHIJKLMNOPQRSTUVWXYZ

abcdefghijklmnopqrstuvwxyz

1234567890/%

(.,-:;!?)[''„"""»«]—+=/$§*&

ÆŒØÇæœøçáàäâéèëêíìïîóòöôúùüû

italique
kursiv
italic

ABCDEFGHIJKLMNOPQRSTUVWXYZ

abcdefghijklmnopqrstuvwxyz

1234567890/%

(.,-:;!?)[''„"""»«]—+=/$§&*

ÆŒØÇæœøçáàäâéèëêíìïîóòöôúùüû

demi-gras
halbfett
medium

ABCDEFGHIJKLMNOPQRSTUVWXYZ

abcdefghijklmnopqrstuvwxyz

1234567890/%

(.,-:;!?)[''„"""»«]—+=/$§*&

ÆŒØÇæœøçáàäâéèëêíìïîóòöôúùüû

italique
demi-gras
kursiv halbfett
medium italic

ABCDEFGHIJKLMNOPQRSTUVWXYZ

abcdefghijklmnopqrstuvwxyz

1234567890/%

(.,-:;!?)[''„"""»«]—+=/$§*&

ÆŒØÇæœøçáàäâéèëêíìïîóòöôúùüû

gras
fett
bold

ABCDEFGHIJKLMNOPQRSTUVWXYZ

abcdefghijklmnopqrstuvwxyz

1234567890/%

(.,-:;!?)[''„"""»«]—+=/$§*&

ÆŒØÇæœøçáàäâéèëêíìïîóòöôúùüû

italique gras
kursiv fett
bold italic

ABCDEFGHIJKLMNOPQRSTUVWXYZ

abcdefghijklmnopqrstuvwxyz

1234567890/%

(.,-:;!?)[''„"""»«]—+=/$§*&

ÆŒØÇæœøçáàäâéèëêíìïîóòöôúùüû

Times New Roman

Modern readers aren't really interested in when a given typeface was born; all they care about is whether they can read it or not. Many of today's favourite typefaces came into being more than 200 or even 300 years ago. If the punch cutters had had different materials to work with, they would probably have used different methods, so the irregularities and other features of our favourite typefaces are often due to shortcomings in production methods. Each new design has to compete with the force of habit, but the influence of new typesetting and printing technology will affect the results.

So a successful typeface designer has to be pragmatic. As well as being an artist, you have to balance all the factors involved - habit, technology, current fashion, money and pressure of time. The art lies in submitting to these compromises and still producing something memorable.

And who better to do it than the British, whose everyday life is based on compromise? Like everything else, this attitude has its corresponding typeface: Times New Roman. This, the most successful typeface of all time, owes its origins more to the requirements of technology than to any artistic inspiration. And - as with most Monotype faces - it is virtually impossible to say today who made the original drawings, who made the corrections or who was responsible for all the different versions.

Stanley (Ignatius) Arthur Morison

On the other hand, the story of how this typeface came into existence has been handed down to us in great detail, and is inseparably linked to the name of Stanley Morison. Many books have already been written on Morison's life, so I will limit myself here to describing his role in the creation of Times New Roman.

In 1923, Morison (1889-1967) became typographical adviser to Lanston Monotype in England, and was in charge of designing some families of typefaces on historical models, but also those of Eric Gill, whom he had known since 1914. Although Gill was against industrial production in principle, and showed no interest in designing typesetting faces. He preferred to chisel his letters in stone or paint them on signs. It took years for Morison to convince his stubborn friend to make a few drawings, which he then had cut by the famous punch cutter Charles Malin in Paris. By 1928, this typeface was available in a single size on mono matrices and was first used for the private edition of *The Passion of Perpetua and Felicity.* December 1928 saw the appearance of the official Perpetua - in Eric Gill's book *Art-Nonsense.*

Morison's persuasive abilities also played a major role in the story that follows.

The manager of *The Times* had heard that Morison had been very scathing to an advertising agent about the paper's poor printing and outdated typography. On August 1st 1929, the managing director of *The Times,* William Lints-Smith, met Stanley Morison, who said that there was nothing for it but to re-disign the paper from scratch. The newspaperman was impressed, and promptly offered Morison a position as adviser. Morison thought it over for a while, and finally accepted, on condition that they drop the full stop after the name in the banner head. This was duly done on August 13th and Morison became typographical adviser to *The Times.*

Signs of The Times

In an essay in a special supplement on printing and typesetting called "Newspaper Types", Morison described the history of the typefaces which the newspaper had used, and explained that up to then

THE *TIMES* NEWSPAPER SMALL ADVERTISEMENTS
SERIES Nos. 333, 335 and 327—5¼ point
Unit Arrangement Nos. 325, 329, 330
SET AND CAST IN ONE OPERATION

A Champion pedigree WIRE-HAIRED DOG, 10 months; thoroughly house-trained and obedient; bargain 5gns.; seen London.—Write Box G.21

EXCELLENT OPPORTUNITY of two years' PUPILAGE for Public School boy. Sound, practical, theoretical training large mixed farm. Modern methods, cropping, stock raising, milk production cultivations. Ideal home life with similar students. Premium for period (all in) payable in advance, £150. References, interview essential.—Write Box G.44

HOSPITALITY OFFERED to COUPLE for winter, in gentleman's comfortable house in delightful neighbourhood; golf, bridge, racing; London one hour; central heating and every comfort; private sitting room and bath room. Five guineas each.—Write Box G.41

LADY with attractive Country House and successful Kennels, Hants, would like GUEST or PUPIL; excellent staff; every comfort; car; terms moderate.—Write Box G.43

MANUFACTURER desirous retiring next summer wishes find suitable successor. The business is an interesting one, the technical details of which can be easily acquired, but it requires a good business man to run it. Capital without a wide commercial experience would be useless. Factory capacity fully booked months ahead. 400 employees. £130,000 turnover. Tremendous scope for expansion. Capital required about £40,000. No agents.—Write Box J.1354

1933 Owner-driver Saloon 25 h.p. ROLLS-ROYCE slightly used, cost over £1,600, for £1,325. Also the following three amazing bargains in 1931 models at under £1,000: 25 h.p. 1931 owner-driver Saloon certified; Phantom 2 Saloon "all-weather" 5-seater; and 25 h.p. 1931 7-seater Limousine, indistinguishable from new.—TURNER'S, 19-21, Great Portland Street, W.1. Langham 3966

BUCKINGHAM PALACE (close to).—Excellent FLAT
£425 P.A. 2 reception; lifts, porters; independent hot water; new lease. Also 6 bed-room flat at £400 p.a.—ADAMS and WATTS, 38, Sloane Street, S.W.1. Sloane 6208–9

GARDEN WITH TENNIS COURT
7GNS. KENSINGTON, W.8.—Delightfully FURNISHED HOUSE available; 4 bed rooms, bath room, 2 reception, large garden.—Inspection and recommended by ADAMS and WATTS, 32, P.W. Church Street, W.8. Western 6130

LUXURY FLAT IN MAYFAIR in modern building with very fine rooms.
£500 RENT ONLY Five bed rooms (lavatory basins), 2 bath rooms, 2 reception rooms, excellent domestic offices. PER ANNUM Central heating throughout; constant hot water. Polished oak floors. INCLUSIVE. Electric passenger and service lifts. This amazingly low rent will be accepted, and orders to view should immediately be obtained from TURNER LTD and RANSOM, 127, Mount Street,W.1

MAXIMUM OF SUNSHINE
QUEEN'S GATE GARDENS
£400 P.A. THE advantageous LEASE of a delightful BALCONY FLAT overlooking large square gardens can be secured with early possession. Contains 4 bed rooms, 2 bath rooms, 2 sitting rooms, kitchen, &c. CONSTANT HOT WATER. Absolutely quiet.—Sole Agents, E. R. PRITCHARD and Co., 11a, Gloucester Road, S.W.7. Western 1167 and 1168

N.Y.K. LINE
(JAPAN MAIL)
FORTNIGHTLY PASSENGER & CARGO SERVICE TO EGYPT, CEYLON, STRAITS, CHINA & JAPAN.

	Tons	London	M'seilles	Naples
FUSHIMI MARU	11,000	Sept. 22	Sept. 29	Oct.
HAKOZAKI MARU	10,500	Oct. 6	Oct. 13	Oct. 15
TERUKUNI MARU	11,000	Oct. 20	Oct. 26	Oct. 28

Also calling at Gibraltar.
RETURN FIRST CLASS FARE TO JAPAN from £135
FORTNIGHTLY PASSENGER SERVICES from SAN FRANCISCO via HONOLULU and from SEATTLE and VANCOUVER to JAPAN and CHINA (Through Bookings from Europe).
NIPPON YUSEN KAISHA, 4, Lloyd's Avenue, E.C.3. West End Agency,Cunard Line,26-27,Cockspur St.,S.W.1.

ORIENT LINE TO AUSTRALIA
Carrying His Majesty's Mails
Through Tickets to NEW ZEALAND and TASMANIA.
SPECIAL ROUND VOYAGE TICKET TO AUSTRALIA
FIRST £140 CLASS.

	Tons	London	Palma	Toulon	Naples
ORONTES	20,000	Sept. 16	Sept. 21	Sept. 22	Sept. 24
ORFORD	20,000	Sept. 30	Oct. 5	Oct. 6	Oct. 8
†ORSOVA	12,000	Oct. 14	—	Oct. 20	Oct. 22
ORONSAY	20,000	Oct. 28	Nov. 2	Nov. 3	Nov. 5
ORAMA	20,000	Nov. 11	Nov. 16	Nov. 17	Nov. 19
†ORMONDE	15,000	Dec. 9	—	Dec. 15	Dec. 17

† Tourist One-class steamer.
Managers, Anderson, Green and Co., Ltd., 5, Fenchurch Avenue, E.C.3. T.N., Mon. 3456. West ,End Offices, 14, Cockspur Street, S.W.1; No. 1, Australia House, Strand.

NEDERLAND ROYAL MAIL LINE
Regular SAILINGS from SOUTHAMPTON
MEDITERRANEAN HOLIDAYS
visiting
ALGIERS AND GENOA
Genoa return fares: 1st Class, £22; 2nd Class, £16. OPTIONAL ROUTES FOR RETURN. Apply D. H. DRAKEFORD, 60, Haymarket, S.W.1 (Whitehall 3833), or Travel Agents.

TO JAPAN AND CHINA
BY THE EMPIRE SHORT ROUTE
One service all the way—Canadian Pacific steamers across the Atlantic, Canadian Pacific trains across Canada (connecting with all sailings). Canadian Pacific Empress ships across the Pacific. The route of beauty, speed and variety. Write for Trans-Pacific Booklet.

SAILINGS FROM VANCOUVER
Largest and fastest ships on the Pacific Ocean.
EMPRESS OF CANADA (via Honolulu) ... Oct. 7
Latest connecting steamer from Southampton .. Sept. 23
EMPRESS OF RUSSIA ... Oct. 21
Latest connecting steamer from Southampton .. Oct. 7

NEW ZEALAND & AUSTRALIA
(Fastest route to New Zealand)
To and across Canada by Canadian Pacific—and from Vancouver by Canadian Australasian Line.
To Honolulu, Suva, Auckland and Sydney.
AORANGI .. Oct. 11 NIAGARA .. Nov. 8

INDEPENDENT WORLD TOURS
Your choice of 66 routes. Leaving weekly. Moderate all-inclusive fares. Write for full particulars to:—

CANADIAN PACIFIC
WORLD'S GREATEST TRAVEL SYSTEM.
62-65, Charing Cross (Trafalgar Square), London, S.W.1., 103, Leadenhall Street, London, E.C.3 and Liverpool, Glasgow, Manchester, Bristol, Birmingham, Newcastle, Belfast, Dublin, &c., or Local Agents everywhere.

ANCHOR LINE LIVERPOOL TO BOMBAY AND KARACHI
CALLING AT GIBRALTAR, MARSEILLES, PORT SAID, AND SUEZ.

	London	
†BRITANNIA ..	Sept. 26	†TUSCANIA .. Oct. 24
From Marseilles	Oct. 3	From Marseilles Oct. 30
*CALIFORNIA ..	Oct. 10	†*ELYSIA .. Nov. 22
From Marseilles	Oct. 16	From Marseilles Nov. 30

† First Class and Tourist Passengers.
* Cabin Passengers only. * Calls Port Sudan.
All vessels recognised by Indian Government.
ANCHOR LINE, 88, LEADENHALL STREET, E.C.3. and at 26 and 27, Cockspur Street, S.W.1, or Agents.

TUNBRIDGE WELLS. THE EARL'S COURT HOTEL. Tel. 1511. Finest position on Mt. Ephraim. Passenger lift.

WORTHING TEL. 800 BEACH HOTEL
A first-class charmingly appointed Hotel facing sea (A. A.) Hot and cold running water in every bed room. Each bed has a Vi-spring overlay mattress on a box-spring. Lift to all floors. Telegrams: "Sunny Worthing."

WINCHESTER—ROYAL HOTEL
Quiet, comfortable Family Hotel. Facing Garden. Tel. 31.

SITTING ROOMS, CHELSEA
102, OAKLEY STREET, CHELSEA. FLAX. 6435
NEWLY decorated, modern, and in perfect order; fitted basins, gas fires; breakfast, bath, service; dinners optional; from 25s.; double £3 7s.

PHYLLIS CHAMBERS
Comfortable BED-SITTING ROOMS, each fitted with hot and cold running water. Breakfast, baths, light and attendance. Terms from 25s.—48, Inverness Terrace, Hyde Park, W.2. Tel. No., Bayswater 0423.

QUEEN'S GATE
THREE HOUSES arranged for every need; rooms with private baths. 3gns. Suites from 3½gns. Bed-sitting rooms (fitted basins) 31s. 6d., with breakfast; central heating.—32, Elvaston Place, West. 6051

NEW ZEALAND LINE
To New Zealand and through bookings to Australia.
*RANGITIKI 17,000 tons London Sept. 9
*ROTORUA 12,500 tons Liverpool Sept. 30
*RANGITANE 17,000 tons London Oct. 19
*RANGITATA 17,000 tons London Nov. 16
and thereafter every 28 days.
*First TOURIST and Third Class. * Tourist Class only. Apply N.Z.S. Co. Ltd., Agents (J. B. Westray & Co. Ltd.), 138, Leadenhall Street, E.C.3 (Tel. Avenue 5220); or Trans-Pacific Passenger Agency (W. L. James), 14; Cockspur Street, S.W.1 (Tel., Whitehall 2953).

CANADIAN AUSTRALASIAN LINE AND UNION ROYAL MAIL LINE
TO NEW ZEALAND AND AUSTRALIA.
By any Atlantic Line to Canada or U.S.A., thence via VANCOUVER or SAN FRANCISCO

	From Vancouver	From San Francisco
MAUNGANUI		Sept. 27
AORANGI	Oct. 11	
MAKURA		Oct. 25
NIAGARA	Nov. 8	

† Canadian Australasian Line via Honolulu, Fiji, and Auckland to Sydney. † Union Royal Mail Line via Tahiti, Rarotonga, Wellington to Sydney. Apply the Trans-Pacific Passenger Agency, Ltd. (W. L. James, General Manager), 14, Cockspur Street (third floor), London, S.W.1 (Tel., Whitehall 2953), or for Vancouver Service any office of the Canadian Railways.

P. & O. TOURIST CLASS TO INDIA & AUSTRALIA
Superior accommodation at low fares. Next Sailings: Strathnaver, Oct. 6; Strathaird, Nov. 3. To Bombay, fares from £30; return £52. Australia, from £40; return £72.

P. & O. BRANCH SERVICE
FAST STEAMERS TO AUSTRALIA.
Via Malta, Port Said, Suez, Aden, and Colombo.
ONE CLASS ONLY. FROM £38 single, £68 return.

Ship	Tons	LOND'N	Plymouth	Liverpool
Barrabool	13,000	Sept. 15	Sept. 16	—
Balranald	13,000	Sept. 29	Sept. 30	—
Bendigo	13,000	Oct. 27	Oct. 28	—
*Baradine	13,000	Nov. 24	Nov. 25	—

* Carrying H.M. Mails.

NEW 20/25 h.p. ROLLS-ROYCE, WINDOVER Enclosed Limousine; luxuriously finished; roomy and comfortable face forward seats; on view: immediate delivery.—WINDOVERS, LTD., 477, OXFORD STREET, W.1. Mayfair 7043.

USED ROLLS-ROYCE CARS
1933, 20/25 h.p. ROLLS-ROYCE synchro-mesh WINDOVER Enclosed Limousine.
1933, 20/25 h.p. ROLLS-ROYCE synchro-mesh WINDOVER Sedanca.
1929, 20 h.p. ROLLS-ROYCE Sedanca.
1928, 20 h.p. ROLLS-ROYCE Enclosed Limousine.
1929, 40/50 h.p. ROLLS-ROYCE ENCLOSED LANDAULETTE.
1929, 40/50 h.p. ROLLS-ROYCE Coupe.
WINDOVER. LTD.
ROLLS-ROYCE LONDON RETAILERS and BODY SPECIALISTS
474-477, OXFORD STREET. MAYFAIR 7043.

LONDON: THE MONOTYPE CORPORATION LTD PARIS: SOCIÉTÉ ANONYME MONOTYPE BERLIN: SETZMASCHINEN-FABRIK MONOTYPE G.M.B.H.

Monotype presents Times as newspaper style: 'Newspaper Small Ads'.

173

products, but soon dismissed them as unlikely to succeed.

Of course, as he was still working as an adviser to Monotype, he was bound to concentrate on their products, although they were really designed as book faces. His aim was to see of any of them were suitable for printing on the curved metal cylinders used in rotary presses. In early 1930, Morison had an illustrated volume printed for the proprietor of *The Times,* Major John Astor (later Lord Astor), called *The Typography of* The Times. This was set in a specially-cast 24-point Bembo, and illustrated with over 40 reproductions. This was a very limited edition, just one copy, which the staff presented to their boss at a formal ceremony. Although expensive, the gesture worked: Morison's influence continued to grow.

As was to be expected, the experiments failed, and Morison decided that what was needed was a completely new typeface. Once again, he published a document in support of his decision, a 34-page memorandum, which he presented to a decision-making committee on November 26th. The print run was somewhat longer this time, however: 25 copies, although an over-zealous warehouseman subsequently threw away 14 of them.

Ring out the Old, ring in the New

This presentation must have been very impressive, but the committee did not get to see what Morison's proposed typeface would look like until he presented them with two designs on January 28th 1931: an overhauled Perpetua and a 'modernised' Plantin. The committee decided on the second of these, which was then christened "Times New Roman" (the old typeface being "Times Old Roman").

No-one knows how the first drawings for New Roman came about, because

everything had more or less been a matter of chance. However, experiments were already under way to find the ideal newspaper face. Morison came up with the idea of setting test pages from *The Times* in different typefaces, including Baskerville, Plantin, Imprint and Ionic; he even used a version of Perpetua, with shortened ascenders and descenders.

In the USA, 1922 saw the appearance of C.H. Griffith's Ionic, the first of the "Linotype Legibility Group", a series of typefaces for setting long texts, whose designs were the result of legibility studies. The second member of this group, Excelsior, followed in 1931, and is still one of the most popular newspaper typefaces. Morison considered these competing

SPECIMENS OF 'MONOTYPE'

Times New Roman

AND ITS RELATED SERIES

designed, tested and commissioned by

THE ⟨crest⟩ TIMES

OF LONDON

The Monotype Corporation Limited

was entrusted by *The Times* with the task of cutting the thousands of patterns and steel punches required for the experimental and final versions of this renowned face. *The Times* New Roman Series 327, with its related bolds, italics, etc., and no fewer than five series of related titlings, was approved and adopted by *The Times* in 1931. One year later, The Monotype Corporation Ltd. was permitted to place on the market the entire family (of 12 series, totalling almost 70 different founts) of this face which has been called "THE MOST IMPORTANT NEW TYPE DESIGN OF THE TWENTIETH CENTURY".

Morison's memory was subsequently reluctant and inaccurate when it came to definite dates and facts. What probably happened was that he handed Victor Lardent, a *Times* draughtsman, a photographic enlargement of a page from a Plantin-Moretus specimen sheet of 1905 - the same sample that Monotype had used in 1913 as the model for its Plantin 110.

According to Morison, it was Lardent who designed the initial version of the new typeface, and this was then reworked by Monotype's casting and engraving specialists. No-one now knows exactly who was responsible for what; all we do know is that the final version called for more steel punches that any other typeface before. There seems to be no dispute as to how many there were (1075), but we must remember that each size of course needed its own punches. Morison later said that the total number of them was 14,750. Given the economic situation at the time, we can assume that Monotype was not exactly dismayed at the extra work involved, since *The Times* paid all the costs of its house style.

The new typeface made its first appearance in *The Times* of October 3rd 1932. A few weeks later, it also came available on Linotype and Intertype linecasting machines. It remained the exclusive property of *The Times* for a year before going on general sale. Since it was available on any typesetting machine and also for manual setting, it quickly caught on. The first book set in Times appeared in 1934, and it soon turned up in magazines, mainly in the USA, such as *Time, Life* and *Fortune*.

Bread and butter

What makes Times New Roman so successful is not quite clear. It was not the universal typeface many printers were calling for, but it was a good bread-and-butter typeface for most jobs. In small sizes, it is suitable for text work; the capitals, although a little on the heavy side, are well proportioned, and the italics are really beautiful. Above 12-point, however, some letters no longer fit together. As it was designed for use on newsprint, it comes across as somewhat feeble on better-quality paper. Although Version 327

was not actually designed as a book face, it came to be used as such, instead of Times New Roman Wide (427), which was. Times New Roman Semi-Bold (421), which was initially intended solely for Bible printing at Cambridge University Press, is probably superior up to 10-point.

The bold face (324), Times Bold, is an in-house product, which looks too heavy and narrow, because the strokes are made up from the inside. The bold italic face, on the other hand, is based on the standard italic version, and so does not sit particularly well with the bold.

Monotype gives all its own products a number: the first was Modern 1, the second Old Style 2, and so on, right up to the present. In this case, the italic face shares the same number with the upright: Times New Roman 327 and Times New Roman 327 Italic.

Times Very New Roman

The advent of new printing technology and paper stocks led *The Times* itself to look for a better typeface once more. In 1972, it switched to Times Europa, a Walter Tracy design for Linotype. The only feature this had in common with the old Times New Roman was the 'Times'.

A few years ago, the paper made another switch, to web offset. This time, the owners decided that Times New Roman was better after all, so that things at *The Times* are now what they used to be - as far as the typeface is concerned at any rate.

Times have moved on, however, and, as with any other successful typeface, Times has produced its imitators - not to mention the bootleg versions under other names.

The Times available on any laser printer today is not an especially successful version, so that both Linotype and Monotype now have better products in their ranges - Linotype with Times Ten, Monotype with Original Times New Roman - than the poor imitations from the early days of DTP.

АБВГДЕЖЗИЙКЛМНОПРСТУФ абвгдежзийклмнопрстф
АБВГДЕЖЗИЙКЛМНОПРСТУФ *абвгдежзийклмнопрстф*
АБВГДЕЖЗИЙКЛМНЗ абвгдежзийклмн
АБВГДЕЖЗИЙКЛМНО *абвгдежзийклмн*
АБВГДЕЖЗИЙМ абвгдежзийк
АБВГДЕЖЗИЙМ *абвгдежзийк*
АБВГДЕЖИЙ абвгдежзи
АБВГДЕЖИЙ *абвгдежзл*
АБВГДЕЗИ абвгдеж
АБВГДЕЗИ *абвгдеж*
АБВГДЕЗ абвгдж
АБВГДЕЗ *абвгдез*
АБВГДЕ абвгез
АБВГДЕ *абвгде*

The typographical boiler hen

Just as Stanley Morison searched for the
best possible typeface for the technology of
the time, failed to find it and was reduced
to designing his own, nowadays there are
typefaces better suited to laser printers and
other printing and typesetting processes
than good old Times. But most people
keep away from them, not because they
can't adapt them to their own purposes,
but because they can't be bothered.

But as long as Times New Roman is a
standard laser printer feature - even if not
exactly in its most faithful form - it will
remain the typeface for all reasons.
If Helvetica is the family pig, Times New
Roman must be the boiler hen.

Thanks to its wide distribution, the species
can be expected to survive.

Univers

45 **85**

55

65

75

Adrian Frutiger

1967

Haas'sche Schriftgießerei AG

H. Berthold AG

ABCDEFGHIJK
LMNOPQRST
UVWXYZ
1234567890
&

abcdefghijklmn
opqrstuvwxyz
–.,:;!?„""—

normal normal regular	ABCDEFGHIJKLMNOPQRSTUVWXYZ abcdefghijklmnopqrstuvwxyz 1234567890/% (.,-:;!?)[''„""›‹]—+=/$§*& ÆŒØÇæœøçáàäâéèëêíìïîóòöôúùüû
italique kursiv italic	ABCDEFGHIJKLMNOPQRSTUVWXYZ abcdefghijklmnopqrstuvwxyz 1234567890/% (.,-:;!?)[''„""›‹]—+=/$§*& ÆŒØÇæœøçáàäâéèëêíìïîóòöôúùüû
demi-gras halbfett medium	ABCDEFGHIJKLMNOPQRSTUVWXYZ abcdefghijklmnopqrstuvwxyz 1234567890/% (.,-:;!?)[''„""›‹]—+=/$§*& ÆŒØÇæœøçáàäâéèëêíìïîóòöôúùüû
italique demi-gras kursiv halbfett medium italic	ABCDEFGHIJKLMNOPQRSTUVWXYZ abcdefghijklmnopqrstuvwxyz 1234567890/% (.,-:;!?)[''„""›‹]—+=/$§*& ÆŒØÇæœøçáàäâéèëêíìïîóòöôúùüû
gras fett bold	ABCDEFGHIJKLMNOPQRSTUVWXYZ abcdefghijklmnopqrstuvwxyz 1234567890/% (.,-:;!?)[''„""›‹]—+=/$§*& ÆŒØÇæœøçáàäâéèëêíìïîóòöôúùüû
italique gras kursiv fett bold italic	ABCDEFGHIJKLMNOPQRSTUVWXYZ abcdefghijklmnopqrstuvwxyz 1234567890/% (.,-:;!?)[''„""›‹]—+=/$§*& ÆŒØÇæœøçáàäâéèëêíìïîóòöôúùüû

'Mr. Univers'

Adrian Frutiger is an almost ideal combination of the abilities a typeface designer should have: a fascination with the free interplay of black and white, and an ability to think in two dimensions. The preference for plant-like structures which shows in his art is combined with an almost unparalleled industry and craftsmanship. Even in his spare time work, he never loses sight of the point of a composition. With traits like these, he was almost bound to be a typeface designer for, as well as a feel for the form of individual letters, the designer must never forget that ultimately they must be subordinate to the word and line.

A Swiss in Paris

It is no accident that Adrian Frutiger has been working in Paris since 1952, following a thorough basic education in Switzerland. The combination of Swiss thoroughness and persistence with Gallic charm is a characteristic of his typeface designs, which are neither overbearing and solemn like some by his German colleagues or pragmatic and conservative like those of some British designers.

The typeface which brought Frutiger worldwide fame has its origins in exercises from as far back as 1949, when he was a 21-year-old student at the Zurich school of arts and crafts. What was new about Univers was that, for the first time, a family of typefaces was treated as a single entity, giving typographers a wide range of potential design combinations. Even the work on the new typeface at Deberny & Peignot departed from the normal method of cutting the first face and then building the family up gradually: all the versions were there right from the start.

Grotesque but subtle

One school of thought maintains that Grotesque is impoverished, void of expression or life. But another claims that it has all the essential features of a typeface, without embellishments such as serifs, etc. The eye is more sensitive than many measuring instruments, and picks up the slightest design fault, which can be a particular problem with Grotesque. Univers, on the other hand, is not based on a rigid design principle, but on careful balancing of optical factors.

First and foremost there is the medium face (Univers 55), from which all the rest were developed. The black-white balance is such as to make it suitable for long texts, even books, although setting books in sansserif is still unusual even today. Although other languages use fewer capitals than German, Frutiger put great care into matching the stroke width differences between upper and lower case, giving an overall calm effect. For its time (work on Univers began in 1954), the x-height is relatively large.

All typefaces within the same weight share a common 10s figure. In this case, all the standard faces are numbered in the 50s; the light faces in the 40s and the bold in the 60s and 70s, and so on. Odd-numbered faces are upright, even-numbered italic. That may not sound logical, but it makes sense once you've seen the table. The higher the units figure, the narrower the italic face. Since the strokes in any one size are all the same width, they can only be classified by the spacing within and between letters. There are natural limits to this, so that separate categories had to be set up for the boldest and most extended face (Univers 83) and the condensed light (Univers 39). While these two typefaces are still separate within the Univers

180

univers

181

Diagram of original Univers series of 1954: other fonts have been added since.

					monde 39
	monde 45	*monde* 46	monde 47	*monde* 48	monde 49
monde 53	monde 55	*monde* 56	monde 57	*monde* 58	**monde** 59
monde 63	**monde** 65	*monde* 66	**monde** 67	***monde*** 68	
monde 73	**monde** 75	***monde*** 76			
monde 83					

A calm-type body: the ascenders
are only slightly higher than the
capitals, which are only slightly
bolder than the lower-case letters.

Slanting Univers: on the centreline
of the upright character, the vertical
form slants: 55 becomes 56.

182

family, Linotype subsequently took its numbering system to the limits with Helvetica, extending the series from the ultralight (25) to the extra bold (95), plus condensed, extended and italic versions. The Univers family originally consisted of 21 typefaces, later extended to 35. Any of these can be combined without a loss of aesthetics, enabling them to be used for a wide range of typographic requirements.

Hot and cold running type

When Deberny & Peignot engaged Adrian Frutiger to design a new sans-serif face, they also asked him to design it both for lead setting (known as 'hot metal' because it uses molten metal in the casting) and for one of the first photosetting machines ('cold type'), the Lumitype/Photon.

Frutiger tackled the problems inherent in these requirements systematically. All the typefaces for the Lumitype have a uniform capital height, and fit into a 36-unit system (as opposed to the 18-unit system which was common at the time). In many cases, fast-exposure photosetting makes demands on a typeface which are the opposite of those made by lead. Weak dots on the 'i's or punctuation marks risk being 'burnt out',

and have to be strengthened. Points where a number of strokes meet (as with the 'W', for instance) must be opened out considerably, but not so much that this shows up in the larger sizes for, in the last resort, photosetting (like modern digital systems) has to use just one model for all print sizes. Some of these details were intended to make up for mechanical or physical shortcomings of the typesetting technology of the time, and as such are no longer required; others meet visual rules, but have fallen victim to the demands of digital technology (such as the use of hints).

The universal typeface

Classic typefaces are not designed: only posterity can decide what becomes a classic. With Univers, it took nearly 15 years before it was widely known and available in all sizes. Its cool, systematic nature was what the prevailing rationalism of typography in the late 1970s was looking for. The aspiration to Total Design, as formulated by Wim Crouwel and Ben Bos in founding their design studio of that name in 1964, was precisely what Frutiger's design offered, and Univers has since become something of a national style in Holland. In the USA and Germany, on the other hand, graphic designers tended to opt

An even appearance calls for uneven lines. This design hides T, B and H in Univers 65.

for Helvetica, which they saw as even more untainted and timeless.
Otl Aicher's designs for the Munich Olympics of 1972 showed that, in the right hands, Univers could look quietly cheerful rather than cold, although that is one characteristic the prophets of Helvetica definitely did not intend.

Like any other typeface, Univers has been subject to continuous changes in designer fashions. However, word seems to have got around that elegance, cheerfulness and neutrality need not be mutually exclusive, and that, in the right hands, this is a typeface which can be used for a wide variety of purposes without hogging the limelight while still retaining its own distinctive personality. Thus endowed, Univers still has a successful future ahead of it as a modern classic.

Biographical notes

Adrian Frutiger was born in Interlaken, Switzerland on May 24th 1928. After an apprenticeship as a typesetter, he studied at the Zurich school of arts and crafts before moving to Paris in 1952 and becoming artistic manager at the Deberny & Peignot type foundry. He now runs a graphics studio in Arcueil, near Paris, with Bruno Pfäffli. As well as

designing his famous typefaces, he has worked on house styles and corporate design for a number of industrial companies. He designed the lettering for the Paris Metro and Orly airport and a new information system for Charles de Gaulle airport. He was responsible for the worldwide standard typeface OCR-B and for adapting typewriter and composer typefaces for IBM. In 1968, he was appointed permanent adviser to D. Stempel AG (later Linotype AG), who have since produced all Frutiger's typefaces.

Typefaces by Adrian Frutiger:

(This list gives only the manufacturer of the original version and the first year in which it appeared: it does not include later versions, such as the transfer from hot metal to photosetting, or versions produced under licence.)

President. Hot metal, Deberny & Peignot, Paris 1952
Phoebus. Hot metal, Deberny & Peignot, Paris 1953
Ondine. Hot metal, Deberny & Peignot, Paris, 1953
Meridien. Hot metal, Deberny & Peignot, Paris, 1954
Univers. Hot metal, Deberny & Peignot, Paris 1954/57

Egyptienne. Deberny & Peignot, Paris
1955/56
Concorde. Line casting matrices,
Sofratype, Paris 1959
EDF-GDF Alphabet. House style,
Electricité de France - Gaz de France,
Paris 1959
Opera. Line casting matrices, Sofratype,
Paris 1961
Apollo. Monotype Corporation Ltd.,
Redhill 1962
Alpha-BP. House style, British Petroleum
Co., London 1965
Serifa. Hot metal, Bauer typefoundry,
Frankfurt am Main 1967
Devanagari. Monotype Corporation Ltd.,
Redhill 1967
Tamil. Project, 1967
OCR-B. European Computer
Manufacturers Association, Geneva
1968
Dokumenta. Basler National-Zeitung,
Basle 1969
Roissy Alphabet. Charles de Gaulle
airport, Paris 1970
Facom Co. House style, Paris 1971
Brancher. House style, Paris 1972
Iridium. D. Stempel AG, Frankfurt am
Main 1972
Alphabet Métro. House style, Paris
Metro, Paris 1973
Frutiger. D. Stempel AG, Frankfurt am
Main 1975/76
Glypha. D. Stempel AG, Frankfurt am
Main 1979
Digital face. Monitor displays at Charles
de Gaulle airport, Paris 1980
Icone. D. Stempel AG, Frankfurt am Main
1980
Breughel. D. Stempel AG, Frankfurt am
Main 1981
Versailles. D. Stempel AG, Frankfurt am
Main 1983
Linotype Centennial. Linotype AG,
Eschborn 1987
Avenir. Linotype AG, Eschborn 1988

184

*Drawing by Adrian Frutiger: a
single closed line defines both
internal and external form.*

Van Dijck

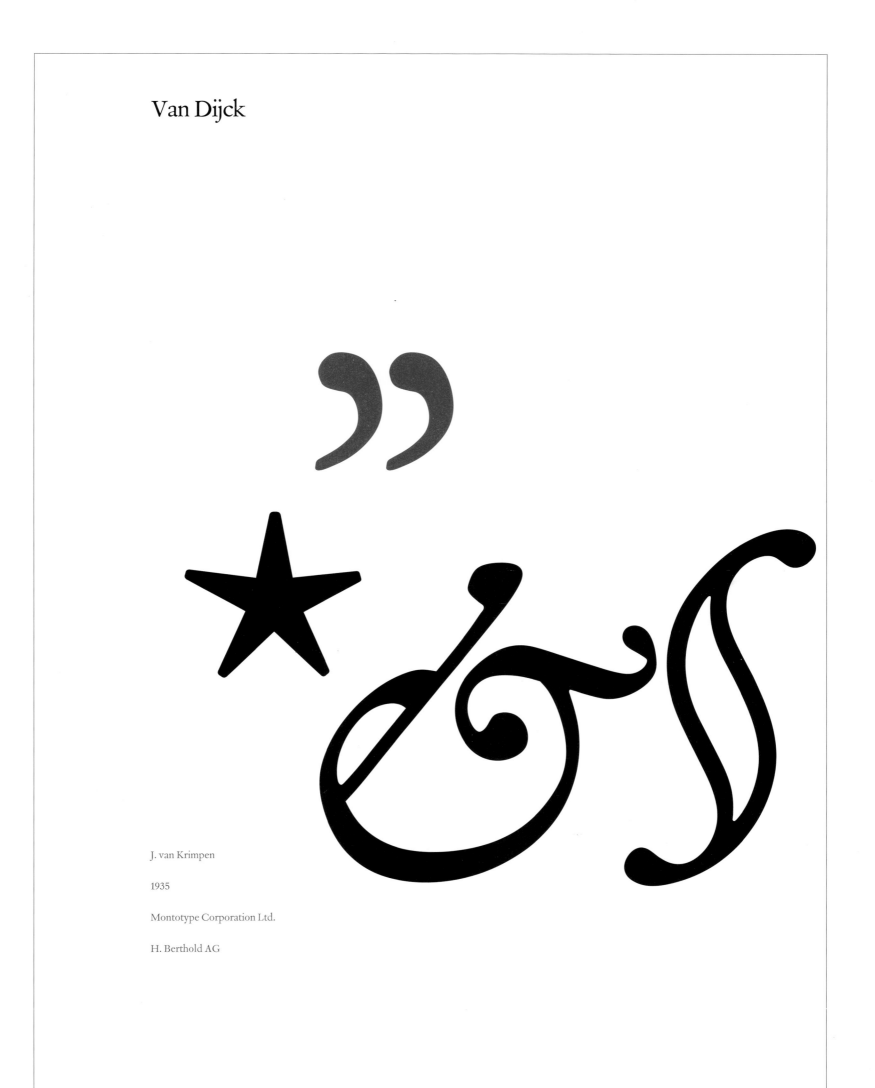

J. van Krimpen

1935

Montotype Corporation Ltd.

H. Berthold AG

Van Dijck

ABCDEFGHIJK
LMNOPQRST
UVWXYZ
1234567890
&
abcdefghijklmn
opqrstuvwxyz
-.,:;!?„"''__
1234567890

ABCDEFGHIJKLMNOPQRSTUVWXYZ

abcdefghijklmnopqrstuvwxyz

1234567890/%

(.,-:;!?)['',,""»«]—+=/$§★&

ÆŒØÇæœøçáàäâéèëêíìîóòöôúùüû

ABCDEFGHIJKLMNOPQRSTUVWXYZ

abcdefghijklmnopqrstuvwxyz

1234567890/%

(.,-:;!?)['',,""»«]—+=/$§★&

ÆŒØÇæœøçáàäâéèëêíìîóòöôúùüû

ABCDEFGHIJKLMNOPQRSTUVWXYZ

abcdefghijklmnopqrstuvwxyz

1234567890/%

(.,-:;!?)['',,""»«]—+=/$§★&

ÆŒØÇæœøçáàäâéèëêíìîóòöôúùüû

From Holland to England to the whole world: Van Dyck

Dutch Renaissance Antiqua capitals, 16th century.

Nowadays, the Dutch are one of the most progressive peoples in the world, and their typography is no exception. They have the only school for typographers in existence, and have already produced a number of interesting high-class new typefaces. But the new Dutch typeface and printing movement did not arise out of nothing: even in the Renaissance, the Dutch were in the vanguard of the type-face and book printing industry.

What followed the Aldine and Garamond, after the start of a new typeface era, which for the first time combined Roman capitals and Carolingian lower-case letters in a single alphabet?

The Dutch: and, at their head, someone whose typefaces are still very much with us in photosetting and even desktop publishing - Christoffel Van Dyck.

Looking at Berthold's Van Dyck today, we tend to use psychological criteria which have more to do with our expectations than legibility or function. If we look at one of these modern versions, Van Dyck comes across as cool and fresh rather than soft and warm, rather masculine, modern and eye-catching, rich and precious, active and dynamic.

Looking at one of Berthold's more recent Van Dyck samples confirms this impression absolutely. On page 2 of its type samples, they provide a character sketch of each typeface, as a kind of aid to the inexperienced, so to speak, since these portraits have about as much value as horoscopes.

To the experienced type designers, however, Van Dyck still looks very readable. It offers an escape from the well-trodden path of Times and Helvetica, giving printed matter an individual, modern, relaxed look.

We owe this Dutch Renaissance typeface to one of the 17th century's outstanding punch cutters, Christoffel Van Dyck. It first came into being in Amsterdam around 1650. Who was Van Dyck?

At that time, the Netherlands had a thriving printers' and punch cutters' guild. Holland occupied the position now taken by the Frankfurt Book Fair. It was at the centre of the world book trade in the 17th and 18th centuries and this was largely thanks to the Elsevier family. Christoffel van Dyck (or Dijck) (1610-1670) was another of the immortals: he seems to have been the leading Dutch typographical artist of the 17th century.

C. JULIUS SOLINUS
ADVENTO S.

UM & aurium clementia & optimarum artium studiis præstare te cæteris sentiam, idque oppido expertus, de benevolentia tua nihil temere præceperim, reputavi examen opusculi istius tibi potissimum dare, cujus vel industria promptius suffragium, vel benignitas veniam spondeat faciliorem. Liber est ad compendium præparatus, quantumque ratio passa est, ita moderate repressus, ut nec prodiga sit in eo copia, nec damnosa concinnitas. Cui si animum propius intenderis, velut fermentum cognitionis magis ei inesse, quam bratteas eloquentiæ deprehendes. Exquisitis enim aliquot voluminibus studuisse me impendio fateor, ut & à notioribus referrem pedem, & remotis largius immorarer. Locorum commemoratio plurimum tenet, in quam partem ferme inclinatior est universa materies. Quorum commeminisse ita visum est, ut inclutos terrarum sinus, & insignes tractus maris, servata orbis distinctione, suo quæque ordine redderemus. Inseruimus & pleraque differenter congruentia, ut si nihil aliud, saltem varietas ipsa legentium fastidio mederetur. Inter hæc hominum & aliorum animalium naturas expressimus. Addita pauca de arboribus & lapidibus exoticis, de extimarum gentium formis, de ritu dissono abditarum nationum, nonnulla etiam digna memoratu, quæ prætermittere incuriosum videbatur, quorumque auctoritas, quod cum primis industriæ tuæ insinuatum velim, de scriptoribus manat receptissimis. Quid enim proprium nostrum esse possit, cum nihil omiserit antiquitatis diligentia, quod intactum ad hoc usque ævi permaneret? Quapropter quæso ne de præsenti tempore editionis hujus fidem libres, quoniam quidem vestigia monetæ veteris persequuti opiniones eligere maluimus potius quam innovare. Ita si qua ex istis secus quam opto in animum tuum venerint, des velim infantiæ meæ veniam. Constantia veritatis penes eos est quos sequuti sumus. Sicut ergo qui corporum formas æmulantur, ante omnia effigiant modum capitis, nec prius in alia membra lineas destinant, quam ab ipsa, ut ita dixerim, figurarum arce auspicium faciant inchoandi: nos quoque à capite orbis, id est, Urbe Roma principium capessemus, quamvis nihil super ea doctissimi auctores reliquerint, quod in novum nostrum præconium possit suscitari, ac supervacuum pæne sit relegere tramitem decursum tot annalibus. Ne tamen prorsus dissimulata sit, originem ejus quanta valemus persequemur fide.

C. JULII

C. JULII SOLINI
ΠΟΛΥΗΙΣΤΩΡ.

CAPUT I.

DE ORIGINE URBIS ROMÆ,
& temporibus ejus, de diebus intercalaribus, de genitura hominis, & his quæ memorabilia in hominibus fuere, de alectorio lapide.

A

SUNT qui videri velint Romæ vocabulum ab Euandro primum datum, cùm oppidum ibi offendisset, quod extructum antea Valentiam dixerat juventus Latina: servataque significatione impositi priùs nominis, Romam Græcè Valentiam nominatam: quam Arcades quoniam in excelsa habitassent parte montis, derivatum deinceps, ut tutissima urbium arces vocarentur. Heraclidi placet, Troja capta quosdam ex Achivis in ea loca, ubi nunc Roma est, devenisse per Tiberim, deinde suadente Rome nobilissima captivarum, quæ his comes erat, incensis navibus posuisse sedes, instruxisse mœnia, & oppidum ab ea Romen vocasse. Agathocles scribit Romen non captivam fuisse, ut suprà dictum est, sed ab Ascanio natam, Æneæ neptem, appellationis istius causam fuisse. Traditur etiam proprium Romæ nomen & verum magis, quod nunquam in vulgum venit, sed vetitum publicari, quandoquidem quo minùs enuntiaretur cærimoniarum arcana sanxerunt, ut hoc pacto notitiam ejus aboleret fides placitæ taciturnitatis. Valerium denique Soranum, quòd contra interdictum id eloqui ausus foret, ob meritum profanæ vocis neci datum. Inter antiquissimas sanè religiones sacellum colitur Angeronæ, cui sacrificatur ante diem duodecimum calendarum Januariarum: quæ diva præsul silentii istius prænexo obsignatoque ore simulacrum habet. De temporibus Urbis conditæ ambiguitatum quæstiones excitavit quòd quædam ibi multò ante Romulum culta sint. Quippe ante aram Hercules, quam voverat si amissas boves reperisset, punito Caco patri inventori dicavit. Qui Cacus habitavit locum, cui Salinæ nomen est: ubi trigemina nunc porta. Hic, ut Gellius tradit, cum à Tarchone Tyrrheno, ad quem legatus venerat missu Marsyæ regis, socio Megale Phryge, custodiæ foret datus, frustratus vincula, & unde venerat redux, præsidiis amplioribus occupato circa Vulturnum & Campaniam regno, dum attrectat etiam ea quæ concesserant in Arcadum jura, duce Hercule, qui tunc forte aderat, oppressus est. Megalen Sabini receperunt, disciplinam augurandi ab eo docti. Suo quoque numini idem

A

Hercules

Above: C. Salmasati, 'Plinianiae'.
Exercitations in Caji Julii Solini.
Printed by: Johannes van de Water, 1689.
Below: Johannes Calvinus,
'Novioduensis, opera omnia, in novem
tomos digesta'.
Printed by: Johannes Jacobus Schipper,
Amsterdam 1671.
Cut by Van Dyck.

IOANNIS
CALVINI
NOVIODVNENSIS
OPERA OMNIA;
IN NOVEM TOMOS DIGESTA.

Editio omnium novissima, ad fidem emendatiorum Codicum quam accuratissime recognita, & Indicibus locupletissimis non sine maximo labore & studio adornata.

Tomorum seriem, & quam quisque complectatur materiam, proxima à Præfatione pagina docebit.

AMSTELODAMI,
Apud Viduam JOANNIS JACOBI SCHIPPERI,
M DC LXXI.

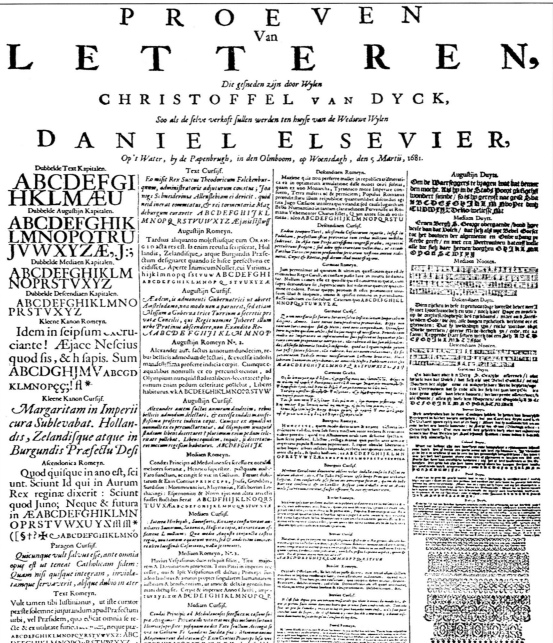

1681. Elsevier prints typeface advertising. The Frutiger or Lange of the Dutch publishing and typeface house was called Christoffel van Dijck. Some of his typefaces are shown in this wonderfull typesheet. They became a major export, and were especially popular in England.

Augustijn Cursijf.

Ædem, is admonenti Gubernatrici ut abiret Amstelodamo, non modo non a paruerit, sed etiam Missum a Guberna trice Turrium a secretis privatæ Concilii, qui Regis nomine Juberet illum urbe Protinus abscendere, non Exaudito Re-
ÆAABCDE FGHJI KLM MNOP

Augustijn Romeyn N°. 2.

Alexander aute factus annorum duodecim, rebus bellicis admodum de lectari, & excelsæ indolis

A B C D E F G H I J K L M N
O P Q R S T U V W X Y Z a b
c d e f g h i j k l m n o p q r ſ s t
u v w x y z ÿ &

Any oversize blocks are set jutting into
the top margin if extra space is required
The demy quarto pages make a splendid prize
ABCDEGHJKMNQRSTUVWXYZ

Originally a punch cutter working as a freelance for a number of type foundries, Van Dyck started his own foundry in 1647-8, and became the appointed supplier to the Elseviers. He is also credited with the creation of his own version of the Dutch Antiqua and Italica. In any event, his contemporaries were unusually fulsome in their praise. The widow of Daniel Elsevier, for instance, who published a sample sheet of typefaces Van Dyck produced for the Elseviers in 1681, says there that he was a great master of his own and future times. This is absolutely right, if we take his current relevance as a guide.

Joseph Moxon, a contemporary student of English book printing, described Van Dyck's typefaces as 'perfect in all respects which make a typeface regular and beautiful'.

Some modern authorities, and not just the Dutch, are full of praise for Van Dyck's Antiqua. Stanley Morison even rates it superior to Garamond's typefaces in aesthetic terms. Morison points out that typefaces derived from classical forms often outdo the originals: this was the case with Garamond and Christoffel Van Dyck, especially in terms of its printing qualities.

The practically-minded Dutch typecutters changed the French Antiqua drawings to bring them more into line with contemporary hand press requirements, so they did not smear so much. With the primitive print technology of the time, the small loop in the 'a' was as likely to fill in as the even smaller loop in the 'e' in French typefaces. Even the graceful serifs of the capitals suffered under the impact of the unwieldy hand presses.

Comparing Garamond and Van Dyck Antiqua, the Dutch version seems somewhat more cumbersome, but it was better suited to the print technology of the times. Its chief feature is the reduction in average lower-case height at the expense of the ascenders and descenders, which makes the latter visibly shorter.

In their efforts to eliminate excesses, the Dutch straightened the curves of the serifs, blunted their points in both upper and lowercase and so created a sober but highly legible, and larger, typeface.

In assessing Van Dyck's Antiqua, we are forced to rely on the Elsevier type sample and printed works of the time. The italics, on the other hand, still exist in their original matrices, and are now in the possession of the Enschede type foundry

M O N O T Y P E

K g o ç d o q W Q Y £ P l
S e N g q H ? E
Y 9 X 1 $ A 3 Æ p
M W f ~" 7 T R P ^ «
ffl P O T R P fl ! i Y
T k G R t G

VAN DIJCK – is a worthy representative of all that was best in the first great age of type design in Holland. It was recut by Monotype in 1937 under the supervision of Jan van Krimpen and this new offering has perfectly captured all the original characteristics of this classic face. Van Dijck contains some natural irregularities which mean that the face demands good quality printing to be seen at its best. Van Dijck has an authoritative, traditional feel and is most suited to book work although it can be used to great effect in quality items such as company reports.

T Y P O G R A P H Y

Van Dyck advert today. Monotype shows
how an old typeface can be used to create
fresh-looking layouts.
Design: Paul Harpin.

in Haarlem. In contrast to Van Dyck's Antiqua, the italics are relatively condensed.

The lower-case alphabet shows the same enlargement of the x-height at the expense of clear linespacing and simplicity of cutting. The capital alphabet is also very plain, simply a skewed version of the Antiqua capitals. The only exceptions are the calligraphic forms of the J and Q and the old shaped Y with its curved shanks.

In the late Renaissance, the use of italic typefaces changed. In the 16th century, whole books had been set in them, especially those which contained verses. It was completely independent of Antiqua. In the 17th century, however, people began to regard the italics as a highlighted version of Antiqua. This happened with Van Dyck's typefaces, as we can see in the sample sheet, where the italics are already used as highlights to Antiqua.

Today, there are new versions, such as those by Monotype and Berthold, which retain the original Dutch version's vitality and modernity. "If you want to make it individual, readable and elegant, why not use Van Dyck?". After all, the Dutch have always had more to offer than just cheese ...

Walbaum

J.E. Walbaum

1800

Günter Gerhard Lange

1975

H. Berthold AG

ABCDEFGHIJK
LMNOPQRST
UVWXYZ
1234567890
&
abcdefghijklmn
opqrstuvwxyz
_.,:;!?„"'—
1234567890

normal normal regular	ABCDEFGHIJKLMNOPQRSTUVWXYZ abcdefghijklmnopqrstuvwxyz 1234567890/% (.,-:;!?)['‘„""»«]−+=/$§*& ÆŒØÇæœøçáàäâéèëêíìïîóòöôúùüû
italique kursiv italic	*ABCDEFGHIJKLMNOPQRSTUVWXYZ* *abcdefghijklmnopqrstuvwxyz* *1234567890/%* *(.,-:;!?)['‘„""»«]−+=/$§*&* *ÆŒØÇæœøçáàäâéèëêíìïîóòöôúùüû*
demi-gras halbfett medium	**ABCDEFGHIJKLMNOPQRSTUVWXYZ** **abcdefghijklmnopqrstuvwxyz** **1234567890/%** **(.,-:;!?)['‘„""»«]−+=/$§*&** **ÆŒØÇæœøçáàäâéèëêíìïîóòöôúùüû**

Walbaum

A classic for the moderates

Justus Erich Walbaum (1768-1837).

Walbaum is regarded as the most human of all classical types. What does this mean in a typeface? Language and writing are rooted so deeply in time and in man that the writing of a period is inevitably a reflection of the basic conditions of the time and reacts to changes like a barometer.
Writing reflects both the general spirit of the time and the subjectivity of the individual. Designing letters is one of the most difficult and sensitive tasks there is.

The Enlightenment and rationalism, its yardstick, had a profound effect on the social, political and cultural life of the time. They promoted individualism, a belief in progress and the emancipation of man. This made the Enlightenment the leading philosophical movement in 18th-century Europe. The French Revolution was intended to enforce the rights of man: the bourgeoisie replaced the aristocracy. Ultimately, everything led to classicism, which now differentiated the Roman from the Greek and put the latter on a pedestal as the ideal in art and culture. This spread to all social strata and all art movements. Classicism was a universal style. While the change in outlook happened very quickly and very visibly in art and architecture, its effects on type were slower and less sudden.

The first signs of rational, scientifically oriented thinking had already emerged under Louis XIV. In 1692, he ordered the most beautiful and correct typeface to be created for the Imprimerie Royale in Paris. It was to be something quite unique, to replace the existing typefaces of Garamond, Le Bé and Grandjean, which were seen as obsolete. The task was given to the Academy of Sciences. For the design, a mathematical grid was created. The new style was called Romain du Roi, and was the first to show classical features: a vertical shading axis, fine horizontal thin strokes, highly contrasting base and thick strokes, the capitals the same height as the lower-case ascenders. The capital italics were simply a slanted version of the upright ones. Romain du Roi was finally completed in 1754. Only the royal printers were allowed to use it, but during the Revolution Jean Marat made off with four of their presses and their types, and used them to set and print his revolutionary pamphlets.

In 1757, John Baskerville created a transitional Antiqua in England, which he presented in a new, proper typography, moving away from the decorative to glorious use of space. Already, Baskerville showed more contrast between thick and thin strokes, a vertical axis and relatively straight serifs, although these were still slightly grooved. To give this delicate style its full effect, he also invented a blacker printing ink and smoother paper.

The Parisians then thought about how to circumvent the King's veto on copying Romain du Roi. Pierre Simon Fournier, a local type founder (1712-1768), designed a style which bears his name today. Fournier is a mix of Renaissance and classical elements.

The Didot printing, foundry and publishing dynasty not only reformed Fournier's point system, but also brought out the first pure-style classical Antiqua. In 1784, François Ambroise Didot (1730-1804) published an Antiqua with hair-thin straight, shallow serifs. The letters were narrow, vertical and full of contrast. They were created by his son, Firmin Didot (1764-1836), who went on to introduce new styles and refined these features to perfection. The interesting thing here is that they embodied the new idea of what italics were for: no longer a text face in their own right, as in the Renaissance, but as a subordinate to the upright style.

Didot's styles were perfect and contemporary, and ousted the Renaissance styles almost completely. In fact, they were so modern that the English used the term as a category in

itself, and have continued to do so right up to the present day. But, even at the time, criticism of these artificial styles could be heard. Their delicacy was difficult to reproduce in print so that they quickly wore down, and their greater contrast than, say, Garamond made them difficult to read.

Napoleon: I want beautiful editions and elegant bindings - and I've got the money!

Their main competitor lived in Parma, in Italy: Giambattista Bodoni (1740-1813). He rose from 'king of printers' to 'printer of kings', and his fame overshadowed that of the Didots. His influence on European and American book printing has been more permanent than that of the French, and has lasted to our day. His fame is shown by Georg Jacob Decker's journey to Parma in 1788. Decker was printer to Frederick the Great of Prussia, and bought matrices for Greek and Latin styles from Bodoni.

Bodoni's work falls into two periods. Until around 1790, he followed in the footsteps of Fournier and Didot, designing similar styles and concentrating on typography and printing. The second period, when he was less dependent on commissions, was devoted more to his own styles and presenting them more nobly. He created innumerable variations, each one designed for a specific purpose, so that there is no such thing as the Bodoni. Like Baskerville and Didot, or Unger and Göschen in Germany, he felt that books had no need of decoration, but that the type, clean, sharp-edged printing and arrangement alone gave them life. His discerning approach showed not only on a large scale, but also in the smaller pocket format.
As a print quality, 'Bodoni black' became the goal of all European printers. In the 20th century, Bodoni has enjoyed an enormous revival, reflecting as it does our present post-modern neoclassical mood.
After Baskerville's death, the English had followed Bodoni but using Baskerville's modified forms, which were easier to print and read. New classical styles emerged, which are known as Scotch-Roman.

In Germany, things were different. Here, the Enlightenment meant less an intellectual rationalism than

humanism and 'internalised' rationality. This led to Pietism, Sturm und Drang and ultimately to the classical Goethe period.
After Gutenberg's invention of printing type, black-letter styles such as Schwabacher and Fraktur had emerged as the German national style. Antiqua continued in use alongside, being used mainly for religious Latin texts. The Enlightenment and Greek influence made themselves felt mainly amongst the educated classes, who also wanted the lighter, clearer Antiqua rather than the 'angular, ornamental monks' style' or 'runes' (the publisher Bertuch, 1793). The feud between Antiqua and black letter had started. On the other hand, there was a reaction against French political domination, so that the wars of liberation in Germany were followed by a swing towards Gothic styles and Antiqua was not finally accepted until the 20th century.

The francophile Unger is seen as the German 'Didot'. He was a type designer, caster, printer and author, and a friend of Didot's. Didot made him sole agent for his typefaces in Germany.

How baking moulds came to influence German style

Justus Erich Walbaum (1768-1837) was the self-taught son of a pastor. He was apprenticed to a spice dealer and merchant in Brunswick and became a

merchant himself. There was a noticeable shortage of expensive wooden baking moulds. Walbaum made the tools needed from old dagger sheaths and started cutting moulds. Talented and hard-working, he was soon cutting steel as well, and found this a lucrative business. He put his merchant's hat aside. In 1796, the former imperial free city of Goslar allowed him to set up a type foundry; but poor Goslar was soon too small for his ambitious business. Walbaum could see that the leading literary spirits of the time were gathered in the artistic, enlightened dukedom of Weimar and the University of Jena: so he followed a suggestion by the publisher Friedrich Justin Bertuch and moved his concession to Weimar in 1803.

Presumably to make the move more attractive, but possibly also because of Walbaum's superior quality, Bertuch had withdrawn a major typecasting order from the Prillwitz foundry in Jena and given it to Walbaum instead. From this we know that Walbaum's range already included both Antiqua and Gothic styles. In 1828, he handed the business over to his son Theodor, but unfortunately Theodor died in 1836, and so Walbaum was forced to sell his business to F.A. Brockhaus in 1836 to keep his work alive. The Berlin foundry H. Berthold AG then bought the matrices off Brockhaus in 1918, and still has them. Walbaum's Antiqua probably came into existence at the start of the 19th century and was extended during the Weimar period. It is regarded as Germany's most important contribution to classical types. Although based on Didot, it is very different from the idealism and imperialism of a Didot or Bodoni. It is more sentimental, more bourgeois and completely devoid of heroics.

Walbaum's staid middle-class nature combined with his skills as a craftsman to turn the ideal types of a Bodoni into a functional, aesthetically pleasing type. It is somewhat narrower than Bodoni, with less contrast, but overall stronger thick and thin strokes. This gives the type body a leaner appearance, not so black, and less static, making everything softer. Walbaum succeeded in cutting the different fonts very evenly and the same shape, so that the different sizes mix well. Its even, restrained black destined it to be a book face. Since Walbaum's handcuts used

different proportions in each size, however, the larger sizes are particularly useful as highlights. The italic capitals are a repetition of the uprights, while the lower-case letters show traces of handwriting, as with Didot. In the smaller sizes, it is very easy to read. Walbaum's Antiqua was far superior to Prillwitz, in which Göschen set his classics, which he published in both luxury and humble pocket editions, but Prillwitz the typecutter and caster was clearly ahead of Walbaum.

Johann Carl Ludwig Prillwitz (1759-1810) had already presented his samples of the 'new Didot letters' in Bertuch's *Intelligenzblatt des Journals des Luxus und der Moden* in 1790. Prillwitz had simply and unashamedly copied Didot and so evaded Unger's monopoly on sales. The existence of this widespread and much-copied letter in the new spirit of the times enabled Göschen the book dealer to publish his editions of the classics in an improved typography and print. Curiously, this showed up the lack of craftsmanship in punch cutting for printing and boosted sales. Prillwitz also had a stronger ductus than Didot styles: the lower-case ascenders were higher than the capitals, and it saved space. And so it happened that it was Prillwitz, rather than the superior Walbaum, which put its stamp on Göschen's classical editions and the newly-awakened classical art of printing in Germany. Göschen used it in setting Wieland's collected works and a very fine luxury edition of Schiller's *Don Carlos,* Klopstock's *Odes* and many others. Prillwitz clearly benefited from Göschen's sensitivity and reduction in print.

This set the capitals very wide, while the print body was also very loose and with widely spaced lines, and a splendid print image with a generous proportion of white space. Looking at Prillwitz's type samples of 1790, however, we are forced to wonder how anyone could think these shapes were that beautiful at the time. The larger the type, the clumsier the proportions and the more abrupt the transition from straight line to curve. The italics look like a child's first attempts at handwriting. In the smaller sizes, these shortcomings are not quite as glaring. This may have been the start of a specifically German type design - but what a world of difference from Walbaum's Antiqua or even his Gothic!

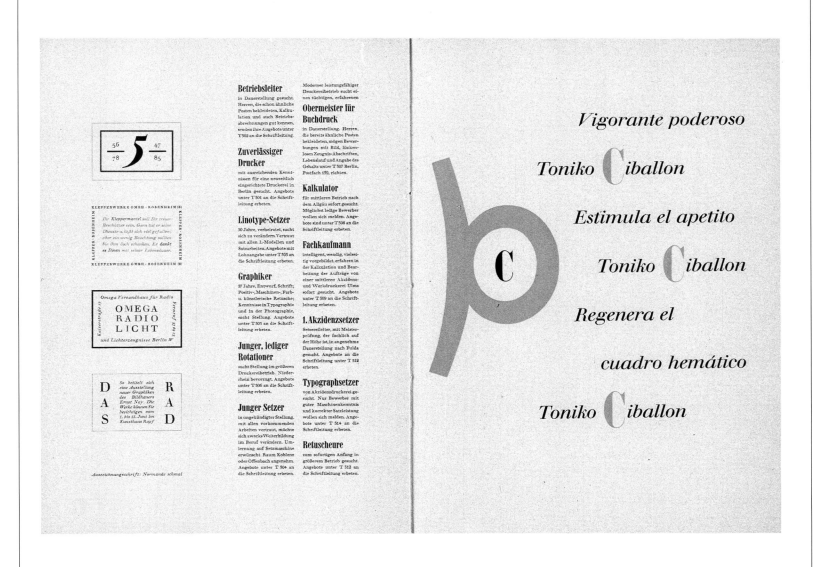

Walbaum comes into its own

We have to thank master printers Jacob Hegner of Hellerau and Carl Ernst Poeschel of Leipzig for the revival Walbaum's Antiqua experienced in the 20s and 30s. Hegner discovered the Walbaum matrices at Brockhaus in Leipzig and was so enthusiastic that he set nearly 4000 pages by hand for Gregorovius' *The History of the city of Rome*. Both printers used Walbaum in many books.

The combination of function and timelessness must also have appealed to the English typographer Oliver Simon, who noticed Poeschel's editions and Walbaum while editor of the typographical magazine *Fleuron*. In 1925, he bought the complete Antiqua series from Berthold for Curwen Press. Oliver Simon was a 'bookman', open-minded but more traditional where typography was concerned. His attitude to Walbaum was enthusiastic, even 'obsessed', and Curwen Press became known as the 'Walbaum house', using it and nothing else for eight years. The *Signature*

typographical volumes which Simon edited were also set in Walbaum. Thanks to Simon's preparing the ground, when Monotype issued Walbaum as a typesetting face in 1933, it was a rapid success, although initially it had the drawback of being set on a Didot base, which was better for sales on the continent. Monotype's Walbaum was based on the original Berthold version, plus a new bold and bold italic versions. In 1933, Berthold's Walbaum was added to Intertype setting equipment. Hermann Zapf adapted it for Linotype linecasting, although linecasting had a very restrictive effect on the design, especially with the italics. Here Monotype, with its single letter casting, had the advantage.

Walbaum Book and Standard

The lucky chance that Berthold had kept the original Walbaum matrices led Günter Gerhard Lange, Berthold's artistic director, to convert it for photosetting. The results were Walbaum Book and then Walbaum Standard, which Berthold brought out in 1975-79.

Some pages from "Walbaum Antiqua und Kursiv", Berthold type sampler no. 377, ca. 1953.

As early as the 60s, he had had the 24-point Antiqua and Italics which Walbaum lacked, plus the small capitals for hot metal casting. From matrices and original castings, Lange was able to proceed to detailed type studies on the principle that the larger the size, the narrower the drawing and vice versa. (Which was how Walbaum himself had worked.) Since photosetting uses one size as the basis for all the others, it was essential to use the right basic size. Walbaum 16 point was selected as the basis for the new Walbaum Book. This is roughly halfway down the scale and, in comparative tests, proved its merits in the body type sizes, as well as being a narrow, economic type.

Lange's own creative contribution was in the bold faces and their italics and the small capitals for the medium face.

The bold faces show the typical problems of classical styles: they start putting on weight if you adjust the x-height. The internal spaces, especially in lower-case letters with diagonals, are very small and are liable to restrict the use of a style in text sizes below 16 point. Lange's subtle detail work makes Walbaum Book very readable, even at 6 point, but the bold style is generally more suited to medium and headline sizes.

Finally, Lange added Walbaum Standard, designed specially for mass setting. Since all handcuts vary in proportion from size to size, in both width and style, the obvious choice was to use the type body sizes of Walbaum handcuts as the starting point for a normally-proportioned type. What book printers had once been forced to do because of the risk of slurring on coarse paper, i.e. setting the smallest sizes wider and more open, is unnecessary in photosetting if people know what they are doing. Walbaum Standard is based on a size between 8 and 10 point: internally, it is more open than Book, so that it looks wider, although it is narrower overall. The contrast between thick and thin strokes is less marked. The overall density of a page of text looks even, light and easy to read. Its neutrality is not the fault of the modern designer, but was already present in Walbaum's original cuts. If the Standard is enlarged to headline size, it looks too wide. In this case, the experts use it in combination with the version derived from the 48-point typecasts.

Otherwise, Standard presents no printing problems. Lange also added medieval figures and small capitals, although, remarkably, these never became popular in Germany. Berthold's Walbaum Standard is the one which comes closest to Justus Walbaum's original handcuts. Today, Walbaum is commonly found in advertising, especially where large areas are involved. The Musée d'Orsay has adopted Walbaum Book as its house style. Designer Rolf Müller uses Walbaum Standard in his outstanding magazine *High Quality*.

𝔥amburgefons

Hamburgefons

Hamburgefons

Weidemann Corporate A.S.E.

Prof. Kurt Weidemann

1990

URW

ABCDEFGHIJK

LMNOPQRST

UVWXYZ

1234567890

&

abcdefghijklmn

opqrstuvwxyz

-.,.:;!?„"''—

normal normal regular	ABCDEFGHIJKLMNOPQRSTUVWXYZ abcdefghijklmnopqrstuvwxyz 1234567890 / % (.,-:;!?)[''„""»«]–+=/$§*& ÆŒØÇæœøçáàäâéèêëîìïíóòöôúùüû
italique *kursiv* *italic*	*ABCDEFGHIJKLMNOPQRSTUVWXYZ* *abcdefghijklmnopqrstuvwxyz* *1234567890 / %* *(.,-:;!?)[''„""»«]–+=/$§*&* *ÆŒØÇæœøçáàäâéèêëîìïíóòöôúùüû*
normal normal regular	ABCDEFGHIJKLMNOPQRSTUVWXYZ abcdefghijklmnopqrstuvwxyz 1234567890 / % (.,-:;!?)[''„""»«]–+=/$§*& ÆŒØÇæœøçáàäâéèêëîìïíóòöôúùüû
italique *kursiv* *italic*	*ABCDEFGHIJKLMNOPQRSTUVWXYZ* *abcdefghijklmnopqrstuvwxyz* *1234567890 / %* *(.,-:;!?)[''„""»«]–+=/$§*&* *ÆŒØÇæœøçáàäâéèêëîìïíóòöôúùüû*
normal normal regular	ABCDEFGHIJKLMNOPQRSTUVWXYZ abcdefghijklmnopqrstuvwxyz 1234567890 / % (.,-:;!?)[''„""»«]–+=/$§*& ÆŒØÇæœøçáàäâéèêëîìïíóòöôúùüû
italique *kursiv* *italic*	*ABCDEFGHIJKLMNOPQRSTUVWXYZ* *abcdefghijklmnopqrstuvwxyz* *1234567890 / %* *(.,-:;!?)[''„""»«]–+=/$§*&* *ÆŒØÇæœøçáàäâéèêëîìïíóòöôúùüû*

The aesthetics of technology
Kurt Weidemann's Corporate A-S-E

N.B. For technical reasons, the text of
this chapter could not be set in
Corporate A.S.E. Instead, we chose
Weidemann Book.

"Just to be able to think is not enough today -
you have to be able to discriminate. You can't
just use one Helvetica for letterheads, speeches
or a spare parts catalogue." The words of
Kurt Weidemann during a discussion on his
latest type product, the Corporate A-S-E trinity.

There is no getting away from the fact that
complex electronic technology and its net-
working structures are changing our Western
written culture and forcing typeface designers
and typographers to think systematically.
In the same way that people's thinking is
influenced more and more by thinking in
numbers, our traditional alphabets, governed
by language and causal thinking, are reduced
to mathematical formulae. Genuine crafts-
manship has been replaced by traces, fleeting
digital pulses of infinite dimensions.
The artistic concept is reduced to artificial
plotter thinking and the tools we use to
achieve it are now soft ones. We are in the
process of remodelling our type tradition and
aesthetics, redefining them to suit the
computer rather than people.
The consequences for human beings are
scarcely imaginable. A comment by
Kurt Weidemann is symptomatic: "I don't
need individual typefaces if I have a discrimi-
nating typographical instrument". This can be
taken to mean that the development of
personality and differentiation is no longer just
an act of historically developed thinking and
creative power: most of the initiative now
comes from the computer. The programmer is
the real designer: he can create an apparently
traditional image or a completely imaginary
one and incorporate it into reality.

Corporate is still based on drawings by skilled
craftsmen, which the computer first breaks
down into digits and then recreates in the form
of a digital image.

Weidemann began working on the idea of a
corporate identity style in 1984. It was finally
completed in 1990. It is compatible with all
printing systems, and provides otherwise
amateurish office communication systems with
a practical typographical tool. The Daimler-
Benz group decided on Corporate in 1989, and
now has it as its permanent exclusive style.
And the Mercedes group now has a uniform
image all over the world.

The forebears of the type family

The idea of systematising typefaces perhaps
began with the Dutch type designer Jan van
Krimpen in 1931-37, when he created Romulus
Antiqua for the type founders Enschede &
Zonen in medium, bold, extra bold, bold
condensed and italic. Then he added Romulus
Grotesque in four styles: light, medium, bold
and extra bold. In its proportions, ascenders
and descenders and stroke width, this matched
Antiqua. These four fonts were cut in 12-point,
but never went into commercial production.
They probably thought there was no future in
it.
With the advent of electronics and its
seductive versatility, Dutch type designer
Gerard Unger has been working on standardi-
sing fonts for specific typesetting and printing
technology. In 1975, there appeared the
newspaper font Demos, an Antiqua for Hell-
Digiset. This was followed in 1977 by the
Grotesque font Praxis, whose proportions and
line strengths matched those of Demos, so that
the two could be easily used together. In 1985,
there appeared Flora, a sans serif informal style
looking like an upright italic, which went
particularly well with Praxis, which as a
Grotesque had no italic style of its own.

The same year also saw the emergence of the first genuine type family for low-resolution laser printers: Lucida Antiqua, Lucida Grotesque and Pel-Lucida, a screen font. Charles Bigelow and Kris Holmes, the type designers from California, based their ideas directly on those of Jan van Krimpen and the humanistic handwriting styles and early printing styles of the Renaissance. They tried in particular to bring the good type style and resulting easy readability to electronic systems and so keep it intact.

Between 1984 and 1987, Summer Stone of Adobe Systems Inc. was involved in designing the Stone family, the first extended digital compatible family. The original 18 fonts, which are still being extended, included an Antiqua, a Grotesque and an Informal. Stone, too, is based on the classical precepts, making it easy to read, with a pleasantly subdued, inconspicuous character, although putting different members of the family together gives exciting, contrasting typography. Only the informal is weak, neither a pure handwriting style nor a strong typesetting font. 1988 saw the appearance of Otl Aicher's Rotis family, a vehicle for Aicher's theoretical claims to optimum readability and designed to solve all the typographical problems in the world. The Rotis range includes a Grotesque, a Semi-Grotesque, a Semi-Antiqua and an Antiqua. It is designed as a running face, but its reduced legibility makes it more suitable for jobbing work. It is a family of highly varying characters. They are all a bit too alike and trying to hide this with superficial individuality, but this only has the opposite effect, and just makes reading difficult. Aicher, who makes his typeface design the basis for a whole philosophical edifice, has made sure that Rotis is the subject of much heated debate.

The Corporate A-S-E

This was the background against which Kurt Weidemann took a new route with his trinity, Corporate Antiqua, Sans and Egyptienne. "This isn't a font for setting novels, it's a house style," he says. As far as the fonts are concerned, this means:
- They must be compatible with one another in terms of form, width and boldness
- They must be independent of any input/output unit.
- They must be legible at any level of resolution.
- Although with much in common, they must be clearly distinguishable from the other members of the family in terms of charm.
- Office communications (electronic publishing) in particular must be given a range of design possibilities which reduce the chances of typographic errors.

With Corporate A-S-E, Weidemann has created a prototype whose form and aesthetics are governed by pluralistic electronic technology. Even so, the designer's 'handwriting' is still apparent. Once again, this shows that human beings carry an idea, a basic design which appears in the most varied guises. If we look at Weidemann (formerly Biblica), the likeness with Corporate is immediately visible.

Adrian Frutiger likes to say, "Putting my type-

206

faces side by side, I find that they all share the same basic structure, that of Univers". Nonetheless, Univers and Frutiger have a quite different appearance, suiting them for different typographical purposes.

The Corporate A-S-E concept consists of the Antiqua, sans and Egyptienne families, and is divided into 72 potential (and actual) fonts. From these, 37 fonts or, as Weidemann puts it more accurately, 'type images' were created, the rest being called up as required.

Antiqua, Sans Serif and Egyptienne are the three most meaningful types of font classification. In basic design, proportions and rhythm, they are matched to one another. The aesthetic differences arise mainly from the senses: classical, objective, technical. This means that, although the formal criteria are the same, an Egyptienne can never be confused with an Antiqua, or a Grotesque with an Antiqua. There are no intermediate hybrid forms. Their clear arrangement and demarcation make Corporate easier to read overall and much more versatile than, say, Rotis.

This family clan works on the basis of a natural, harmonic basic similarity of style. This will be useful to the office secretary - the 'office typographer', as Aaron Burns of ITC calls her. Without needing any major special training, she will be able without too much trouble to produce professional-looking print, and in particular without committing any in the minefield of font mixing.

Grace

Corporate is a very neutral, static, perfectly legible style, designed using economic criteria. For a group which spends millions on print a year, such economies matter. Close set, it saves a lot of room without losing out on legibility, even in the small sizes - but without making people want to read it either. It may be

that the 'new humans' have learnt to do without emotional stimulation, and are turning little by little into 'reading machines', which read everything in print without asking the why or the wherefore.
The reasons for this view lie in the formal proportions: the very high x-height, the short ascenders and descenders, the large, open internal spaces, the vertical shading axis. By reducing the differences in proportions between upper- and lower-case letters, Weidemann believes he has democratised print and eliminated authoritarian thinking.

Looking at individual letters, we find unusual, often top-heavy proportions such as in the P, R or G. Weidemann abhors the polished style. He likes putting in 'eyecatchers', such as the r in the Egyptienne, the dot on the i in Grotesque, or the very thin 'g' in all the fonts. The Q always looks like an O with an afterthought, a characteristic it shares with Weidemann. In the Antiqua, the p and q are virtually identical. They look like mirror images, the only exception being the squashed serifs in the q. The b and d, on the other hand, are clearly distinguished, and easy to differentiate, even when used together.

As the head of the family, Corporate Antiqua is a neoclassical medium-contrast style, which comes alive as it increases in boldness. Putting the three groups side by side, we can see that the apparent density has been brought to an optical common denominator, ensuring total readability and font compatibility.

Corporate Sans is perhaps the least successful of the three, although it has its own independent, balanced style and is based on early American sans serif styles. It is simply a sans serif linear Antiqua without any obvious individual touch. Internally, it is more open than the Antiqua, as the absence of serifs has to be made up for by adjusting the running width.

Großunternehmen
können heute nicht mehr
mit <u>einer</u> Schriftfamilie
<u>alle</u> Bedarfsfelder abdecken.
Es gibt Bereiche
klassischer, <u>sachlicher</u> und
<u>technischer</u> Anwendung.

Corporate ·A· Corporate ·S· Corporate ·E·

Großunternehmen
können heute nicht mehr
mit *einer* Schriftfamilie
alle Bedarfsfelder abdecken.
Es gibt Bereiche
klassischer, *sachlicher* und
technischer Anwendung.

Corporate ·A· Corporate ·S· Corporate ·E·

Großunternehmen
können heute nicht mehr
mit **einer** Schriftfamilie
alle Bedarfsfelder abdecken.
Es gibt Bereiche
klassischer, **sachlicher** und
technischer Anwendung.

Corporate ·A· Corporate ·S· Corporate ·E·

Mixing styles within the trilogy.
Designing styles on the basis of fixed
proportions enables them to be mixed
harmoniously.

Corporate Egyptienne is actually a Clarendon: in other words, it has differing line strengths and clear but differing serifs and characteristic non-Antiqua features (such as E and F).
The internal serifs are all shorter than the external. What is new is that the serifs on the tops of the capitals and lower-case letters are a touch lighter than those on the baseline.
This stops it being too spotty and top-heavy.
It is clear, individual and highly expressive.

As far as I am concerned, this would be a reason for using it more than the Grotesque, and even the Antiqua.

Stamp out type criminality!

Kurt Weidemann is vehemently opposed to electronic modifications or distortions to type.
He believes it is 'criminal', and his response is to make typographical design instrumentation available in a wide range, in the hope that this will neither reduce the style to a 'common' nor entice the inexperienced user into a quagmire.

The three type families have their italics and cursives, and some have medieval figures and small capitals. The Antiqua Italic is a combination of electronic skewing and adding new, individual characters with a touch of the handwritten: a, k, v, w, x, y, z, K, R, W, X and Y. Its combination of skew and true italics makes it an extension to the Antiqua rather than a font in its own right, such as garamond Italic. As a moderate italic, it reapproaches Stanely Morison's theory of the ideal italic, which was feasible neither in the 30s nor since then. It seems as if this idea reoccurs each time the technical side comes uppermost, as here with the house style.

The sans serif and Egyptienne, on the other hand, are purely electronic creations.
Of course, this did not simply involve skewing the uprights, but revising the shapes to give a good, legible design.

Letter, original size, with marking
points for resolution. After corrections,
the style will be converted to a sequence
of data

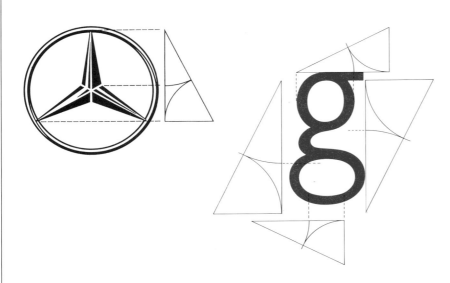

Which brings us to mixing fonts. As far as I am concerned, this is a source of headaches. I am afraid that it is a mistake to assume that using a wide, compatible type family makes designing any easier or better. Highlighting an individual word in an Antiqua text by setting it in sans serif or Egyptienne is not enough: the basic similarity and low frequency of repetition will mean that the reader will miss it.
You need at least to use italics or high contrast. Corporate's basic similarity and overall neutrality do not make for exciting typography. You still need sensitivity and a knowledge of typography. Whether Corporate can create dynamic type remains to be seen.

G.G.L.

This type family is an enormous project, calling for a lot of power, persistence and attention to microscopic detail. For many years, some of the load has been shared by Kurt Stecker, Weidemann's conscientious draughtsman.

To give his type the finishing touches and ensure its legibility under varying production conditions, in the final stages Weidemann called on the services of one of the most experienced and sensitive typeface designers, Günter Gerhard Lange, who made the final corrections down to the last detail, such as the serif thicknesses in the Egyptienne. He made the letters harmonise in form and aesthetics, so the type shines.
One of GGL's correction sheets includes the note: "Now all we need is the breadth!".
A job for the URW digitalising team.

Most Daimler-Benz Group activities are involved with movement. Movement means dynamics. Surprisingly, they opted for a static, neutral, technical style, which makes advertising with emotional appeal difficult. Weidemann says: "The group keeps advertising to the minimum. Emotions are conveyed via design, content and text. As far as type's contribution is concerned, it is

enough to have the large range of characters and design possibilities."

Corporate A-S-E meets the demand for legibility and universal compatibility in technical terms, but makes a considerable contribution to maintaining type and typographic quality even in a tight corner. "I've never forgotten that legibility is important."

Looking at the Mercedes star, we find that it uses the Golden Mean twice: once in the height of the lower limb relative to the point of the star, and in the star as whole relative to the total height of the symbol. These proportions were also followed in the lettering where possible.

Mercedes-Benz AG
Nutzfahrzeuge

Zapf Chancery

Hermann Zapf

1979

International Typeface Corp.

H. Berthold AG

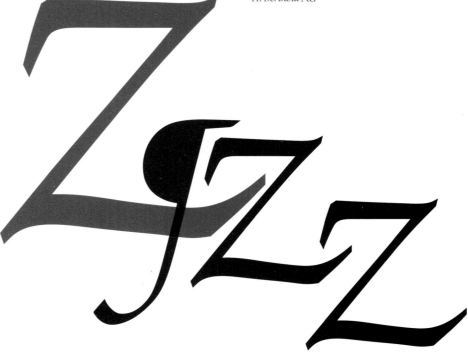

ABCDEFGHIJK
LMNOPQRST
UVWXYZ
1234567890
&
abcdefghijklmn
opqrstuvwxyz
—.,:;!?„""''—
1234567890

normal
normal
regular

ABCDEFGHIJKLMNOPQRSTUVWXYZ

abcdefghijklmnopqrstuvwxyz

1234567890/%

(.,-:;!?)[''„""»«]—+=/$§*&

ÆŒØÇæœøçáàäâéèëêíìïîóòöôúùüû

italique
kursiv
italic

ABCDEFGHIJKLMNOPQRSTUVWXYZ

abcdefghijklmnopqrstuvwxyz

1234567890/%

(.,-:;!?)[''„""»«]—+=/$§*&

ÆŒØÇæœøçáàäâéèëêíìïîóòöôúùüû

demi-gras
halbfett
medium

ABCDEFGHIJKLMNOPQRSTUVWXYZ

abcdefghijklmnopqrstuvwxyz

1234567890/%

(.,-:;!?)[''„""»«]—+=/$§*&

ÆŒØÇæœøçáàäâéèëêíìïîóòöôúùüû

211

italique
demi-gras
kursiv halbfett
medium italic

ABCDEFGHIJKLMNOPQRSTUVWXYZ

abcdefghijklmnopqrstuvwxyz

1234567890/%

(.,-:;!?)[''„""»«]—+=/$§*&

ÆŒØÇæœøçáàäâéèëêíìïîóòöôúùüû

Where did Chancery and Dingbats on the PC come from?

Until the mid-80s, Hermann Zapf was only known in specialist circles: to the public, he was largely unknown, although we see his harmonious products every day.

To most people, typography is still an unknown entity. We recognise the role of design in houses, interiors, furniture, cars and everyday objects, but not very often in print. Did you ever hear of anyone buying a washing powder just because the packaging used 60-point Univers bold?

Nevertheless, there are men like Hermann Zapf who have devoted their whole lives to perfecting the 26 letters from A to Z and their numerous companions, from the comma to the ampersand.

Since 1985, however, at least three of Zapf's creations have suddenly burst into public awareness. They are now 'resident' on tens of thousands of PostScript laser printers - in other words, included in the permanent memory. Along with Times and Helvetica, they are some of the first typefaces new PC users get to try out: Palatino, Zapf Chancery and Zapf Dingbats, the latter not actually a typeface, but a collection of incidentals.

Zapf Chancery, for instance, was produced to the order of the International Typeface Corporation in New York. The idea of

creating a calligraphic Antiqua came from Edward Rondthaler in New York. It was to be as widely applicable as possible, not just for headlines, but also for running text - with the right line spacing, of course, although people don't always get this right. The Antiqua capitals were also produced as a text face. The six versions of Zapf Chancery were also designed for rub-down lettering. This was achieved by using a variety of curved letters and special final letters.

Not all photosetting or PC versions can include all these versions, especially since some figures are not accessible via the standard keyboard. Since they require special codes, this prevents the typeface's design qualities being used to the full, especially since untrained PC users find this unusually wide range too much to cope with.

Who is this Hermann Zapf whose products are now such a prominent feature of desktop publishing?

He was born in 1918, just before the creative twenties, in Nuremberg, the city of Dürer, someone else who was very concerned with typeface design.

Zapf's father worked in a car factory, but, as a child, Hermann wanted to be a chimney sweep. In the end, however, he started an

¶ Typografie ist im Grunde
zweidimensionale Architektur.
¶ Die Harmonie der einzelnen Proportionen,
die Gruppierung der Schriftzeilen,
das Abwägen von Kontrast und Ausgleich,
die Symmetrie wie die dynamische Spannung
der anaxialen Anordnung sind Gestaltungsmittel,
die der Typograf je nach der gestellten Aufgabe
so anzuwenden hat, daß der Text dem Leser
in der ansprechendsten Form vermittelt wird.
¶ Seiner Phantasie sind nur durch die Gesetzmäßigkeit
des Materials und der stilgeschichtlichen Bindung
der Formen Grenzen gesetzt.
¶ Immer wieder ist man erstaunt,
welch ein Formenreichtum
den Lettern innewohnt.

A statement by Hermann Zapf, 1954,
found in Linotype's 'Thesen zur
Typograpfie'. An expression of the
credo of one of the great typeface
designers of our time.

Hermann Zapf

ABCDEFGHI
· ROTUNDA · OMNIUM · SCRIPTURARUM · NOBILISSIMA ·
JKLMNOPQR
· VOCATUR · ETIAM · MATER · ET · REGINA · ALIARUM ·
STUVWXYZ
· LEONHARD · WAGNER · 1505 ·

Gilgengart · ABCDEF
GHIJKLMNOPQ
RSTUVWXYZ abc
defghijklmnopqrstuvwxyz

ABCDEFGHI
JKLMNOPQR

214

apprenticeship at 14 as a positive retoucher with a large printing firm. Soot from the chimneys ended up in the printing inks, and these inks, the printing presses and above all the letters of the alphabet captivated him - a love which would last for life.

At school, Zapf had no special love of writing, but now he practised the alphabet incessantly. He took up calligraphy as a private study. While his friends went out dancing, he stayed bent over his desk, conjuring up lively figures on paper - a victim of the obsession without which no-one can spend a lifetime creating beautiful letters.

He covered hundreds of pages, only to crumple them up in disappointment. One day, he found he was holding the pen the wrong way.

Like most great artists, he had to spend many years working his way to the top. His persistent, single-minded practice eventually made him one of the great typographers of this century.

After passing his apprenticeship, he went to Paul Koch's "Haus am Fürsteneck" printing and banknote works in Frankfurt. The famous print historian Gustav Mori gave him books from his library, giving him the opportunity to study the history and

methodology of printing. At the age of 20, he finally felt ready to start work on his first typeface, Gilgengart. The year was 1939. Not long afterwards, Hitler had broken typefaces banned.

As well as Gilgengart, Palatino, Dingbats and Chancery, Zapf was of course also responsible for many other typefaces, such as Melior, Optima, Comenius Antiqua, AMS Euler (specially designed jointly with Stanford University for mathematical type-setting), Scangraphic Renaissance Antiqua, Michaelangelo, Sistina, Hunt Roman, Marconi and Comenius.

Today, Hermann Zapf can still be found at the drawing-board in his studio in Darmstadt, with a sheet of white paper, a pen, a fine sable brush and a dish of Chinese ink which he dilutes with rainwater. He draws or writes as he always does - typeface characters, Roman and exotic, figures, incidentals. And the astounding thing is, they always look new, always different, although they all stem from the same Roman capitals and Carolingian lower-cse letters.

In English-speaking countries, the term 'Chancery' is used to describe everyday Renaissance types. Zapf may well have had such chancery scrbes and their like in mind when he called his highly calligraphic script

abcdefghijklmn
opqrstuvwxyzA
BCDEFGHIJKL
MNOPQRSTUV
WXYZ123456789
01234567890&$¢
£%AÇÐEŁØÄÆÊÅ
ßaçðełøæœ:;,.!¿?¡
.-–—""''/#*()[]†‡§«»‹›

START LETTERS: Jfvw Ⱥthoⱼ LIGATURES

VARIATIONS: gvwxyyyz

SWASH CAPS: ABCDEFGH
IJKLMNOPQ
RSTUVWXYZ
ÆŒJⱢ?

ALTERNATES:

FINALS: ddₑeₑkr.ty⸗·⸜⸝

215

ITC ZAPF

Chancery™

after them. In fact, it is unique among the script and italic faces: a typeface you can use to give your printed matter a completely different appearance. And no doubt Chancery also includes some features of Hermann Zapf's own handwriting - something not even the computer can obscure. It is comforting that even a soulless computer can retain so much individuality.

So what distinguishes a master such as Hermann Zapf from the average graphic artist, who after all is also capable of drawing fine letters on paper?

With a bit of practice, almost any graphic designer can write or draw a correctly proportioned character which looks good on paper.

But the average typeface consists of hundreds of such characters. The art lies in designing them so that they fit together visually and technically, so that they form a harmonious whole. At the same time, they must all be clearly different, so that they are immediately distinguishable to the reader's eye.

Once Hermann Zapf has got to the stage where he has found a new visual line, there follows the laborious process of spacing the characters relative to one another, especially the difficult combinations where the empty

spaces threaten to break up the line: V and A, T and Y, L and A and others. This is now known as kerning.

Typesetting and printing have undergone a revolution since Gutenberg's time. Today, each letter must fit in the electronic world - be 'digitalised', as the term is.

Zapf was one of the first to adjust to the demands of the new technology. Unlike many of his younger colleagues, he has no fear of hands-on experience.

Many people are afraid that one day printing will be a thing of the past, that people might stop reading books and communicate electronically. Zapf thinks this is all nonsense: even the typefaces now produced by laser beam or LEDs are based on Gutenberg's ideas, he says.

He still finds pleasure in finding just the right angle for a new 'q' or the right curve for a capital 'O'. For typographers like him, the 26 characters we use to try to capture the world are all the reason he needs.

Sources of illustrations

The publishers have made every possible effort to meet their obligations in connection with copyright. Should there, despite this, have been some oversight, the publishers would greatly appreciate it if those concerned would contact them.
The publishers would like to thank the following companies, publishers and museums by whose kind permission the illustrations are reproduced.

13 Berthold AG/Jan Tholenaar

20 *'John Baskerville - A Memoir'*
University Press, London, 1907
University library, Amsterdam

21 dito

22 (above, left) *'Baskerville Light, Bold, Italic, Small caps'* Intertype Corporation, New York, 1947.
Museum Meermanno Westreenianum, Den Haag.
(above, right) *'The Roman and Italic of John Baskerville - Acritical note'.*
The Lanston Monotype Corporation, London 1927.
Jan Tholenaar.
(below) *'A Specimen of Printing Letter Designed by John Baskerville'.*
The Lanston Monotype Corporation, London, 1926
Jan Tholenaar

23 Erik Spiekermann

24 Erik Spiekermann

28 Manfred Klein 1990

29 (above, right) *'Random Beowolf'*, Fontshop 1990.
(below) Manfred Klein 1990.

30 (left) Fax, Erik van Blokland - Just van Rossum,
Manfred Klein, 1990.

31 V+K Design (right) *'Page'* 11/1990, Erik Spiekermann

32 above) *'Page'* 11/1990, Erik Spiekermann
(below) Manfred Klein 1990.

37 *'Manuale Tipografico'*, Giambattista Bodoni, Parma, 1818. Erik Spiekermann.
Monotype.
Linotype.

38 Linotype & Machinery Ltd., London, 1925/
University library Amsterdam

39 *'Bodoni Schriften'* Schriftgießerei D. Stempel A.G.
Frankfurt-M, ± 1932
Jan Tholenaar

40 Johan Enschedé & Zonen/
Universitätsbibliothek Amsterdam

44 Erik Spiekermann

45 dito

46 Letterproef, 3 Supplement, Joh. Enschedé & Zonen, 1910,
University library Amsterdam

47 *'The Manual of Linotype Typography'*, The Mergenthaler Linotype Company 1923. Jan Tholenaar (above, left)
The Monotype Corporation (above, right)
University libary Amsterdam.
D. Stempel University library Amsterdam (below)

53 University library Amsterdam

55 Photos: Yvonne Schwemer-Scheddin

56 University library Amsterdam

61 H. Berthold A.G.
Manfred Klein

62 *'Concorde Nova'*, Diogenes Verlag A.G., Zürich, 1983

63 H. Berthold A.G.
Manfred Klein.

68 Rochester Institute of Technology, Cary Library, New York.
Melbert B. Cary, Jr.
Graphic Arts Collection.

Bibliography

Atlas zur Geschichte der Schrift (Band 1,2,3), Technische Hochschule Darmstadt.

Bauhaus, Drucksachen, Typografie, Reklame, Edition Marzona, Düsseldorf 1984.

Berthold Fototypes E2, H. Berthold AG, Berlin 1980.

Berthold Headlines E3, H. Berthold AG, Berlin 1982.

Die Bremer Presse, Typographische Gesellschaft München, 1964.

The Graphic Language of Neville Brody, Thames and Hudson, London 1988.

Monographie künstlerischer Schriften (Band 11), Verlag Scharbeutz (Hermann Zapf, William Morris, Klaus Blanckertz).

Programme entwerfen, Arthur Niggli, Teufen 1964.

Otl Aicher, *Typographie*, Ernst & Sohn, Berlin 1988.

Clifford W. Ashley, *The Ashley Book of Knots,* Doubleday, Doran & Co, New York 1944 / Faber & Faber Limited, London 1947.

Hermann Barge, *Geschichte der Buchdrucker Kunst*, Philipp Reclam, Leipzig 1940.

Peter Beilenson, *The Story of Frederic W. Goudy*, Peter Pauper Press, Mt. Vernon 1965 (reprt.).

Giambattista Bodoni, *Manuale Typografico*, Franco Maria Ricci, Parma 1965.

Gustav Bohadti, *Von der Romain du Roi zu den Schriften J.G. Justus Erich Walbaums*, H. Berthold AG, Berlin/Stuttgart 1957.

Gustav Bohadti, *Justus Erich Walbaum*, Staatliches Lehrinstitut für Graphik, Druck und Werbung, Berlin 1964.

Hans Rudolf Bosshard, *Technische Grundlagen zur Satzherstellung. Mathematische Grundlagen zur*

Satzherstellung (2 Vols.), Verlag des Bildungsverbandes schweizerischer Typographen (BST), Bern 1980/85.

Bruce Brown, *Browns index to photocomposition typography*, Greenwood Publishing, Minehead 1983.

Karl G. Bruchmann, *Walbaum's Early Years in Goslar and Weimar*, Monotype Recorder 4/Vol.41.

Max Caflisch, *Swift*, Typografisches Monatsblatt 4 (1987).

James Craig, *Designing with Type*, Watson-Guptill, New York 1971.

Walter Crane, *The Bases of Design*, George Bell and Sons, London 1898.

Dietmar Debes, *Georg Joachim Göschen*, Institut für Buchgestaltung, Leipzig 1965.

Dick Dooijes, *Over de Drukletter-ontwerpen van Sjoerd H. de Roos*, Zutphen 1987.

F. Fischer & H. Jakob, *Syntaktische Textentwicklung,* Halifax, Berlin 1970 (unveröffentl. Manuskript).

Gerd Fleischmann, *Irish Country Posters*, Grafische Werkstätten des Fachbereichs Design der Fachhochschule, Bielefeld 1982.

Karl-Erik Forsberg, *Mina bokstäver*, Wiken, Stockholm 1983.

Friedrich Friedl (Ed.), *Theses about typography*, 1900-1959, 1960-1984 (2 vols.), Linotype, Eschborn 1985.

Mildred Friedman (Ed.), *De Stijl: 1917-1931 Visions of Utopia*, Phaidon Press, Oxford 1982.

Adrian Frutiger, *Der Mensch und seine Zeichen,* D. Stempel AG, Frankfurt am Main 1978.

Adrian Frutiger, *Type, Sign, Symbol*, ABC Verlag, Zürich 1980.

Ken Garland Associated designers:
Twenty years work and play 1962-82,
London 1982.

Karl Gerstner, *Kompendium für
Alphabeten*, Arthur Niggli, Teufen 1972.

Eric Gill, *Autobiography*, Jonathan Cape,
London 1940.

Eric Gill, *An Essay on Typography*, David
Godine, Boston 1988 (reprt.).

Götz Gorissen (Ed.), *Berthold Fototypes E1*,
H. Berthold AG, Berlin 1974.

Frederic W. Goudy, *Typologia*, University
of California Press, Berkeley 1940.

André Gürtler, *Die Entwicklungsgeschichte
der Zeitung*, Typographisches Monatsblatt
1 (1988).

Robert Harling, *The Letterforms and Type
designs of Eric Gill*, Eva Svensson, 1979
(3e edit.).

Stanley Hess, *The Modification of
Letterforms*,
Art Direction Book Comp., New York
1972.

Charles Holme, *The art of the book*, Studio
Editions, London 1990 (reprt.).

Pontus Hulten (Ed.), *Futurismo & Futurismi*,
Bompiani, Milano 1986.

Alan Hurlburt, *The grid*, Barrie & Jenkins,
London 1979.

Allen Hutt, *Fournier*, Frederick Muller,
London 1972.

Jaspert, Berry & Johnson, *The Encyclopedia
of Type Faces*,
Blandford Press, London 1962 (3rd edit.).

Johnson (J.), *Typographia, or the Printer's
Instructor*
Messrs. Longman, London 1824.

Peter Karow, *Digital Formats for Typefaces*,
URW-Edition No. 2 4/87 URW Verlag,
Hamburg.

Donald Karshan, *Malevich the Graphic
Work: 1913-1930*,
The Israel Museum, Jerusalem 1975.

Rob Roy Kelly, *American Wood Type
1828-1900*, Da Capo, New York 1969.

Alexander Lawson, *Anatomy of a Typeface*,
Hamish Hamilton, London 1990.

Erik Lindegren, *ABC of Lettering and
Printing Typefaces*,
Greenwich House, New York 1982.

Philipp Luidl, *Typografie*, Schlütersche,
Hannover 1984.

Hans-Rudolf Lutz, *Ausbildung in
typografischer Gestaltung*,
Verlag Hans-Rudolf Lutz, Zürich 1987.

Giovanni Mardersteig, *Die Officina Bodoni
1923-1977*,
Stamperia Valdonega, Verona 1979.

Mac McGrew, *American Metal Typefaces
of the Twentieth Century*, The Myriade
Press Inc., New Rochelle, New York 1986
(Preliminary Edition).

Ruari McLean, *The Thames and Hudson
Manual of Typography*,
Thames and Hudson, London 1980.

Stanley Morison, *Towards an ideal Italic*,
Fleuron V 1926.

Frantisek Muzika, *Die Schöne Schrift*,
Werner Dausien Verlag, Hanau a. M. 1965.

Oliver Simon, *Printer and Playground*,
Faber and Faber, London 1956.

Erik Spiekermann, *Ursache & Wirkung: ein
typografischer Roman*, Context GmbH,
Erlangen 1982 / H. Berthold AG,
Berlin 1986.

Erhardt D. Stiebner & Walter Leonhard,
Bruckmann's Handbuch der Schrift,
F. Bruckmann KG, München 1977.

Jan Tschichold, *Meisterbuch der Schrift*,
Otto Maier Verlag, Ravensburg 1965.

Jan Tschichold, *Ausgewählte Aufsätze über
Fragen der Gestalt des Buches und der
Typographie*, Birkhäuser, Basel 1975.

Walter Tracy, *Letters of Credit*, David
Godine, Boston 1986.

D.B. Updike, *Printing Types*, Oxford
University Press, London (2nd edit.).

Hans Peter Willberg, *Buchkunst im Wandel*,
Stiftung Buchkunst, Frankfurt am Main
1984.

*Berthold Aktuell
Deutschen Stein- und Buchdrucker
Fine print
Linotype Express
Page
Types & Typo*

Contributions

Type & Typographers is a project of
V+K Publishing, Laren, The Netherlands
and was initiated by **Cees de Jong** and
Ernst Schilp.

This book was made possible by the
support of:
KVGO, Amstelveen
H. Berthold A.G., Berlin
Wifac B.V, Mijdrecht
Lay-out zetterij Boxem B.V., Amsterdam
FontShop, Berlin
FontShop Nederland B.V., Zeist
URW Unternehmensberatung GmbH,
Hamburg
Proost en Brandt, Diemen.

Texts:
Manfred Klein, Frankfurt;
Yvonne Schwemer-Scheddin, Gauting;
Erik Spiekermann, Berlin;
Germany.

Design:
Cees de Jong, Ernst Schilp,
V+K Design, Laren, The Netherlands.

Project co-ordination:
Stina van der Ploeg, V+K Publishing,
Laren, The Netherlands.

Research work and illustrations:
Ernst Schilp, Gunter Gruben,
Manfred Klein, Yvonne Schwemer-
Scheddin, Erik Spiekermann.

Reproduction photography:
Arthur Martin, Bussum, The Netherlands.

Typesetting and lithography:
Lay-out zetterij Boxem B.V., Amsterdam,
The Netherlands.

Translation:
Andrew Fenner, London, England.
John Rudge, Amsterdam,
The Netherlands.

Printed and bound in The Netherlands by:
Sdu Drukkerij, The Hague.

Paper:
Royal extra matt satin, 135 g/m^2
KNP Papier
Fine Paper Division
via
Proost en Brandt, Diemen.